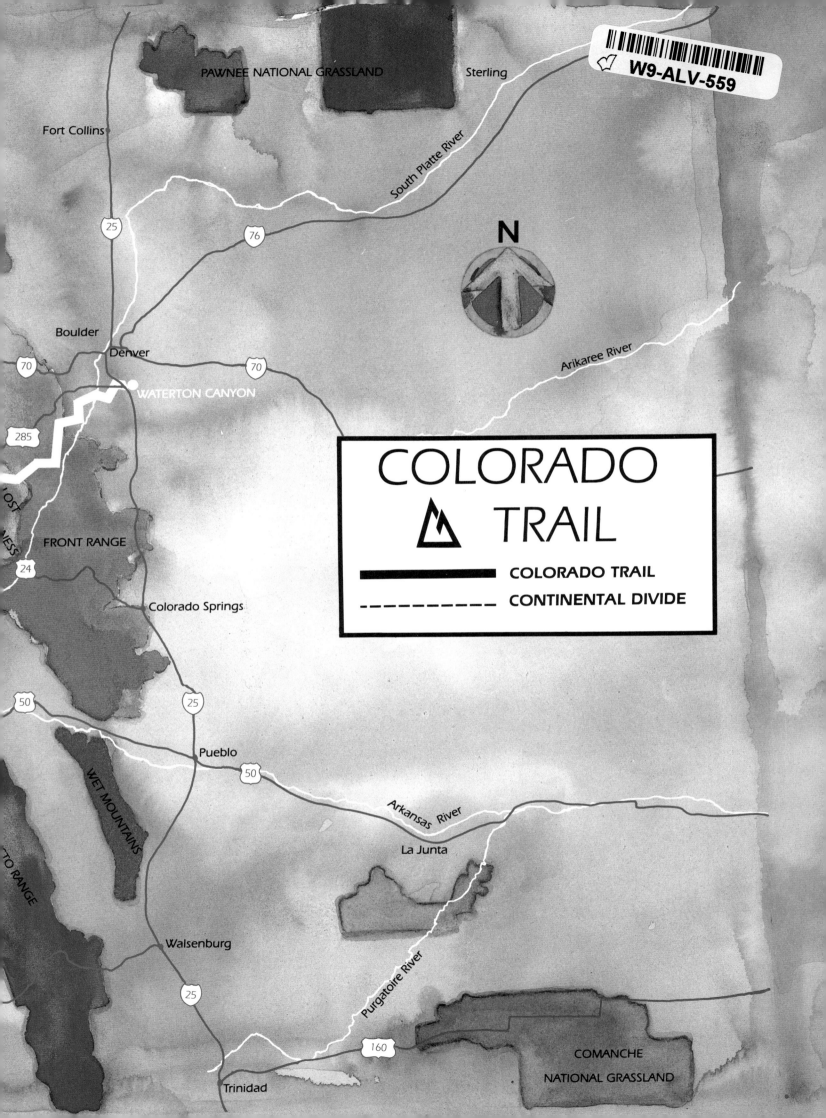

COLORADO TRAIL

▬▬▬▬▬	COLORADO TRAIL
─ ─ ─ ─ ─	CONTINENTAL DIVIDE

PAWNEE NATIONAL GRASSLAND

Sterling

Fort Collins

South Platte River

N

Arikaree River

Boulder

Denver

WATERTON CANYON

FRONT RANGE

Colorado Springs

Pueblo

Arkansas River

La Junta

WET MOUNTAINS

Walsenburg

Purgatoire River

COMANCHE

NATIONAL GRASSLAND

Trinidad

ALONG THE

COLORADO TRAIL

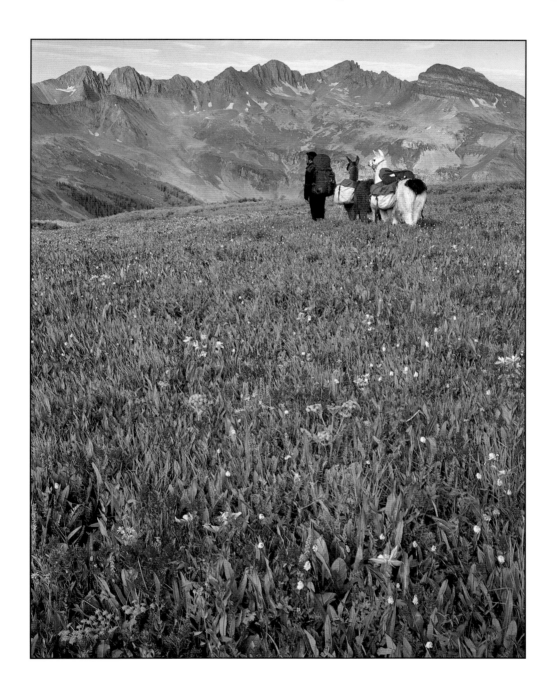

JOHN FIELDER & M. JOHN FAYHEE

WESTCLIFFE PUBLISHERS, INC. ENGLEWOOD, COLORADO

ACKNOWLEDGEMENTS

Hiking the Colorado Trail was one activity among several that kept me busy for a couple of years. This kind of schedule is not possible to keep without help from others. A critical part of maintaining order in the field involves the logistics of getting to and from trailheads, and the degree to which I can concentrate on taking pictures in sometimes hostile conditions.

This project required putting cars at both ends of sections of the Colorado Trail, which often made for much drive time. Recognition is deserved for those who set up these shuttles, hiked up to 15 miles a day, set up camp in bad weather, ate dinner at 10:30 p.m. and breakfast at 10:30 a.m. (after 4:30 a.m wake-up calls) chased wayward llamas, prodded sitting llamas, ran at full speed with 60-pound packs through bogs to get to the light, and received my wrath.

I acknowledge the significant contributions to this book of my loyal sherpas and friends JT Fielder (my son), Mike Larkin, Doug Lewis, Brian Litz, Brian O'Malley and Gary Zermuehlen. Congratulations and thanks go to my wife, Gigi, for maintaining a happy home for JT, Ashley and Katy while "Daddy" was away. Thanks also go to Bruce Ward of REI for being the cover model and to Paul Brown, my llama provider, for keeping the "boys" in such good shape. Speaking of the "boys," this book would not have been possible without four incredible creatures named Tommie, Pogo, Tensing and Repete.

Thanks to my photo lab, Reed Photo Art of Denver, and their many talented professionals who take such good care of me and my film. May frozen water pipes never again burst above stacks of unfiled transparencies!

Lastly, I wish to acknowledge the perseverence of Gudy Gaskill, and the friends and directors of the Colorado Trail Foundation. Without their foresight and devotion to conceive and carry out the construction of the Trail, this book would have not been possible.

— J.F.

Any time a person sets out to hike a 470-mile trail end to end, you can bet there are a lot of people behind the scenes whose help and support are integral to the success of the effort.

Obtaining supplies is one of the most important aspects of hiking a long trail. Because I live in the Colorado mountains, I was fortunate to be able to press several friends into bringing me food drops. For this I would like to thank: Mark Fox and Joe Behm of Summit County, for the good cheer at Twin Lakes; my in-laws, Chuck and Marian Gangel of Cañon City, for their visit — as well as the prime rib — at North Pass; and Greg Wright and Tara Flanagan of Red Cliff, for driving all the way to Lake City with my M&M resupply.

While on any hike of long duration, most people eventually find themselves in need of assistance, sometimes from bad planning, sometimes from bad luck. This assistance is often rendered anonymously. In this regard I would like to thank: the woman living near Jefferson County Road 126 who loaded me up with water when I was high and dry; the man at Buffalo Campground who shared his Coleman fuel with me when it looked as though I might be eating cold food for the next several days; all the people who picked me up hitchhiking into towns for R&R; and the members of the Colorado Trail Foundation-sponsored 1991 CT Treks, especially Lynn Mattingly, who got me to a phone when my pack strap broke near Marshall Pass.

— M.J.F.

No good trail can survive without constant maintenance. If you are interested in donating your time or money, or both, to keep the Colorado Trail beautiful, please contact the Colorado Trail Foundation, 548 Pine Song Trail, Golden, Colorado 80401, or call (303) 526-0809.

Part of the profits from each book sold will be donated by Westcliffe Publishers to the Colorado Trail Foundation.

Editor: John Fielder
Associate Editor: Margaret Terrell Morse
Production Manager: Mary Jo Lawrence
Typographer: Ruth Koning
Map: Anne W. Douden
Printed in Singapore by Tien Wah Press (Pte.), Ltd.
Published by Westcliffe Publishers, Inc.
 2650 South Zuni Street
 Englewood, Colorado 80110

Title page: Standing in wildflowers, Indian Trail Ridge, La Plata Mountains
Right: Alpine sunflowers (rydbergia), Notch Lake, Mount Massive Wilderness

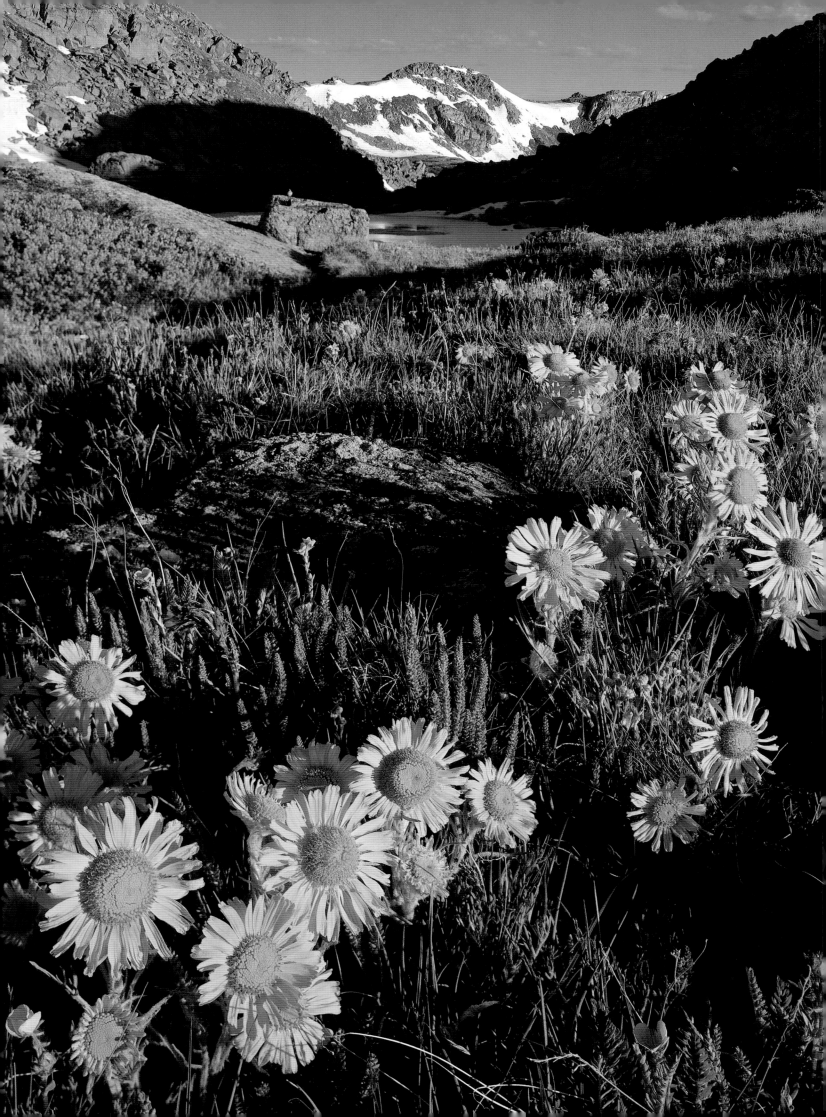

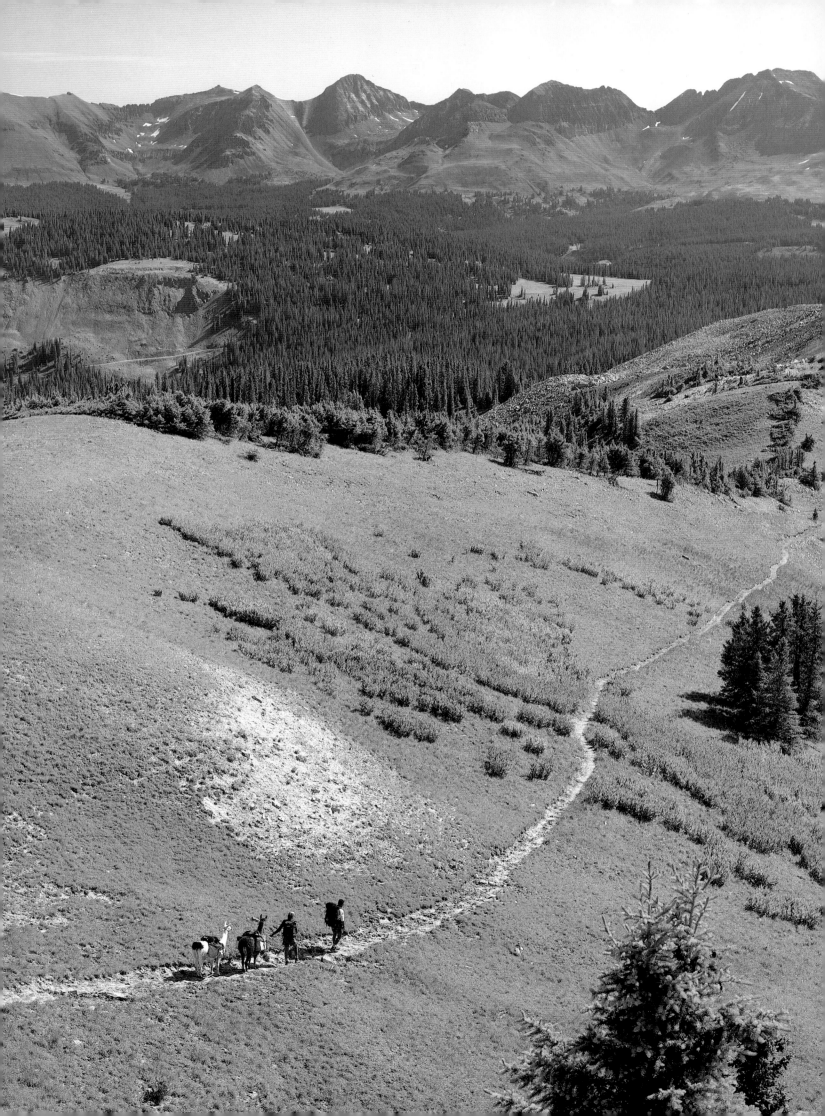

FOREWORD

COLORADO TRAIL

I once met a guy who, in the days when his youthful exuberance was boundless and his back never ached, worked on a National Park Service trail crew. He spent his summer days maintaining the highly used Bright Angel Trail that winds down into the Grand Canyon. He used the pick or shovel constantly in his hands to move rocks, fill holes and repair water damage, stopping occasionally to suck warm water from a canteen as the Arizona sun baked the back of his neck. His duties also included smiling for passing tourist-hikers as they snapped his picture. He theorized that they probably thought he was a member of a modern-day chain gang, since no one of sound mind would volunteer for such an insane activity.

Each morning his crew would head down the trail into the "Big Ditch," and he told me of the things they would find: an abandoned hiking boot, a set of car keys, foreign coins, an occasional pair of underwear, and once, an exhausted and waterless hiker left behind by friends who went in search of help. After a month or two of picking up after others, he thought he'd seen it all and was about as jaded as a human can become.

Then one day he noticed something: some hikers were picking up the others' refuse. In the following days, he focused less on his negative views of humankind and more on the good-hearted people on the trail. His research revealed that there were quite a few hikers packing out trash while enjoying the splendor of one of the world's most amazing natural wonders.

"You know, it would have been so easy to come away from that summer job with the belief that people don't give a damn," I remember him saying. "But they do! There are people out there who care a heck of a lot about what happens to their wildlands. The thing is, they don't go bragging and screaming about it. They don't want to get rich off their efforts. They just want to see something good done for the natural world. They want to give something back."

Which brings us to this book, the Two Johns and their labor of love. Here you have John Fielder, a pre-eminent landscape photographer and a man who puts his film where his mouth is. Fielder has long used his stunning images of wildlands to help preserve their unique natural qualities, not because he wants to make money but because he truly loves the places.

Then there's John Fayhee, a gonzo journalist with a burning passion for rugged, untrammeled places. I've known Fayhee to live on a beans-and-peanut-butter hobo's diet so he could save enough money to buy a discount ticket to go hike through some leech-infested jungle in some country I've never heard of. Unlike so many writers who won't budge from their desks unless they first have a contract from an editor in hand, Fayhee does it for the fun of it all.

And then there's the Colorado Trail itself, a 470-mile footpath created not by a cold federal agency and men in official uniforms, but by volunteers, people whose love for thick woods and trout streams and ponderosa pine groves and high alpine meadows and tundra sent them into the Colorado High Country weekend after weekend to cut a thread through some of the most challenging terrain in North America.

This book fulfills the dreams of the Two Johns. Both have hiked the Colorado Trail; both came home changed by the experience. Both have long sought to give something back, to capture the unique spirit of the trail in words and photographs. That they have done.

In the Colorado Trail, we have a fine new addition to the nation's 200,000-mile network of federal, state and privately held trails. We have a young, unspoiled trail with a bit of a wild streak, filled with excitement and energy. It is a high and mighty trail that winds through Colorado's magnificent mountains, a diverse yet demanding hike that runs from primitive to serene to surprising.

Start walking and you'll soon leave yourself behind and shed the layers that come with the routines of day-to-day life. Step by step, the simple act of putting one foot in front of the other will chip away at the shells of your worries. Nature's textures will become all important. Slowly, surely, you'll be free to watch, to listen, to forget, to remember. The Colorado Trail will take you places, both within and without. Hike a section of it or do it end to end; either way, you'll leave owing this trail a huge debt.

These days, too many trails are falling under the wheels of logging trucks, or becoming choked with weeds and deadfalls, or being erased by clear-cuts or erosion. Too many trails are disappearing from maps because money for maintenance just isn't there. The federal cash cow has gone dry.

If we are to have the trails that take us to the wilderness we so desperately need, it's up to each of us to do our share. The Two Johns and the countless volunteers who helped build the Colorado Trail have done their part. Enjoy the fruits of their efforts. It was a labor of love, remember? Then, when you finish this book, join them and do something for a trail near you.

— TOM SHEALEY
Managing Editor, *Backpacker*

Left: Hiking the Colorado Trail in the Rico Mountains;
distant peaks are the West Silverton Group of the San Juan Mountains

CONTENTS

COLORADO TRAIL

Moss campion wildflowers, La Garita Wilderness
Left: Sunset above 12,614-foot Jura Knob and headwaters of South Mineral Creek, San Juan Mountains

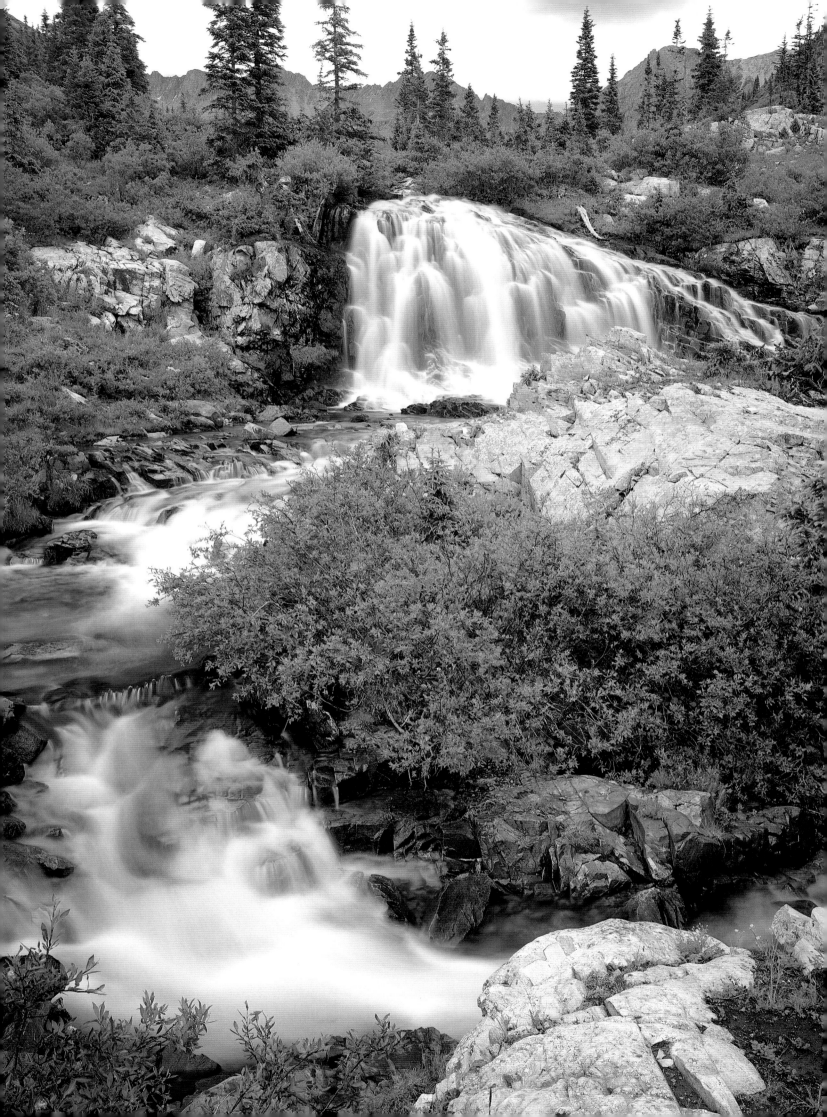

PREFACE

COLORADO TRAIL

The Colorado Trail is the epitome of a state trail: it connects communities and also allows access into some of Colorado's most pristine natural areas. Some sections of the trail skirt the edge of civilization, others are remote. You can hike the entire 470 miles over a summer, or spend years doing sections a day or two at a time. No matter how fast or slow your pace, the countless natural wonders along the way will seduce you.

I hiked the CT over the course of two summers — a week at a time, 60 miles a week on average for eight weeks. Instead of hiking the trail continuously from Denver to Durango or vice versa, I explored particular landscapes along the way — alpine, subalpine, etc. — at times of year that I thought might provide specific photographic conditions — no snow, some snow, flower season, etc.

My two llamas carried 70 pounds of large-format 4x5 camera gear and 120 pounds of food, tents, sleeping bags and other assorted gear for my sherpa-friend-of-the-week and me. On trail we carried just daypacks on our backs, although when conditions demanded fast action in changing light, the big pack and camera on a tripod were transferred from llamas to humans. Llamas go anywhere, eat anything, don't need much water, don't ruin trails or tundra, and rarely talk (or spit!) back. Alas, when I skied portions of the CT with a 50-pound pack and medium-format camera equipment, I could not find a way to bind snowshoes onto llama hooves!

My dedicated sherpas not only helped with picture taking, but set up camp, cooked and generally allowed me to concentrate on my work. Nature photography can be difficult at times — in blizzards, on minus-20-degree mornings, in drenching monsoonal rains. The help of llamas and sherpas made the way much easier, which meant I could stay in a frame of mind more conducive to appreciating the sensual qualities of such a hike. Fresh and whole food (albeit no lobster tails!) was the norm, except for the ubiquitous instant oatmeal.

In addition to making images right along the CT, I took many side trips away from the trail. This activity was particularly appropriate on the stretch from Tennessee Pass to U.S. 50 — a long haul through low-altitude forests on the edge of the Sawatch Range. By heading upward into various drainages, I was able to get above treeline and photograph some of the spectacular cirque basins in the Sawatch. From beginning to end the CT penetrates first-rate scenery, but it's worthwhile to set aside enough time and energy to visit the side places, too.

All told, I made thousands of photographs, then edited them down to just over a hundred for this book. For the most part I did what I do best — document the Colorado landscape. I also saw much wildlife and took a few pictures of the trail itself, but the photographs presented herein record what is visible of the land itself in all directions from the CT. To acquaint you with the style of life along the trail, I have included a few of John Fayhee's trail and camp photographs.

My own images generally follow the trail sequentially from Denver to Durango. Since John Fayhee and I hiked the CT separately, I did not attempt to match the places he describes with appropriate photographs. I think you will appreciate the two views — scenic and written — as well as our different perspectives.

The Colorado map printed on both endpapers of this book is intended only to give you a sense for the lay of the land and the position of the CT. It is not meant to be a trail map. To get from one end of the CT to the other, I recommend the Colorado Trail guidebook and 29 Colorado Trail maps published by the Colorado Trail Foundation.

Creating the images for this book was a labor of love. These photographs and words provide a very real preview of what you may see along the way. Perhaps they will help you plan your route, whether you hike the CT in one summer or in sections over time. However you use this book, I hope the scenes within it will allow you to imagine the sights and sounds and scents I experienced along the way.

At the very least, I pray that this book rejuvenates your appreciation for Colorado's natural environment and encourages you to speak out on behalf of its protection.

— JOHN FIELDER
Englewood, Colorado

To the staff of my publishing company — the three Dian(n)es, Mary Jo, Gail, Janet and assorted warehousemen — who allow me to leave to make pictures.

Left: Aptly named Cascade Creek, San Juan Mountains;
the Colorado Trail passes immediately in front of upper waterfall

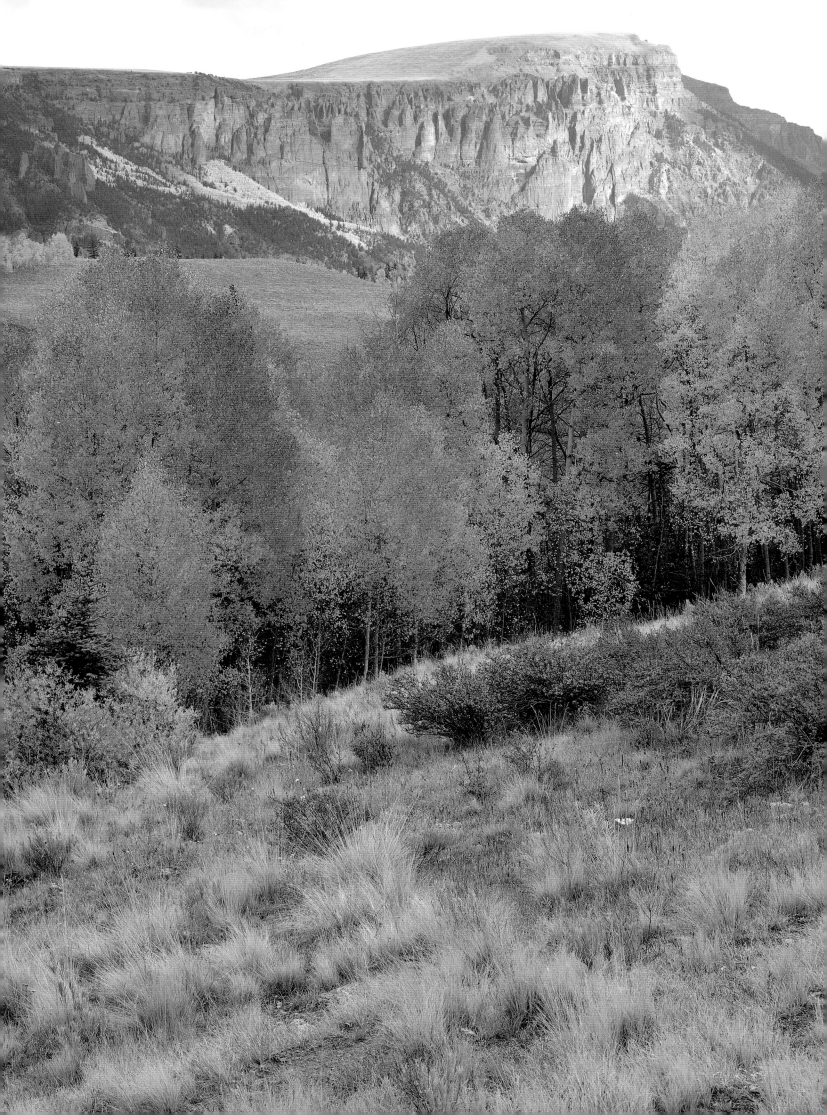

INTRODUCTION

Sooner or later — for whatever reason, on whatever level — most people are likely to mentally add up the pluses and minuses of the place they call "home." When you live in Colorado, as John Fielder and I do, this exercise occurs fairly frequently and tends to be embarrassingly lopsided.

This is not to say that Colorado is Nirvana. It is to say that we dwell in a place so special that it's sometimes hard to keep from jumping up and down and gleefully shouting, "Hallelujah, we live in Colorado!" What other response can there be when the sun breaks through the clouds after a summer rain above treeline, when we doze off beside a mountain stream surrounded by the aspen gold of Indian summer, or when we strap on backcountry skis during a deadly quiet midwinter dumping of three feet of fresh powder?

In July 1988, another item was added to the long list of reasons to be delighted that fate led me to live in Colorado: the 470-mile Colorado Trail, which links Metro Denver with Durango.

Not only is the CT a great resource to have meandering through one's home state, but its history is already the stuff of legend here in the Rockies.

And that history focuses on a remarkable woman named Gudy Gaskill.

The CT was actually conceived in 1973 by a man named Bill Lucas who, at the time, was the regional forester for the Forest Service's Rocky Mountain Regional Office in Denver.

"The Colorado Trail was born when Lucas returned from a hiking trip in Europe," Gaskill recalled while talking with me in the spring of 1988, just a few months before the CT was officially dedicated. "He started talking about how wonderful it would be if Colorado could have a long European-type hiking trail that was named after the state."

Nice idea, of course, but trails do not build themselves — especially when they're 470 miles long. An undertaking as mammoth as Lucas's seemingly fantastical Denver-to-Durango hiking trail would require vast amounts of time, money and, most of all, dedication. So much so that by 1980, Lucas's dream had yet to be realized in the slightest. The problem was that the trail planners were using an old approach to forge a new concept.

Members of the newly formed Colorado Mountain Trails Foundation (CMTF), which eventually metamorphosed into the Colorado Trail Foundation, wanted to construct a mountain footpath that was accessible at as many points as possible to everyone from toddlers to seniors, horseback riders to mountain bikers. At first they took an old-concept approach to getting the job done: relying on government funding and Forest Service trail-building personnel.

Unfortunately, during the mid- to late 1970s, the Forest Service's trail-building budget was axed by about 50 percent. There wasn't even enough cash in the coffers to maintain existing trails, much less build a brand-spanking-new trail all the way from Denver to Durango.

By 1980, Gaskill had grown impatient with the CT's slow progress. A grandmother from Golden, Gaskill was serving as the executive trail director of the CMTF, which had spent the last seven years compiling an inventory of existing trails that might be used to link up a Denver-to-Durango route.

Assertively shouldering the administrative burden of building the CT, Gaskill issued a national call for volunteer labor. By the time the CT was dedicated, more than 3,000 people, from every state and a few foreign countries, had responded. Their help cut the cost of trail building from the $8,000 a mile required by Forest Service crews to a mere $500 a mile. Because about half of the CT was to follow existing Forest Service trails, Gaskill and her legions of volunteers were, amazingly, able to complete the project in just eight years.

In the summer of 1989, almost exactly a year after the CT was officially dedicated, John Fielder and I were introduced by a mutual acquaintance who knew we both had a keen interest in hiking the trail. It didn't take long for us to realize that our shared interest transcended a desire to beat feet on the CT. Right off the bat we were both thinking in terms of producing a book.

Soon after our first meeting, John formally asked whether I would be interested in providing text for a coffee-table book about the CT. He would be the photographer. As owner of Westcliffe Publishers, John told me his only requirement would be that I consent to hike the entire CT.

He didn't exactly have to twist my arm.

By the time we finished the actual footwork necessary to produce the book, we each had hiked more than 700 miles on and near the CT.

John photographed the CT primarily through the summers of 1990 and 1991. He also took several backcountry skiing trips along the trail during the winters of 1989–90 and 1990–91.

I began rubbing elbows with various sections of the CT throughout 1989 and 1990. Then, in the summer of 1991, I hiked the whole shebang from Denver to Durango over the course of 44 days.

The result is a book that chronicles my experiences during that end-to-end hike. Understand, this is in no way a guidebook. *The Colorado Trail, The Official Guide Book*, by Randy Jacobs (The FreeSolo Press, 1988, ISBN 0-944639-01-1), is wonderful, to say nothing of thorough. I could not have been as comprehensive as Randy, even if I had tried.

More than anything, the text of this book is my attempt at "CT impressionism." I have hiked the entire trail — much of it two or three times — and it has impressed me mightily on many levels. This book is my way of passing on these impressions to you. My hope is that it will not only introduce you to the Colorado Trail, but also give you some sense of how it feels to hike through the heart of the Colorado Rockies for 44 straight days.

Maybe just maybe, through John Fielder's images and my words, you will be encouraged to meet the CT face to face. I truly hope so, because it is one of the most magnificent and cogently designed hiking trails in the country. It doesn't matter whether you take a mellow day-hike or a weeklong backpacking trip, the CT is something more special than special.

It is another wonderful reason to visit or dwell in Colorado.

— M. JOHN FAYHEE
Frisco, Colorado

To my wife, Gay Gangel-Fayhee, whose world-famous granola bars, among other things, have fueled me over many a mile.

Left: Autumn aspen below Snow Mesa, Rio Grande National Forest

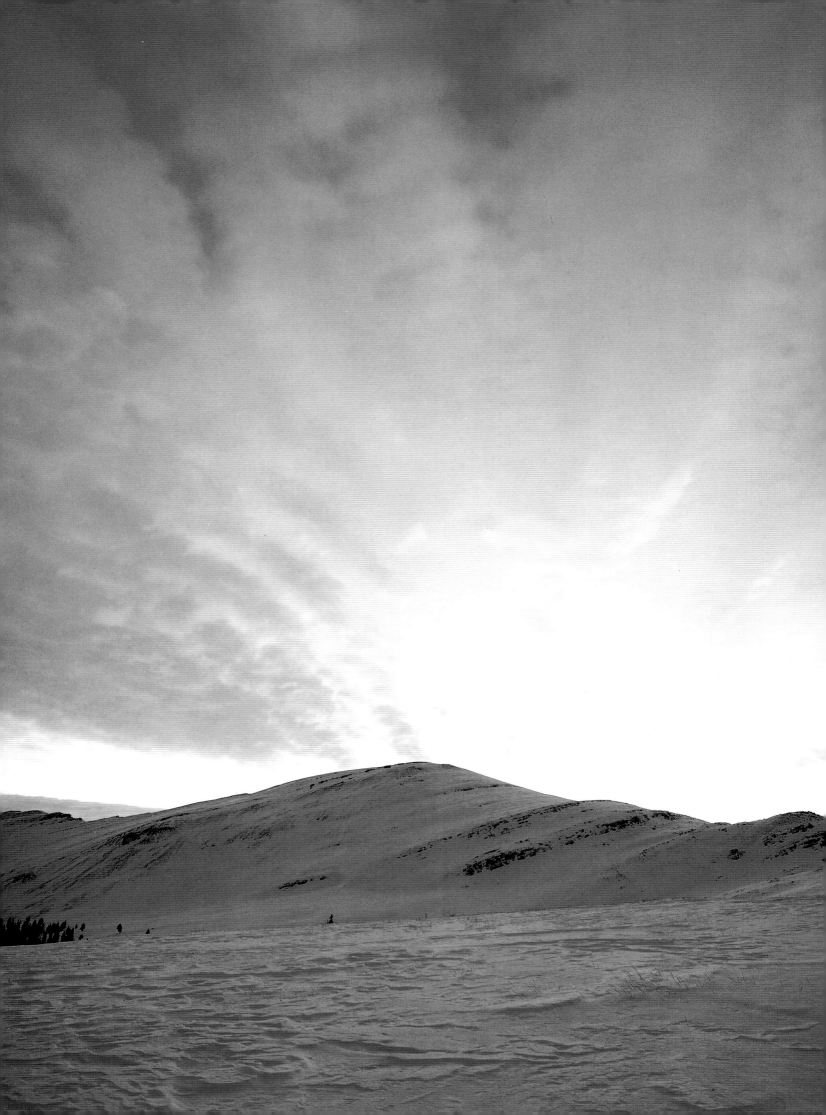

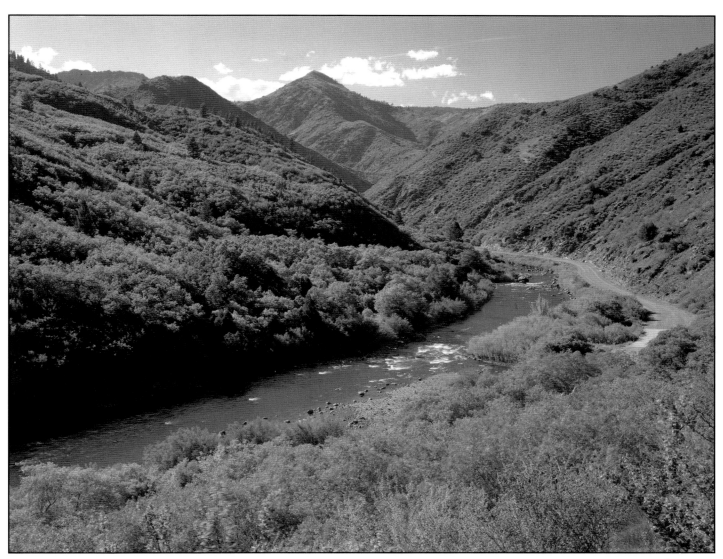

DENVER TO TENNESSEE PASS

COLORADO TRAIL

A FTER MORE THAN A YEAR of planning and preparation, during which time I mentally hiked the Colorado Trail at least a dozen times, it is with a combination of intense joy and stomach-fluttering trepidation that I take these first steps.

My preconceived notions about this hike are already being slapped around viciously by the vagaries and vexations of CT Reality. Durango is a seemingly mythical place, far, far away, over near Utah somewhere. Now is the time for a wrestling match between self-confidence and doubt; the time for wondering if I've forgotten, say, my tent, at the same time I'm wondering whether I've brought too much junk.

I'm thinking how great it will be to rub elbows with nature almost uninterrupted for a period of weeks, how wonderful it will be to push myself, to test myself against the Rockies, to rely on myself for more time than most people spend in the wilderness in their entire lives.

Yet. My pack is so heavy it feels as though some cruel person has strapped a pickup truck onto my back. And the other day I strained my left knee walking out my front door, of all places. And I look down and take notice of an unflattering Buddhalike belly that seemingly looms larger than ever, now that I'm finally on the trail.

And it's 98 degrees.

Even people who live here sometimes fall prey to the snow-covered-mountain-on-a-postcard image of Colorado that dwells happily in the national psyche. In truth, more than half of Colorado is desert. In no way is this meant to sound as though I have anything against deserts. During the five years I lived in southwestern New Mexico, I came to feel perfectly at home among the lizards and the cactuses.

These days, though, I live and feel perfectly at home in a town 9,100 feet above sea level. Which is almost 4,000 feet higher than the place where I now stand: Waterton Canyon Trailhead, southeast of Denver. The eastern terminus of the Colorado Trail.

South Platte River descends Waterton Canyon

Left: January sunrise on Searle Pass, above Janet's Cabin near Copper Mountain

I have a mere eight miles to hike today, which is good because this heat is, at least to this High Country dweller, way too intense. The first six miles of the CT follow alongside the South Platte River on a nearly level paved roadway. Very easy walking. Which, again, is good. Since it is only 10 a.m., I am able to proceed at a leisurely pace. My wife, Gay, who drove me down to Waterton, will walk with me for the first few miles.

Though handsome, rugged and deep, Waterton Canyon is a far cry from wilderness. It is a Denver Water Board-owned park where people can at least pretend to escape from the city for a few hours. Since it is a summer Sunday, there are gaggles of runners, white-legged families pushing baby strollers, fisherpeople and mountain bikers dressed like extras in a Star Wars movie. Even though the parking lot at the trailhead is filled to overflowing and dozens and dozens of people are in the immediate vicinity, I am the only one I see sporting a backpack.

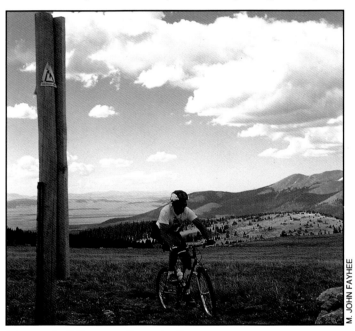
Mountain biker on Georgia Pass

And one major-league pack it is — the kind that sticks out in a crowd: a Lowe Framepack Deluxe with a capacity of 6,100 cubic inches, all of which are filled to overflowing. I am a walking REI catalog, carrying, for this 44-day back-to-nature experience, more material possessions than most Third World people own, cumulatively, in their entire lives.

In my multi-hundred-dollar, state-of-the-art pack, which checked in at about 55 pounds before I left home and somehow gained an extra ton or two in the interim, I have: an MSR WhisperLite Internationale stove; a liter of white gas; a stainless steel cook kit; seven days' worth of food; a Sierra Designs Flashlight two-person tent; a Therm-a-Rest full-length ultralight sleeping pad; a North Face Chrysalis down sleeping bag; a Gore-Tex rain suit; a Nikon 2020 camera with 35-70 zoom lens; 10 rolls of Fuji 100 film; a Synchilla vest; Thermax long johns; a liter of vodka; two liters of water; an empty three-gallon water bag; a pair of Nike Caldera camp shoes; the official Colorado Trail guidebook, by Randy Jacobs; the official series of 29 Colorado Trail maps; a sewing kit; a pair of long pants; an extra pair of underwear; an extra tee-shirt; an extra set of socks; a first-aid kit; a Katadyn water filter; a toiletries kit; field repair kits for the Therm-a-Rest, the stove and the tent; and a copy of Sports Illustrated, to keep abreast of current affairs.

With all this on my back, I am trying to stroll like the baddest hombre in the valley. Sweat is pouring down my face, burning my eyes, leaving behind a salty residue as it evaporates. I feel myself teetering from side to side. Passersby are looking at me funny. They are subtly ushering their children toward the other side of the road as I pass. People look, perplexed, at Gay, then me, then back to Gay. They seem to wonder what this together-looking female is doing walking hand in hand with someone who looks like me.

Even though I have backpacked more than 4,000 miles in my life, it's beginning to dawn on me that by no means is it a sure thing that I will make it to Durango. Motivation, drive and experience alone will not see me through a 44-day hike. My body needs to hold up. Is tendinitis lurking in one of my knees, just waiting for the Sawatch Range? Is a badly sprained ankle with my name on it hiding behind some slippery rock near Georgia Pass?

Gay finally takes her leave and returns home, depressed. She is a member of an increasingly rare breed: a native Coloradan. As such she wants very badly to be hiking, with me, the trail that bears the name of her native state. But, unlike her freelance-writer husband, she has a real job and cannot take off 44 days straight. Someone has to pay the bills back in the grayness of civilization. I feel empty as Gay disappears around a bend. She is my best hiking pal and has been for so long that I scarcely remember what it was like to backpack without her.

I am in camp by 1 p.m., beside the trickle that is Bear Creek. It is too early to be in camp. But this is the last water until the trail rejoins the South Platte River in eight miles. I feel surprisingly energetic, but don't want to risk pushing myself too hard on the first day.

I take a short stroll up the trail. When I return, I try to take a nap, but the inside of the tent is sweltering. I walk down to wash up in the creek, which is only a few inches deep. Unlike the water up where I live, it is of a pleasantly tolerable temperature. I hate frigid water. I am, however, hyperfastidious about personal hygiene on the trail. Almost without exception, after getting the tent set up, I head down to whatever water is nearby, whether it be river, lake or stock tank, and hop clench-teethedly in. Long-distance backpacking is tough enough without feeling like crud every step of the way.

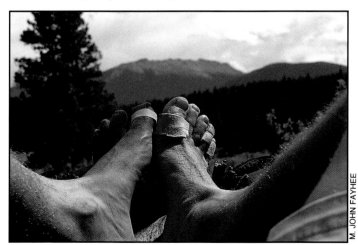
Blistered feet during early stages of the journey

My weight problem is exacerbated, at least psychologically, by my midday nakedness. This is depressing. Last month I hiked more than 100 miles in semi-earnest pre-trail preparation. Yet I am as heavy right now as I have ever been in my life.

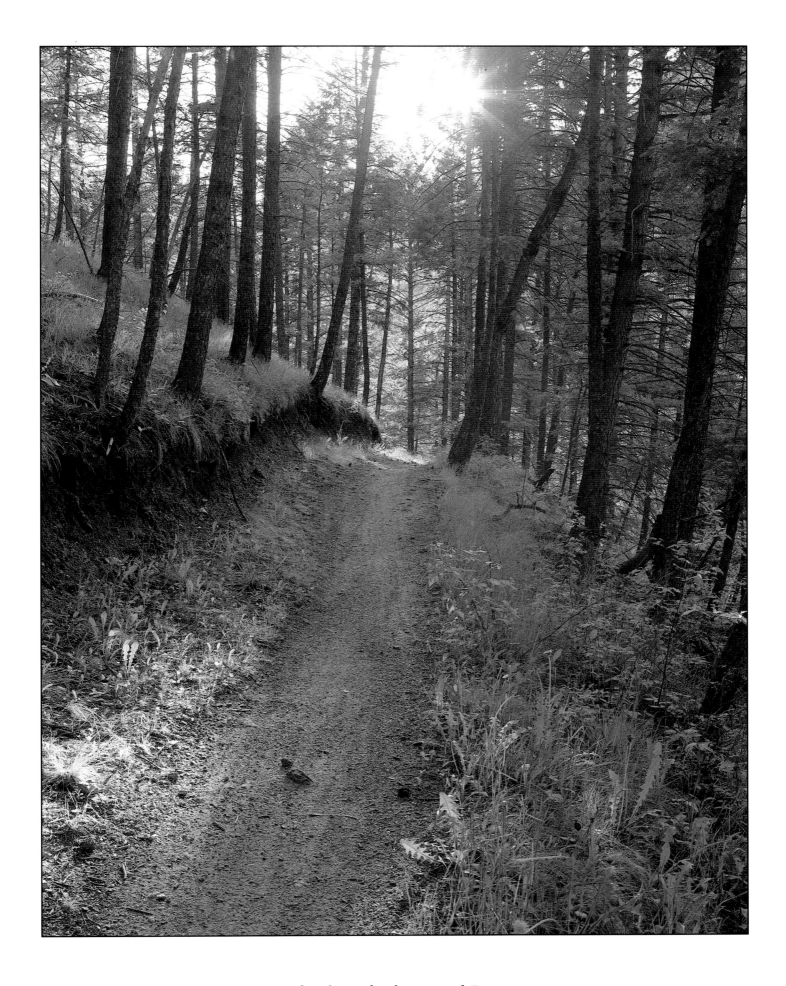

Colorado Trail, Pike National Forest

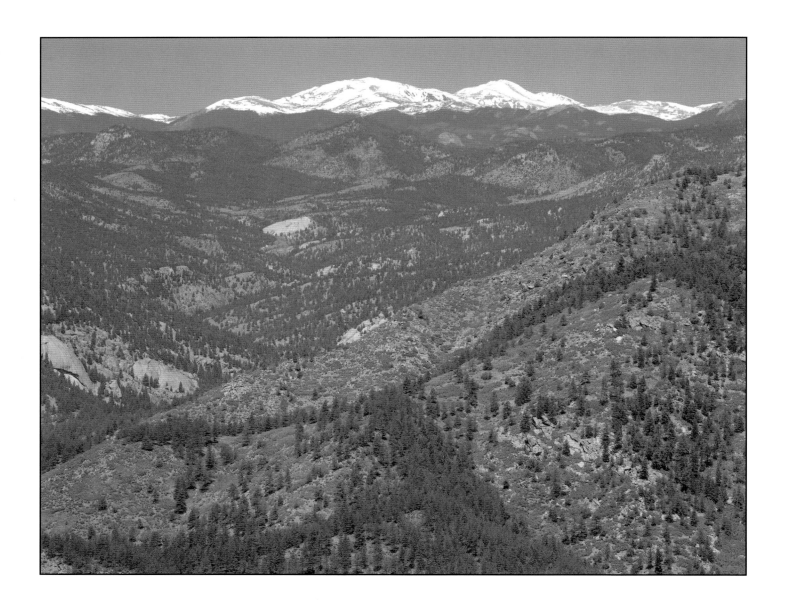

I know full well that our Madison Avenue-driven society puts far too much emphasis on the kind of sleek physique that I actually sported for the first 30 years of my life. I also realize full well that this hike would be a lot easier on numerous body parts if I were at least 20 pounds lighter. In the past several years I have, to a degree I would have once thought impossible, succumbed to, surrendered to and embraced just about every temptation our poison-laden culture has tossed in my path, especially potato chips and beer.

My wife has come to describe me as purposely self-destructive in my habits. This, I believe, is a tad harsh. Perhaps I am simply a bad planner in the realm of health and well-being. Or perhaps I'm having a little trouble accepting that there are indeed, as health experts tell us, lifestyle causal links. You know: if I eat and drink unwisely for several years at the same time my exercise regimen is irregular at best, well then, I'll end up looking and feeling the way I do right now standing in Bear Creek.

Who would have thought it could happen to me?

The point is, on a level suddenly so poignant and palpable it makes me blink as I stand sans clothing in the harsh Colorado sun, this CT hike marks the beginning of something and the end of something.

I have 44 days, mostly to myself, to figure out what these "somethings" are. If I fail, I will be forced to deal with the consequences.

I dress pensively and return to camp.

A MERE THREE DAYS and 32 miles into the CT and I am in at least two kinds of misery as I sit at a picnic table in Buffalo Campground.

First, somehow or another, I have managed to catch a hideous rash. It's all over the backs of my thighs, calves and knees, which makes it hard to bend my legs, a handy thing to be able to do while hiking. It also covers the front of my pelvic region. Is it heat rash? I don't know. I've never had such a thing. It does seem to be starting to clear up in the higher realms, but continuing to spread down below. I first noticed it early yesterday as I was changing into my hiking clothes. I couldn't believe my eyes. Like, yeah, I really need this.

My second kind of misery is of much greater concern: heel

Front Range's 14,264-foot Mount Evans, from Pike National Forest

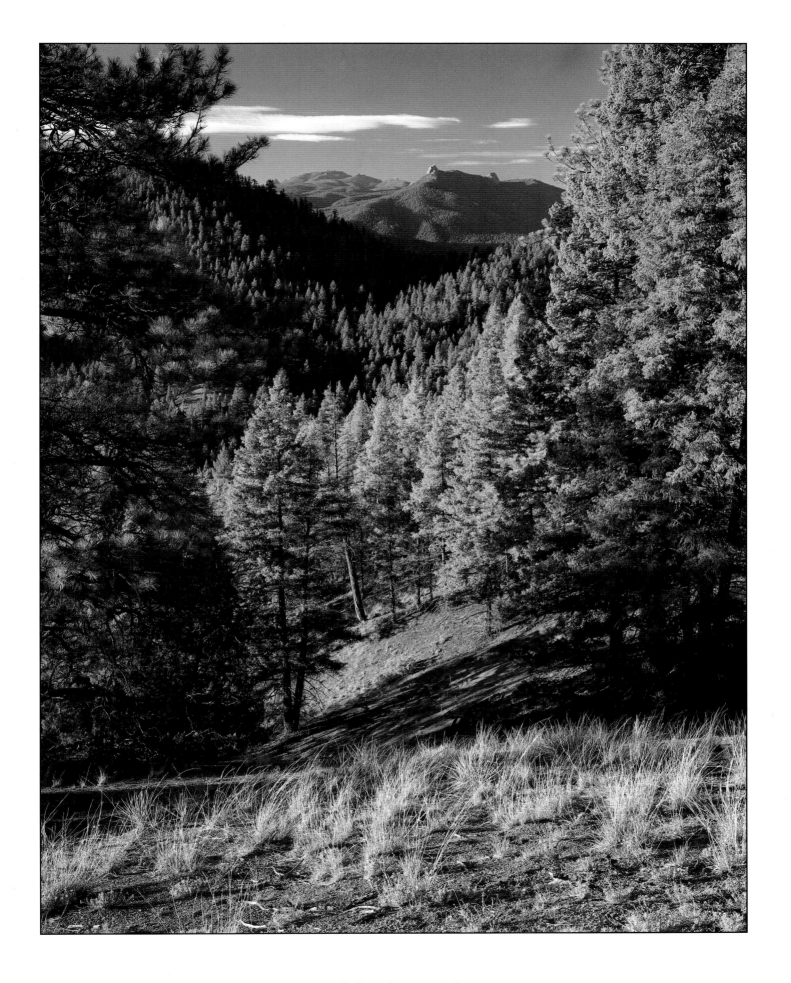

Morning light, Pike National Forest

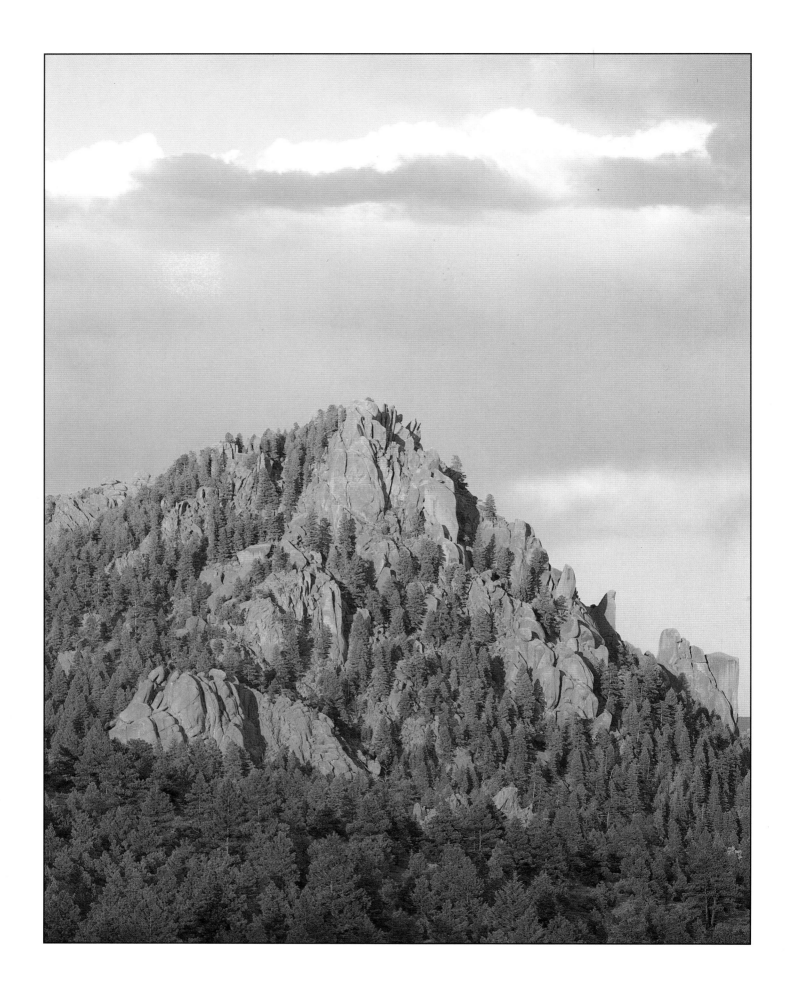

One of numerous granite outcrops characteristic of the Pikes Peak Uplift, Pike National Forest

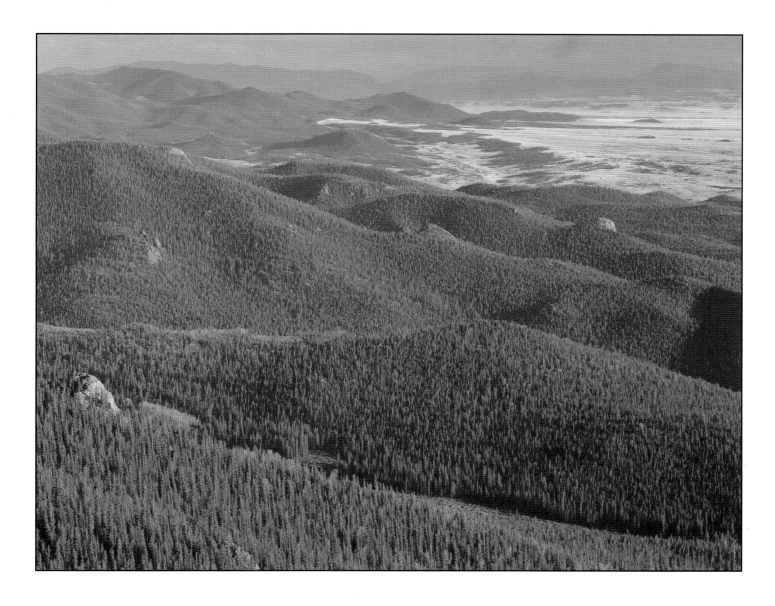

blisters. The rear of my left foot looks like something out of an emergency medical technician textbook. There's one monster blister, surrounded by an entire solar system of satellite blisters. It looks as though I'll be losing several toenails, to boot. I'm not even certain I will be able to hike tomorrow. Certainly not the way I feel now.

I've been popping Advil like candy. And the stock of whatever company makes moleskin has undoubtedly split three times since I began hiking this trail.

To top everything off, tomorrow looks to be a hard day. There will be a 2,500-foot climb, spread out over six or so miles. Meaning all of my weight, along with the weight of my pack, will be directly on my poor, poor heels for several hours.

Right now I'm at 7,500 feet. If I can hike at all, I should be camping in the High Country tomorrow night. It'll be good to get back up to an altitude where a man can breathe.

The first 32 miles of the CT are more akin to southwestern New Mexico than to most people's image of Colorado. The trail passes through the Rampart Range, which is visible on the western horizon from Denver. This is an unusual and intense little set of hills, with crazy, cactus-covered rock formations and peaks with names like Long Scraggy and Devil's Head.

Even the biting insects in these parts are different than what I'm used to. This time of year in the High Country we have a mosquito season we're fairly proud of. Not that it's anything like Minnesota's or the Everglades', mind you. But it'll do.

Colorado's high desert boasts a kind of biting fly that I am not familiar with. Well, actually, I have recently become extremely familiar with it, I just don't know what it's called. As I write in my journal, 320,000 fine examples of the species are in my immediate vicinity — half on my body, the other half flying reconnaissance. They are able to bite through socks, pants, even moleskin. Insect repellent deters them not in the least. And their reflexes are extraordinary. They seem able to tap into my very thought processes. Even before my synapses have finished doing whatever it is they do to get my hand moving, these flies have flown. By the time my hand impacts whatever part of my body has just had a large chunk of meat torn from it, the offending fly is sitting over on a log, laughing at me.

Not surprisingly the CT thus far, though mellow and scenic, has been quite dry. Unlike much of Colorado, in this part of the state you definitely plan your hiking day around water. Or the lack thereof. On days like today this dryness can manifest itself in a Big Way.

Lost Creek Wilderness from atop the Kenosha Mountains

Overleaf: June anvil cloud reflects on last winter's snow, Lost Creek Wilderness

19

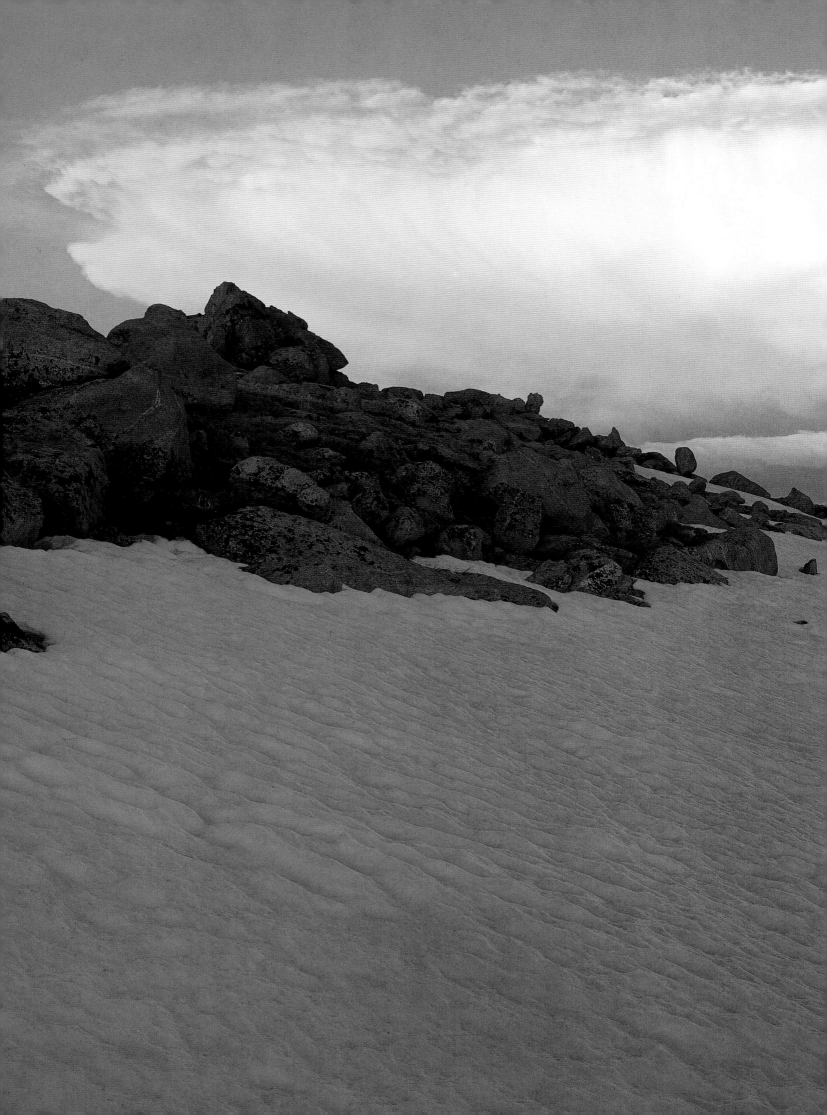

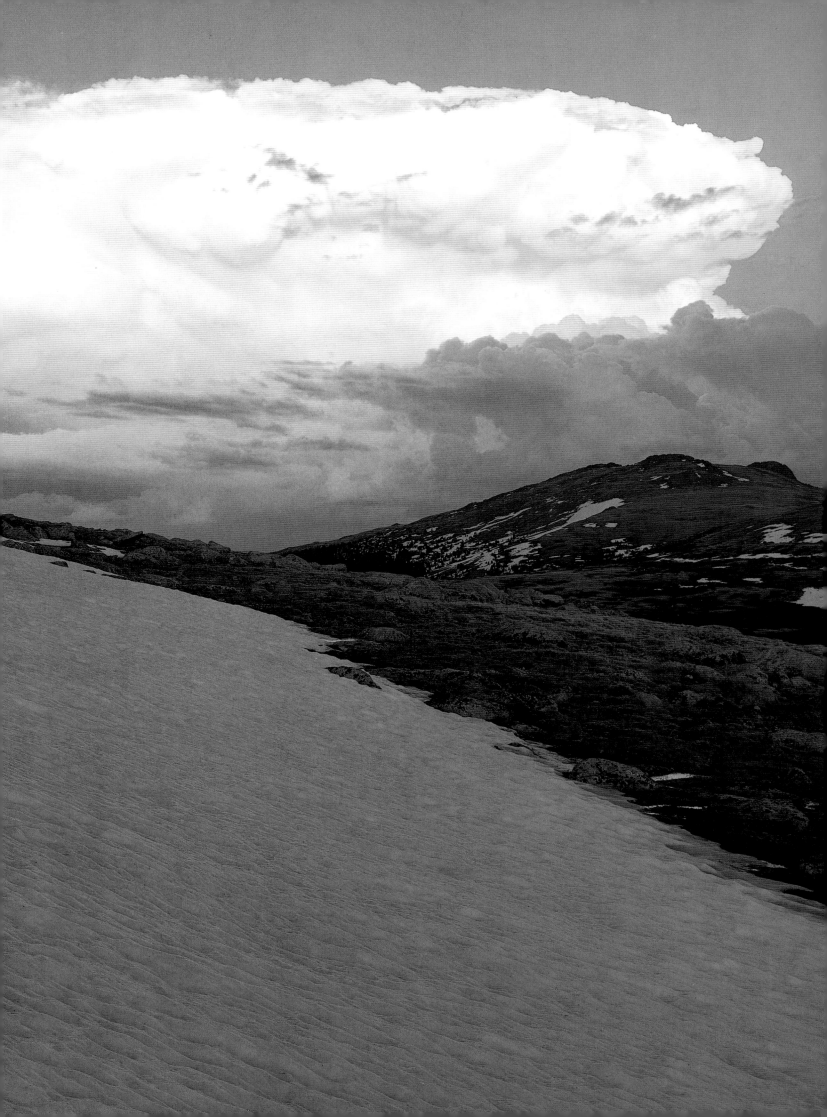

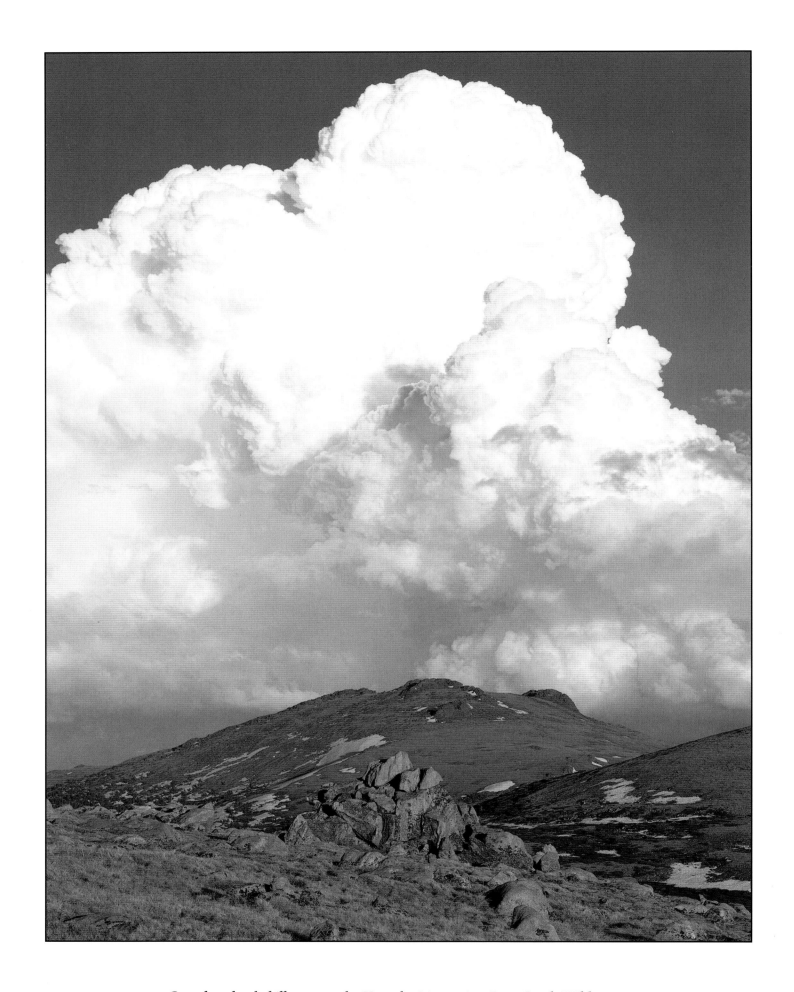

Cumulus clouds billow over the Kenosha Mountains, Lost Creek Wilderness

I leave Bear Creek about 7 a.m., hoping to make it eight miles to the old townsite of South Platte by 10. The trail winds its way through Gambel oak stands in the early morning shade and there are plenty of good views of Strontia Springs Reservoir. Lo and behold, by 9:30 South Platte is in sight, a thousand or so feet below me, apparently only a few minutes away.

Wrong.

Sherpa JT Fielder takes a trailside rest

From the top of the ridge where I first see South Platte — which is nothing more than a dirt road passing by an ancient, long-closed hotel on the banks of the South Platte River — the CT suddenly becomes the most winding and meandering stretch of trail in the world.

It switchbacks to the left and heads down toward the Mexican border. After dropping four inches or so in elevation, it begins a switchback that ends in the middle of Montana. There must be 800 of these switchbacks. Despite the CT's wanderings, at 10 a.m. sharp I sashay into South Platte all ready for a swim in the river. Coming as I do from the land of the wind chill factor, I am operating under the assumption that, at least for the first few days, all water along the trail will be, at a minimum, above freezing. With regard to the South Platte, I have assumed incorrectly. The water here is frigid. I walk in up to my knees, change my mind and beat a hasty retreat.

I sit under a cottonwood and eat a granola bar while my feet dry. The spot where I am resting is at the heart of one of the most heated environmental debates Colorado has ever seen — to the degree that it has spilled out of the Rockies and into the fetid halls of Washington.

> *Instead of fighting Two Forks in the state arena . . . the environmental community took its case directly to Washington.*

At issue is a proposed dam, which, if built, would be called Two Forks. A stone's throw from where I sit, the North and South forks of the South Platte converge. The Denver Metro Water Providers, a group of 40-some-odd suburban water-providing governmental agencies, would like to construct a 1.1-million-acre-foot reservoir at the site. Proponents believe it would meet the water needs of Metro Denver for the next half-century.

In the early 1980s, Colorado's environmental community rose

up in righteous indignation, and the battle against Two Forks began. And a funny thing happened: not only did the anti-Two Forks forces triumph, but they ran up the score so decisively that the Metro Water Providers and their ilk have still not recovered psychologically. The environmentalists ran a savvy political end-around against the state's pro-development coalition. Instead of fighting Two Forks in the state arena, where most western water wars are fought, the environmental community took its case directly to Washington.

The anti-Two Forks crusaders argued, I believe rightly, that a beautiful canyon with a Gold Medal trout stream flowing through it should not be destroyed to water lawns in Denver. Which is a darned good point, although it is not the argument that swayed Environmental Protection Agency Administrator William Reilly to veto the project.

The environmental community convinced Reilly and his staff that Two Forks would adversely affect the home turf of several endangered species, including the whooping crane, which hangs out in ever-diminishing numbers on the Platte River way downstream in Nebraska.

Colorado's pro-development forces were flabbergasted. They had never lost a battle of this magnitude. One of Colorado's senators, the notoriously anti-wilderness Bill Armstrong (since retired), lobbied President Bush directly to overturn Reilly's veto.

Trail food

Armstrong tried in vain to make Two Forks a states' rights issue rather than an environmental fight. To the surprise of most people, Bush was unswayed. During his campaign he ran as the "environmental president," and Two Forks was his first chance to take an environmental stand. And, by God, he took it.

As I sit munching lunch, though, I know the battle may not be over. The Metro Water Providers have not gone gently into the good night. They are not taking defeat well. They are talking about taking the EPA to court. But, for now at least, I feel as though I'm sitting on hallowed ground, where the words progress and growth and development can begin to mean something other than "destruction."

By the time I finish lunch, it is 11 a.m. The CT guidebook says it's 13 miles to the "next reliable water." I'm caught in between. I don't even want to think about the possibility of having to hike 21 miles on my second day on the trail.

And I know I'm not going to spend the night on the side of a dirt road in South Platte, where there are several dozen not-so-inviting NO CAMPING signs.

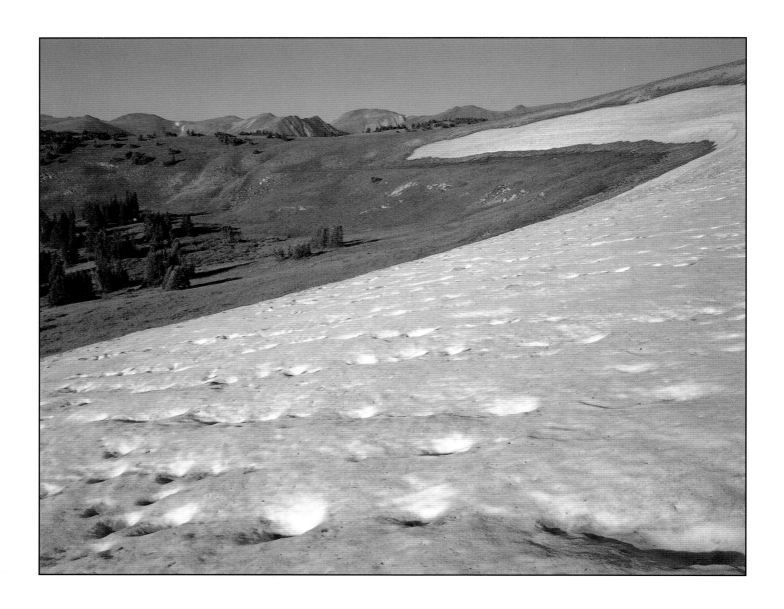

I fill my two water bottles and bolt with the intention of making it eight miles to Top of the World Campground, a lovely though waterless place where I hope against hope I can get some water from an RVer. That is, if there are any RVs there. If there aren't, I'll have to go to Plan B, which, sad to say despite a year of pondering this stretch of trail, I have yet to devise.

In retrospect, the side of the road at South Platte seems like a serene and campable spot.

From here, the CT ascends maybe 1,000 feet. This is hot and dry territory, especially at midday. The trail slaloms its way through cactus, juniper and zillions of blooming wildflowers. The views of Platte Canyon and the surrounding rock formations are wonderful. Soon, though, I find myself ignoring the views completely. I focus on hiking at high speed from shade patch to shade patch, where I rest for four or five days at a stretch.

Not surprisingly, it takes several centuries to make it to where I think Top of the World should be. I walk and walk. I sweat and sweat. My water supply dwindles and dwindles. I begin to think that somewhere along the line I have taken a wrong turn and ended up in hikers' purgatory.

Shortly after I become an old man, Jefferson County Road 126, which connects Buffalo Creek with Deckers, appears before me. I have walked right by the turnoff to Top of the World. (Just call me Pathfinder Fayhee.) Great. I am almost three miles farther along than planned, with about two molecules of water to my name. And it's still three or four miles to that "next reliable water." For the first time in my hiking life I don't think I'm going to make it. Surely I am about to perish from dehydration. A few days from now someone will stumble upon my shriveled carcass, like the way Jeremiah Johnson stumbled into that frozen guy with the Hawken rifle.

At the moment, I would trade my backpack and all its contents for a liter of almost anything liquid — including, but not limited to — motor oil.

But, wait, there are several houses along the highway. I know, begging water from a homeowner is not considered a skillful survival technique in outdoorsman circles. I cross the highway and approach the gate of the closest residence. NO TRESPAS-SING, PROTECTED BY GUARD DOG signs are all over the place. I call several times from the gate, but no one answers.

Along the Jefferson Creek Loop Trail, a side hike near 11,585-foot Georgia Pass, Mosquito Range

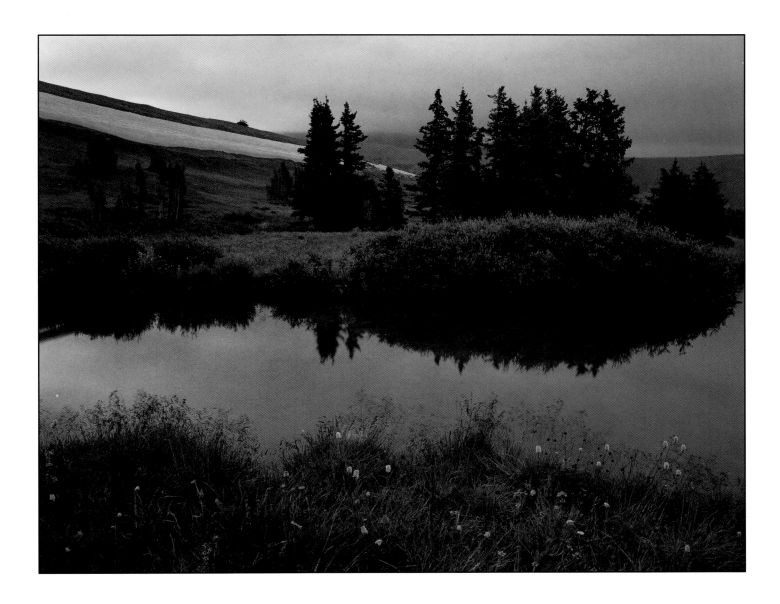

I cross back to the other side of the highway and walk up to another house. Same signage, almost verbatim. None of these houses are shanties. They are big, near-new domiciles owned by obviously well-to-do folks who probably moved up to the hills from Metro Denver. From the looks of their signs, they brought their urban attitudes with them.

Which is their problem. My problem is that my tongue is so parched it feels as though I've been chewing on a mixture of dirty socks and spiderwebs for several straight weeks.

At this second house, I can tell people are home. I walk around to the front of the property and limp — for effect — up the driveway. Before I can reach the door, the lady of the house walks out, frowning. Quickly I apologize for my trespassing transgression. Before I can even ask for water, she says in a flat voice, "I know what you want" and points me to an outdoor spigot. It takes scant seconds to fill my water bag and two water bottles. I thank her profusely, bowing and genuflecting as I take my leave.

I set up camp nearby and spend the entire evening joyously quaffing water. As a result, I might as well try to sleep standing up outside the tent.

The next morning I get a very early start, hoping to beat the heat. After moleskinning every square inch of my lower body, I hobble toward Buffalo Campground, which is one of those Forest Service campgrounds with picnic tables, running water and primitive outhouses. Because I overshot my intended destination yesterday, I have only seven miles to hike today.

The hiking is easy prior to the midday sizzle. I make it to the campground by 12:30 p.m. and immediately lie down for a snooze on a picnic table. The Benadryl I ate earlier for my insidious rash has really put me out. I can scarcely keep my eyes open.

In the ponderosa pines all around me, the local Mormon Tabernacle Choir of the Bird World is singing the Hallelujah Chorus. Now, in most circumstances I definitely prefer listening to, say, the blues at maximum volume than to, say, the sounds of silence. But I also very much like bird music. I can't remember the last time I paid this much attention to bird babble. It makes me realize how badly I may need this hike, not just physically, but mentally.

Sunset along the Jefferson Creek Loop Trail, Pike National Forest

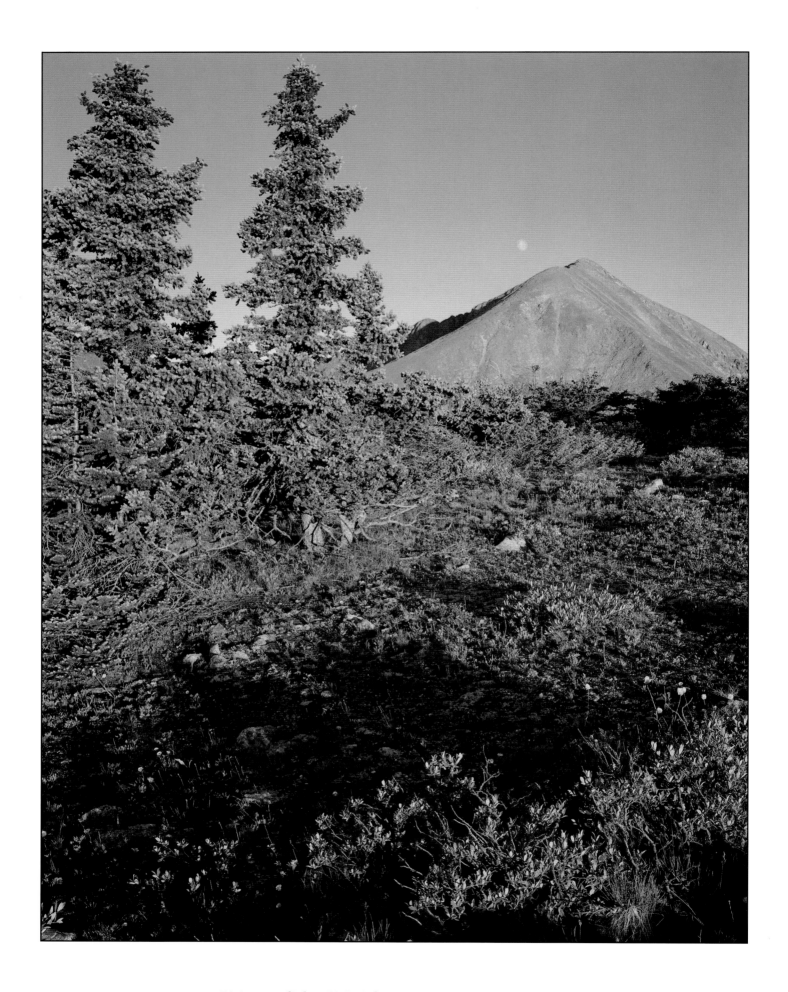

Rising sun lights 13,370-foot Mount Guyot, Georgia Pass

Dead conifer, Pike National Forest

By 3 p.m. some other campers arrive. A family with one of those Sears tents that, when set up, occupies most of the continent. They brought with them a boom box and now they're playing it fairly loudly. Twangy country-western. The birds are almost drowned out, but I believe they're still up in the trees, swing dancing.

TODAY IS THE FIRST fairly serous uphill, a six-mile ascent into the Kenosha Mountains, which I hiked several years ago with my wife while we were living in Denver. Almost every step of this uphill follows a logging road built in the early 1880s. One thing about stretches of trail that follow old roadbeds: they have few switchbacks. Miners, loggers and ranchers back in old timey days were not interested in backcountry aesthetics. Nor were they interested in dillydallying in the woods. They generally built roads and trails to get where they were going as directly as possible.

My plan is to make it 15 or so miles today. By 2 p.m., when the trail crests and begins a slow mile-long descent into the Lost Creek Wilderness, I decide, after only 11 miles, to park it for the night at the first pleasant-looking campsite.

The Lost Creek Wilderness is the first of six wilderness areas the CT passes through. It is my favorite wilderness area in the state, though the CT crosses only its northern fringe. The most scenic part of Lost Creek is a few miles off the trail to the south.

I haven't talked with a single person who has checked this area out and not returned nearly dumbfounded by Lost Creek's astounding and unique geophysical grandeur. The usual reaction from a first-time visitor is something like, "I didn't expect there to be anything like that in Colorado."

What "that" is, is some 106,000 acres of the most amazing rock formations in the entire state. When I hear people extol the virtues of Eldorado Canyon and Lumpy Ridge — both attractive enough places — I'm amused. Neither place is in the same league as Lost Creek.

Lost Creek's wilderness roots grow back to 1963, a year before Congress passed the Wilderness Act, when the Forest Service designated 15,000 acres of the area's most scenic rock formations as a "scenic area." That designation was expanded in 1980 when the current wilderness boundaries were drawn.

The rocks in Lost Creek, like most in this part of the state, are granite. The entire area is part of the Pikes Peak Uplift, which includes, not surprisingly, Pikes Peak some 50 miles to the south. Millions of years of erosion have resulted in near-endless domes, spires and cliff faces that I once heard described by an Aussie rock climber as "bloody awesome."

As it passes through a section of the Lost Creek Wilderness I have never visited, the CT follows the North Fork Lost Creek upstream for almost eight miles. Though the rock formations hereabouts are not as spectacular as those a few miles farther south, this place has a splendor all its own. The meadow through which the trail passes is one of the longest and lushest I have ever seen.

While strolling downhill toward the creek, I notice something that is becoming increasingly prevalent in wilderness areas: mountain bike tracks. Mountain bikes are not allowed in wilderness areas. Even though I own a mountain bike and ride it often, the lawlessness of other bikers infuriates me.

The vehemence of my attitude shocks and dismays many of my mountain biker friends, most of whom love wilderness as much as I do. Many people argue that mountain biking in wilderness areas is more of an aesthetic issue than an environmental one. Well, mountain biking is an environmental issue, insofar as mountain bike tracks cause significant channeling in trails which, in turn, causes significant erosion.

More importantly, the question must be asked: So what? Aesthetics, I contend, are an important part of the wilderness experience. Much as I love mountain biking, the sport is an aesthetically inappropriate wilderness use. Mountain bikers have no problem agreeing that certain trails should be closed to motorized dirt bikes for aesthetic reasons, and I have no problem accepting the notion that certain portions of overused wilderness areas should be closed to all human use, including backpacking. If mountain bikers want to experience wilderness, they should park their bikes and walk.

Amen.

I get to camp about 15 minutes before one of those wonderful Colorado High Country summer afternoon cloudbursts hits full force. Just enough time to get the tent set up and crawl in for a much-needed siesta. Few things beat lying in a tent while the rain pitter-patters you to sleep.

Tonight's camp is a pure joy — the first truly magnificent spot on the trail. After 44 or so miles, there have been plenty of places where the view over there is quite nice, but this is the first time on the trail that I've actually camped in a gorgeous area.

I am set up a few hundred feet outside the wilderness boundary, right where a very primitive four-wheel-drive track comes into the meadow. True to form for a place accessible by vehicle, there's a "camp" here, replete with all sorts of attendant "camp projects" seemingly straight out of the old Boy Scout Pioneering Merit Badge booklet.

Several saplings have been cut and tied head-high between two pines. The purpose of this project escapes me. Perhaps it has something to do with disciplining mischievous children. I can only envision the scene: A handful of good ol' boys are sitting around their 38-foot-diameter campfire, drinking Coors, when one of them says, "Well, I reckon it's time to cut some saplings down so's we can tie them youngsters between these trees here." Everyone nods in unison and proceeds to do just that.

A wide array of beautifully crafted sitting logs have been placed on end around a monster fire ring, which is filled with trash, mostly aluminum cans.

The meadow through which the trail passes is one of the longest and lushest I have ever seen.

Why can't people who come to the woods simply be in the woods? Why do some people have to make their campsite as rustically homey as possible? This isn't to say that I don't utilize sitting logs whenever I happen upon them. Right now, for instance, I am sitting on one while writing on another. Nor is it to say that when I'm camping off in the boonies somewhere sitting on wet ground, I don't ever yearn mightily for a sitting log ensemble. It's just that I wish all people took the concept of minimum impact camping to heart.

At 7:45 p.m., just as I am polishing off my last cup of Nighty Night tea, three trucks pulling horse trailers roll in to camp. This does not surprise me, as it's July 3, the evening before a four-day holiday weekend. The vehicles' occupants get out and stand 40 feet or so away from me, without introducing themselves, and stare longingly at my camp. They seem particularly

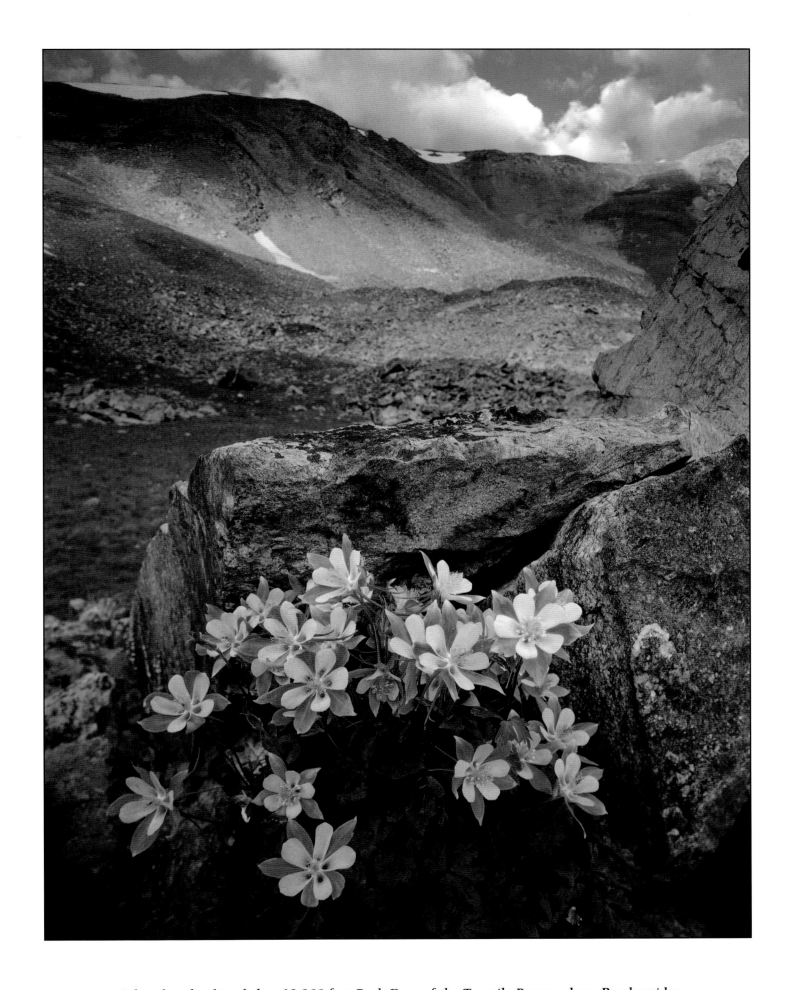

Colorado columbine below 12,866-foot Peak Four of the Tenmile Range, above Breckenridge

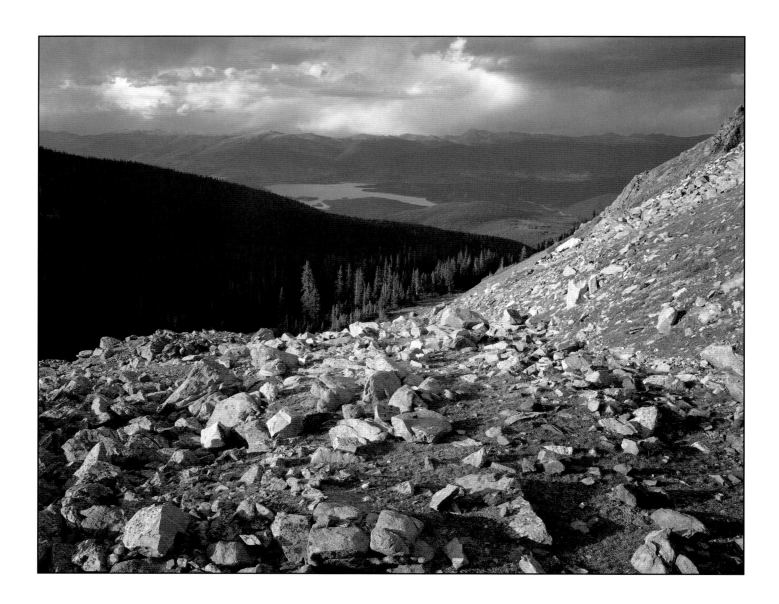

focused on the sitting logs, as though maybe they know a little something about their history.

With one of the biggest meadows in the state Right Here, they set up camp four inches from my tent. They have a half-dozen horses, which they immediately hobble. One is not yet hobble-broke, or whatever you call a horse with enough horse sense to not buck wildly when hobbles are attached to its front legs. It goes crazy and heads straight for my tent, changing direction at the very last instant as my heart jumps into my throat.

These folks, who are from Colorado Springs, eventually saunter over and shake hands. They are avid fisherpeople who plan to horsepack across to Craig Creek for a few days. They end up being very nice. They get a fire going and roast some huge brown trout they caught this morning over at Taylor Park Reservoir near Crested Butte. These they share with me. Though I'm not at all hungry, having already eaten 90 or so pounds of lentil soup, I consume an entire fish.

I retire at 10 p.m. My neighbors tell me they'll be going to bed within 20 minutes, so I need not worry about being kept awake. Courteous. In 20 minutes, they do indeed retire and all

is quiet. I open the front of my tent fly and look out at a shimmeringly vibrant sky — the kind of sky that the Colorado High Country is famous for. In the middle of the night I wake and put more clothes on. By dawn the temperature has dropped to 29 degrees.

Man, it's good to be back up high.

I pull out well before my neighbors are out of the sack. Judging from my topo maps, I have 15 fairly easy miles today. Though my feet are still hurting like crazy, a funny thing is happening on the way to Durango: I'm getting my trail legs. Despite having commenced this hike in awful shape, I have hiked enough in my life that my legs remember how to carry a pack up and down mountains all day. It's just taken a few days to wake them up from a lethargy that has lasted far too long.

I make the 15 miles to Rock Creek in a breeze by 2 p.m. The next day I cross Kenosha Pass and descend into the windswept magnificence of South Park without even breaking a sweat. Day after that, after 21 miles, I'm down at the Butterhorn Bakery in Frisco, my hometown, eating two lunches at once and smiling. I know now that I will make it to Durango just fine, thank you.

Dillon Reservoir appears diminutive from high in the Tenmile Range

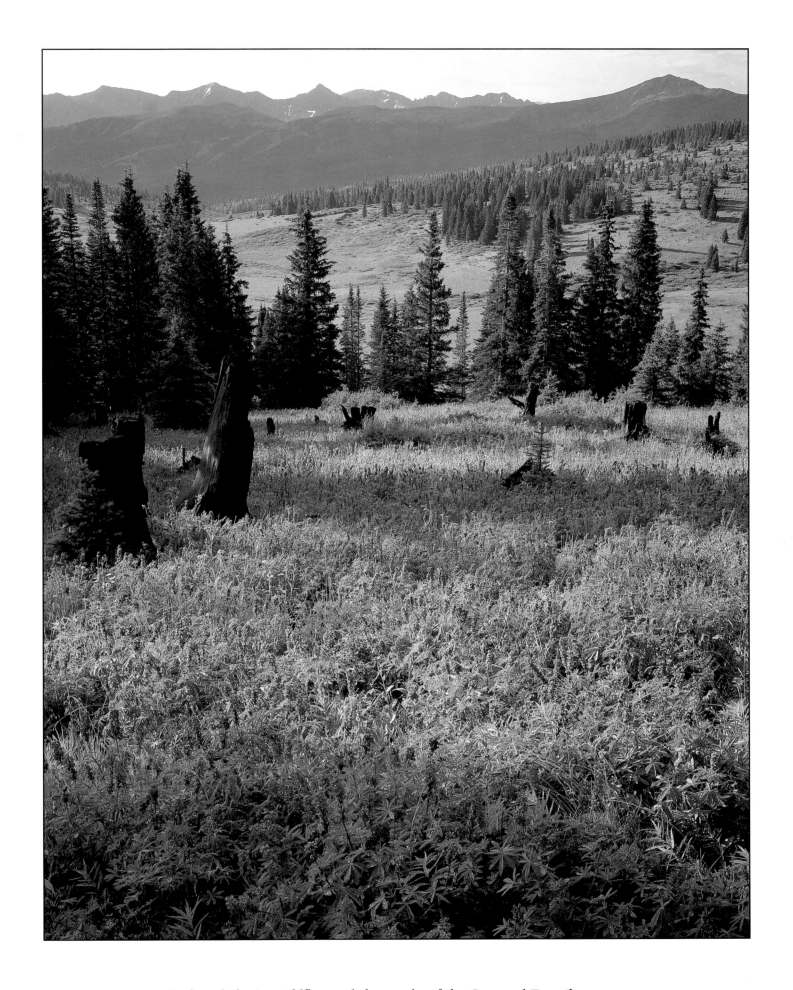

Lodgepole lupine wildflowers below peaks of the Gore and Tenmile ranges

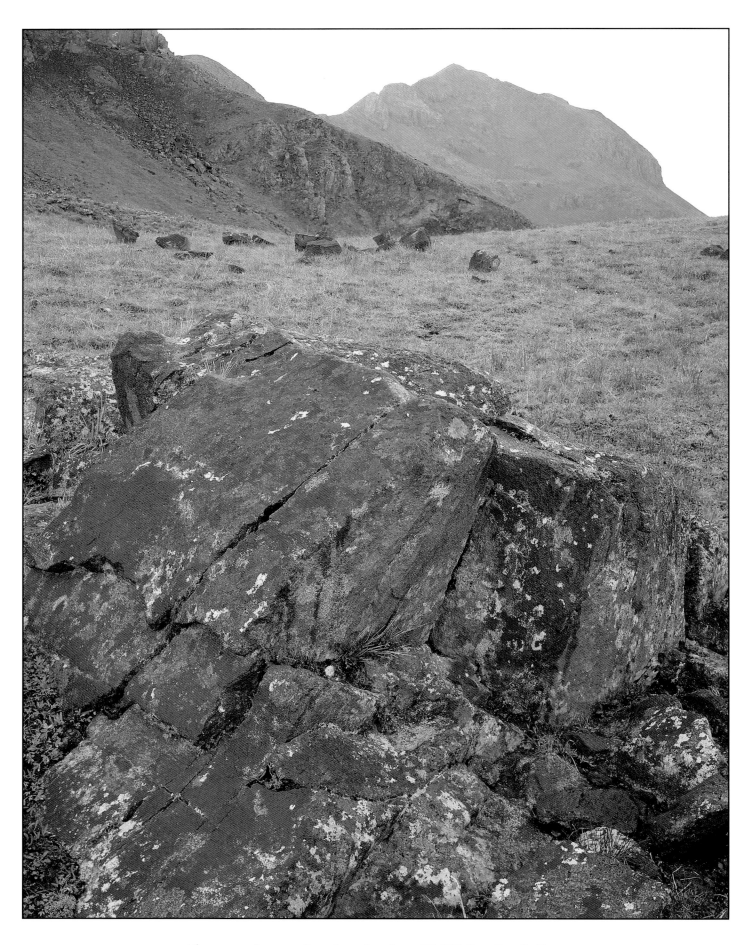

Afternoon showers drench rocks along 12,000-foot Searle Pass,
on the way to Camp Hale from Copper Mountain

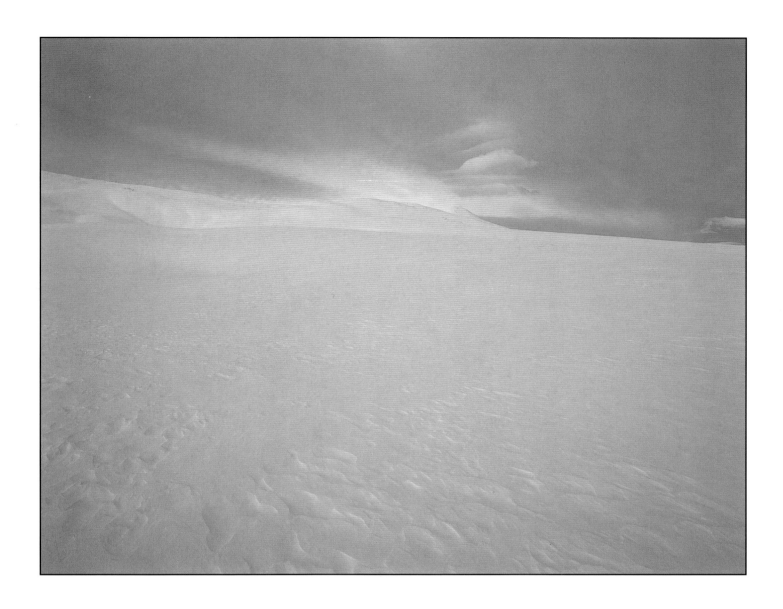

HAVING 40-PLUS-OR-MINUS MILES of the CT pass through my home county is convenient on many levels, most having to do with sleeping and/or eating. This is also a good time to perform some equipment fine-tuning. With enthusiasm I decide to get rid of the boots and socks that have made my feet look as though they spent the last 70 miles in a meat grinder.

This blister problem has really irritated me, if for no other reason than I wanted to strut into my home county, you know, mostly upright. Instead, the way I'm walking, people are asking me if I was hit by a high-speed vehicle.

So it's back to my old boots and the kind of socks I wore for eight years before deciding, at nearly the last minute before leaving on this hike, that I needed to make a change.

The Tenmile Range, which forms the backbone of Summit County, presents the first challenging climb of the CT: a 3,000-foot-plus gain, with few switchbacks, spread over six miles. From the Goldhill Trailhead on Colorado 9 just north of Breckenridge, I plan to day hike — without my backpack! — 14 miles over to the Wheeler Flats Trailhead near Copper Mountain.

I did this same stretch, from Gold Hill to Copper, then over to Camp Hale, with John Fielder last summer. That two-night, 31-mile trip gave me my first chance to see a nature photographer at work in the field.

Most of us would, in a skinny minute, trade places with a man who, when he reports to work, slings on a pack and heads into the backcountry for a little creative picture-taking. When you spend most of your professional life in, as a random example, a stuffy newspaper office, the thought of collecting a paycheck for standing atop a mountain and exposing film while the sun sets over Colorado seems like the stuff of fantasy.

"It's a good way to make a living," Fielder deadpanned as we loaded up for our trek into the Tenmile. "But it's a lot harder and a lot more work than most people want to believe."

The first thing to understand about professional nature photographers is that they hit the woods with a lot of gear. If you think it takes serious machismo to tote your 35mm SLR camera and a couple of lenses, try taking a Linhof large-format view camera, seven lenses and 300 sheets of film, to say nothing of the requisite camping gear and food.

January light along Searle Pass, above Janet's Cabin at head of Guller Creek

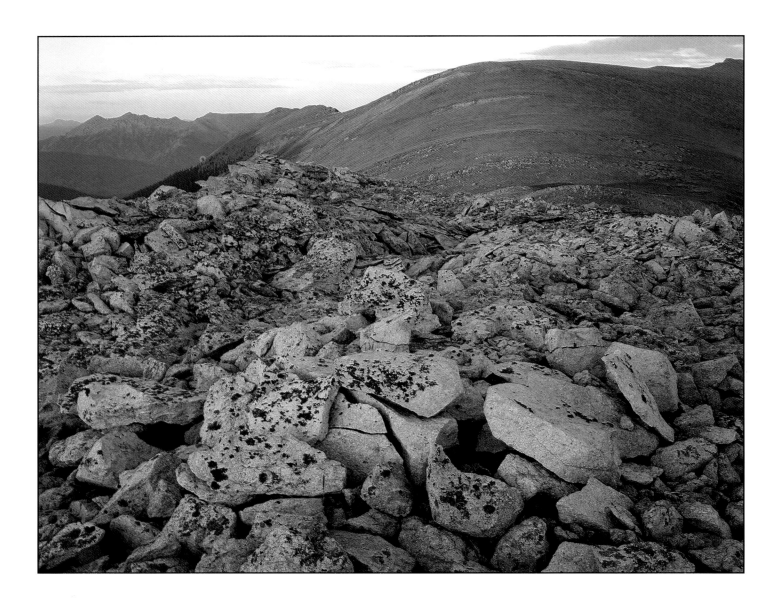

Fielder handles this large load in the only sane way: he uses two llamas. "When I was younger, I used to carry over 100 pounds of equipment with me in the Sierras," said Fielder, who is big and strong and intense enough that this is a believable statement. "I started using llamas five or six years ago because I knew if I kept carrying so much weight, I wouldn't be able to hike by the time I was 40."

Fielder turned 40 while I was with him on the trail and one thing is certain beyond the shadow of a doubt: he hikes like a madman. "Aggressive hiking" is what he calls it as he zooms ahead, leaving me to huff and puff and try to stay at least in the same time zone. (Llama-less person that I am, I am carrying a full pack.) I am beginning to get the feeling that there is more to this nature photography thing than I had imagined — at least when John Fielder is involved.

"The llamas make it so, after a week on the trail, I still feel strong and can go about my work, which is the main reason I am out here," Fielder said. "I don't mean for that to sound like I wouldn't come out into the mountains if I wasn't a nature photographer. After all, I started doing this because of my love of the outdoors. But when I'm out here working on a project, I need to have enough drive and energy. With the llamas, I can carry more clean clothes and more and better food than I'd be able to carry on my back. I can carry as much film as I want, a larger and more comfortable tent, and I'm not as tired."

Although our trip last summer was in my own backyard, Fielder knew the terrain better than I without ever having set foot on this section of the trail. "When you spend as much time as I do in the mountains, you learn to really study your topo maps," he explained. "There are certain kinds of areas I love to photograph — cirque basins, for instance. I photograph predominantly in the evenings and mornings, so I need to camp close to the area I plan to shoot. It's helpful to have campsites planned in advance, though you don't want to plan yourself into a corner and not have room for spontaneity."

By 4 p.m., Fielder wanted to be camped just above treeline at about 11,300 feet on the east side of the Tenmile Range. "This gives me time to scout around and get a bite to eat, though

Talus and evening light, Searle Pass, White River National Forest

Overleaf: Looking down Searle Gulch toward peaks of the Tenmile Range, from Searle Pass

sometimes I don't eat until after I'm done photographing for the day, usually after dark."

Once Fielder decides on a campsite — in this case a stretch of meadow below a cliff face and overlooking Dillon Reservoir some 2,000 feet below — he shifts into overdrive, running around checking out lighting and angles and all sorts of photographer things. This particular evening, though, he wasn't convinced there would be good shooting.

"This is more of a morning place," he commented. Nonetheless, once the sun started setting, he was behind his view camera, black towel draped over his head. He shot continuously until almost pitch dark. After the rest of the group retired, he spent an hour loading film in his tent.

The next morning, Fielder and my best friend, *Summit Daily News* photographer Mark Fox, were up well before dawn. They hiked 1,000 feet up to the top of a nearby ridge, where they

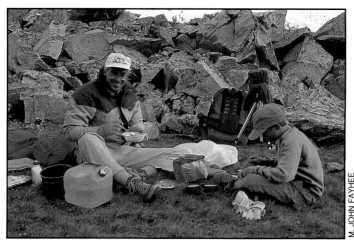

John and sherpa JT Fielder atop the Tenmile Range

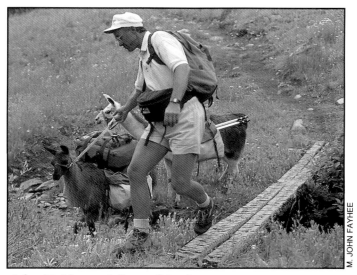

John Fielder and llama friends

fired away for more than an hour. "A lot better than last night," Fielder said after returning to camp, rudely awakening me in the process.

We left Copper Mountain early the next afternoon, following Guller Creek up toward treeline. It was a beautiful, easy hike. Unfortunately, the weather deteriorated quickly, as it is wont to do in the Rockies in late summer. By the time we reached the tundra, it was freezing and raining hard. Fielder, proving positively that picture-takers are not like you and me, couldn't have been happier. "When the weather's bad, that's about the only time I can shoot in the middle of the day," he said, scurrying to unload his gear.

While the rest of us stood around cold and miserable under the swirling clouds, Fielder set up his camera just above Searle Pass. The views of the Gore Range to the west were stupendous. Finally, the weather broke, and we set up camp near several alpine ponds. Then came the snow.

Since it was Fielder's birthday, he'd brought along several pounds of barbecued ribs and carrot cake. Mark and I had brought the kind of bottled beverages appropriate for a 40th birthday celebration. As the August snow fell, we sat in a tent, filling our bellies and telling serious lies. A lot of people would consider this cold and uncomfortable, but Fielder thought other-

wise. "I wouldn't trade this for any other job in the world," he said, grinning.

At that moment I realized John Fielder and I have a lot more in common than I had once thought.

THIS GO-ROUND, I am traversing the Tenmile on a beautiful sunny day with my wife. Just past Miners Creek, we notice all-terrain-vehicle (ATV) tire tracks in the trail. This is one of the few stretches of the CT where motorized vehicles are allowed. A sign says motorcycles are legal. It says nothing about four-wheeled ATVs.

As we approach treeline, we meet a lone hiker who tells us there are three of these foul machines up ahead. They are well off the trail and tearing up the tundra. When he confronted the drivers, they called him a "Nature Nazi" and many other unprintable names.

A few minutes later the ATVs pass us going down. I mention to them the fact that, in my opinion, this stretch of trail is closed to ATVs. They brand me, too, a Nature Nazi.

My day is ruined.

While the rest of us stood around cold and miserable under the swirling clouds, Fielder set up his camera. . . . The views of the Gore Range to the west were stupendous.

When I'm done with this hike, I'm going to lobby the Forest Service to prohibit all forms of motorized vehicle traffic on all segments of the CT. Right here in Summit County, we have thousands and thousands of acres of land open to those who are too lazy to walk or bike up into the hills. That should be enough.

I'm starting to feel possessive toward this trail.

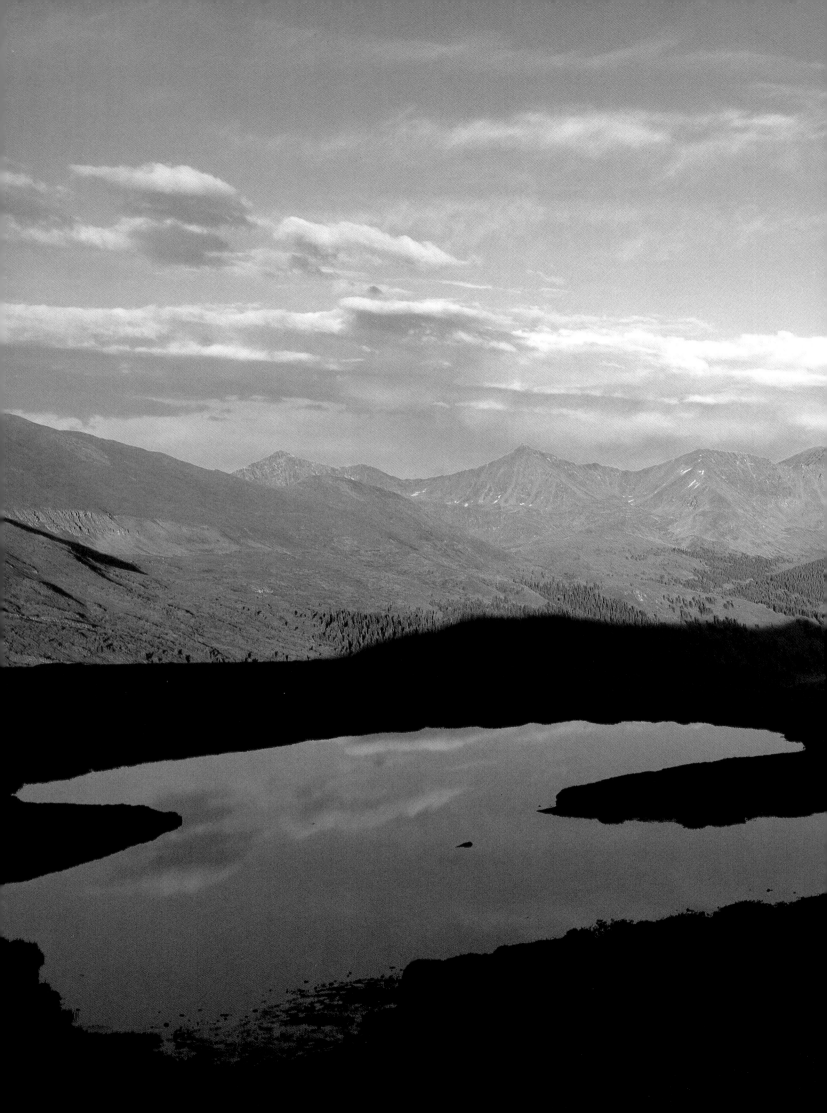

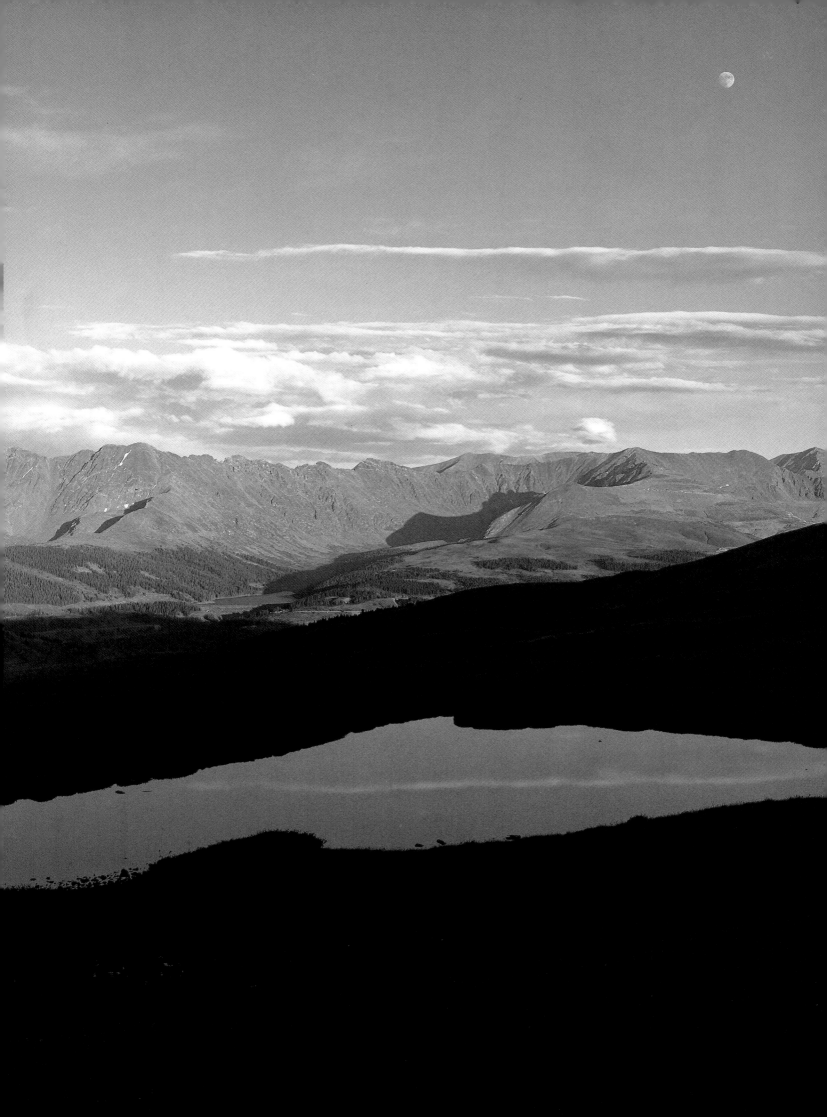

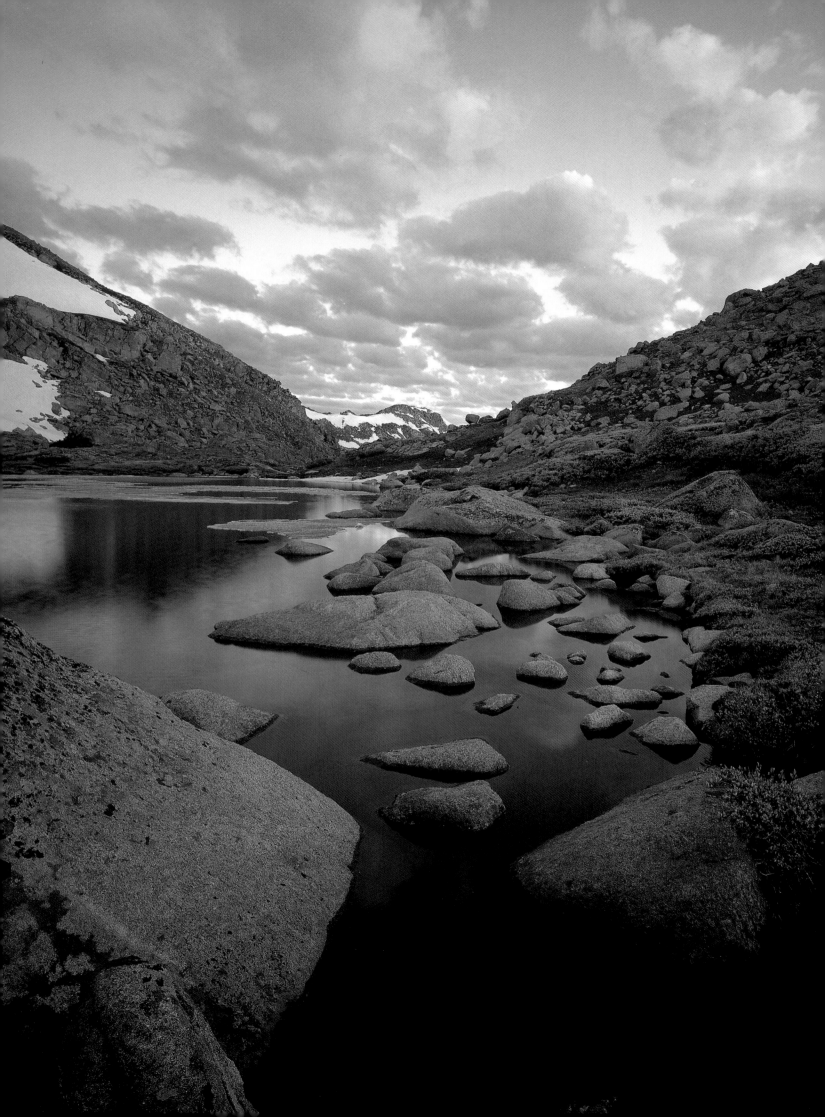

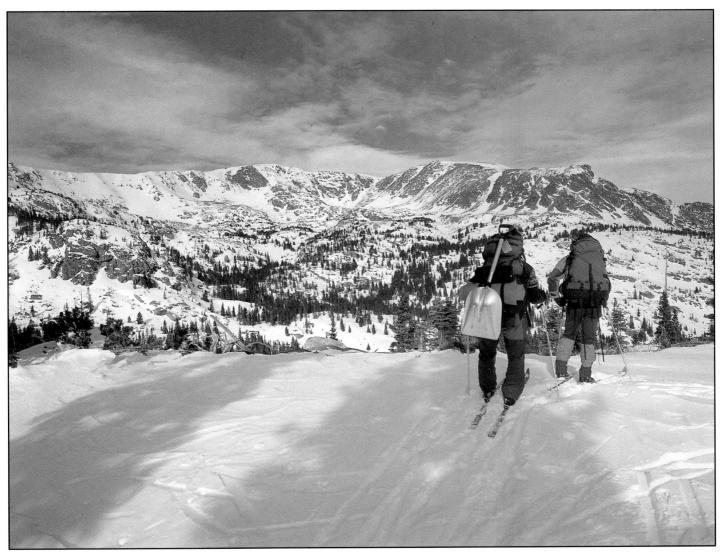

TENNESSEE PASS TO NORTH PASS
COLORADO TRAIL

NOTHING IN THE WORLD beats camping above treeline. I would rather have teeth pulled without anesthesia in Colorado's tundra territory than attend a wild party down in the lowlands. Well, that may be something of an exaggeration, but you get the point: I love just about everything about being above treeline — much the way, I guess, the late Edward Abbey loved the desert.

The CT has crossed three above-treeline segments thus far — at Georgia Pass, along the Tenmile Range, and between Searle and Kokomo passes. In each of these instances my timing was all wrong, as I was above treeline during the middle of my hiking day. When I started this hike I made myself two promises: 1) I would finish the entire trail even if I had to crawl into Durango, and 2) I would camp above treeline as often as possible. Tonight is my first opportunity to live up to the second promise.

I decide to pitch camp after hiking only 12 miles from Camp Hale — six miles from Tennessee Pass — just after crossing into the Holy Cross Wilderness. This is the first of three wilderness

areas the CT passes through during its 100-mile north-south traverse of the Sawatch Range's eastern flank.

Over the years I have hiked a fair amount of this section of the trail. My past forays into the Sawatch — Colorado's highest mountain range — were fairly easy. So I assumed long ago that this would be a rather painless 100 miles — to the degree that, despite all my pre-trail guidebook perusing, I neglected to scrutinize the Sawatch section in any detail because, after all, "I really know this neck of the woods."

As I pitch my tent about 20 inches inside the Holy Cross Wilderness boundary, I am feeling better mentally, physically and (dare I say it?) spiritually than I have in at least 10 years. One week ago, I despaired that this entire hike would be one long sweat-drenched limp through some of the most gorgeous turf in the country. Hurting as I was 50 miles back, it was hard to concentrate on ogling at vistas.

Since I changed back into my old boots a few days ago, the ogling quotient of this hike has skyrocketed about as quickly

January view of Homestake Peak, Holy Cross Wilderness

Left: Morning light at Notch Lake, Mount Massive Wilderness

as the elevation of the trail. I am what you call a happy man.

Not only are my feet feeling considerably better, my spare tire is literally melting away, which is what happens when a person exercises hard all day, eats less, and what little he does eat is very low-fat, high-complex-carbohydrate fuel such as oatmeal, homemade granola bars, more oatmeal, whole-wheat pasta, dried fruits, dried vegetables and beans. It's tough to run out every evening for a six-pack and a three-pound bag of potato chips when the closest Jeep track is 10 miles away. It's beginning to dawn on me that all I have to do to become a full-time healthy person is spend the rest of my natural life hiking back and forth between Denver and Durango along the CT. Winters may get a little rough, but I'll sure be skinny.

Summer storms can assume an unbelievable fierceness. Plain and simple, you're closer to the clouds.

Tonight I am camped in a wondrous meadow a few hundred feet from Longs Gulch. To the west, the crags and cliffs of the Continental Divide provide an impressive alpine backdrop. The meadow is filled to overflowing with wildflowers in full bloom. By far this is the best wildflower summer I have ever seen. Sad to say, though, I have no mind for memorizing the names of flowers, wild or tame.

This surprises many people who assume I have a good natural history background because I am a writer who specializes in outdoor topics. I have often tried to learn some botany things, but the information refuses to pay my memory banks a long-term visit. I literally forget the names of flowers before the person laying the pertinent information on me is even finished. "Pretty red ones" or "pretty yellow ones" seems to be about the best I can manage. In most circumstances, that's good enough.

The one exception is our state flower, the blue columbine. Of all the good reasons to call Colorado home, two lead the list: aspen in the fall and columbine in the summer. The meadow where I'm camped is columbine heaven, a veritable visual symphony, accompanied by the babbling of several nearby creeks and several thousand birds yakking their fool heads off.

From my tent site, I can see the back of the Holy Cross Wilderness boundary sign. Being in a legally designated wilderness area makes me feel as though I am in a fortress surrounded by hostile territory, even though on the other side of that wilderness sign Right There, things look about the same as they do Right Here. Legally designated wilderness areas are safehouses for psyches that may not be handling civilization all that well. Or is it the other way around? Are they safehouses for civilizations that aren't protecting individual psyches?

Either way — and many do not know this — Colorado is near the bottom of the list of western states in terms of legally designated wilderness. Only Utah has a lower percentage. Colorado's almost 3 million protected acres cover less than 4 percent of the state, less than half the percentage found in Washington State.

I have met several people on the CT who are perplexed by my passion for treeless tundra. They look at above-treeline stretches of the trail as interesting enough vistas, yes, but otherwise a place to enter and exit as quickly as possible. A hiker I met before Kenosha Pass told me he never camps above 10,000 feet unless there's absolutely no way to avoid it. When the route is about to cross an above-treeline stretch, he hits the trail by 5 a.m., hoping to get back in the trees as early as possible. He

feels psychologically and physically naked above treeline. The average person, I guess, cannot handle that sensation.

Of course, this attitude makes perfectly good sense. After all, you are extremely exposed above the trees. It's little you and your little tent alone in the middle of the mountain equivalent of an endless Nebraska cornfield, without the corn. Summer storms can assume an unbelievable fierceness. Plain and simple, you're closer to the clouds. You can see the internal churnings of vicious 50,000-foot-high black thunderheads that seem to be searching for you specifically. You can almost reach out and touch the places from whence lightning comes. You can smell ozone. Your hair can stand on end as static electricity builds up all around you. When the lightning comes, you can view multiple hits simultaneously, with the thunder exploding before the flash is even finished.

Now, I'm hardly a Muir-clone. On several occasions I have almost taken up religion during a high-altitude storm. But, for reasons I have never figured out, I don't care about the danger. Well, I do care. I'm just not smart enough to do anything about it.

Ordinarily, I avoid fearsome situations like the plague. I do not climb rock. Nor do I kayak whitewater. And all my downhill skiing takes place on the easiest runs. But the high tundra — storms, wind, cold, scorching sun and all — attracts me like no other place. If I could figure out a way to live above treeline, I would do so in a minute. But I would have to do so alone. My wife, who is an adaptable person under ordinary circumstances, feels that living above treeline transcends "ordinary circumstances" by a wide margin. She is of the opinion that our home town, at 9,100 feet, is plenty far up in the clouds.

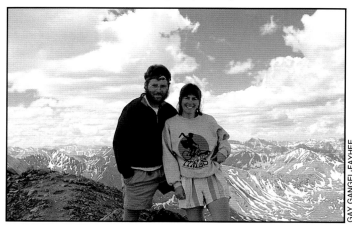

M. John and Gay on 14,421-foot Mount Massive

PRETTY THOUGH IT WAS, I really wish I hadn't camped in that meadow of wildflowers last night. The scenery encouraged me to stop four miles short of my intended destination. That decision means I have to make up those extra miles today.

It may seem odd to many people that I would paint myself into such chronological corners by establishing a strict day-to-day schedule. Certainly, it would be better to just go with the biorhythmic flow, hiking as many miles as I feel like hiking on a particular day.

Well, this is a lot easier said than done because of the inconvenience of needing to plan your food situation precisely. You don't want to carry too much food because it's heavy, and heavy is a bad thing. At the same time you don't want to carry too

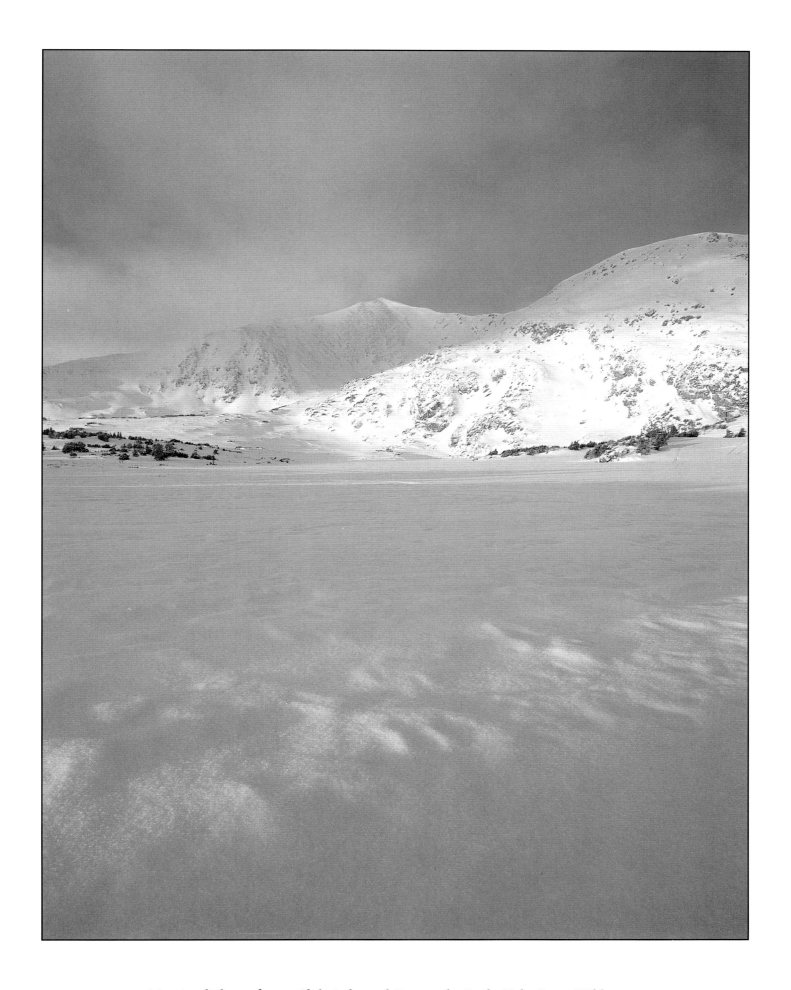

Morning light on frozen Slide Lake and Homestake Peak, Holy Cross Wilderness

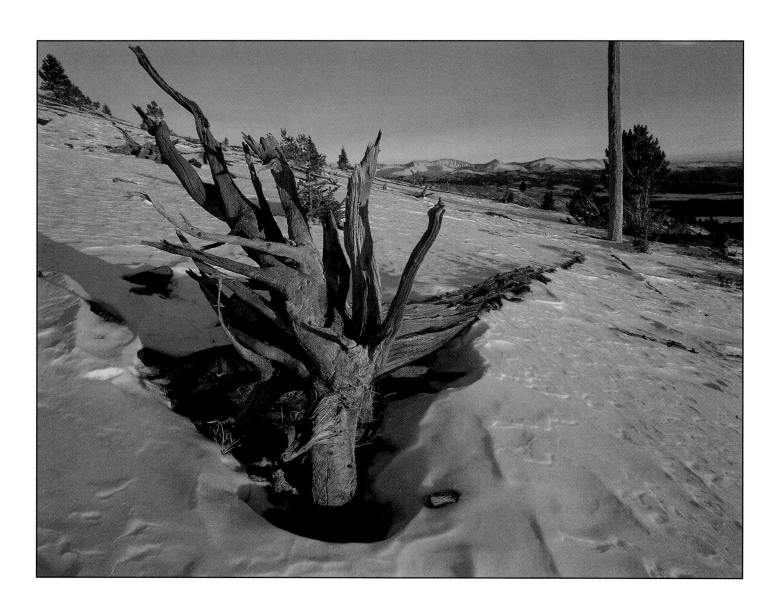

little, because you need lots of calories when you're hiking up and down mountains all day. Thus, you have to plan how long it's going to take you to knock off a particular stretch of trail, and you have to basically stick to that plan.

Most CT hikers have to go into towns for their food. This means leaving the trail at road crossings and walking and/or hitchhiking to the closest store and/or post office. A lot of hikers mail food packages to themselves in care of General Delivery in towns along the trail. Heading into town can be inconvenient, but it does provide the flexibility to dillydally on the trail.

Because I live in Colorado, I am lucky enough to have friends and family meeting me on the trail with my food drops. All told (not counting Waterton Canyon, where the trail started, and Summit County, where I live), I have five drops: Twin Lakes, U.S. 50, Colorado 114, Lake City and Silverton. This works out well, but it also means I have to be where I say I'm going to be when I say I'm going to be there. Within a couple of hours, that is.

It's not just food drops that are keeping my nose to the grindstone. Tomorrow at 7 a.m. I'll be meeting my wife at the point where the trail to Mount Massive leaves the CT. Our plan is to hike to the summit of Mount Massive, the state's second-highest peak. Gay will be arriving at the Halfmoon Creek Trailhead at 4 a.m., then hiking to meet me. Our "date" is much more serious than a food drop. It's a spousal rendezvous, and it is important to the continuing success of my marriage that I show up on time. On the right day.

This is where that extra four miles come into play. Originally I planned to hike 16 miles yesterday and 12 today. Unfortunately, those figures are now reversed, which might lead someone to inquire what the difference is. As I said earlier, I didn't peruse the Sawatch section of the CT guidebook very well before leaving on this hike. This lack of perusal, sad to say, continued unabated until, well, about 6 a.m. today. Come to find out, the hard way, that 16 miles yesterday would have made for, yes, a long day, but a tolerable one, simply because of the lay of the land. Come to find out that today the lay of the land is upward and downward and upward and downward.

This fine day there are four steep multi-mile ascents. The first one begins about nine seconds after I leave camp. It is a captivating way to begin the day and is immediately followed by a

Evening light on old snags at head of Longs Gulch, Holy Cross Wilderness

42

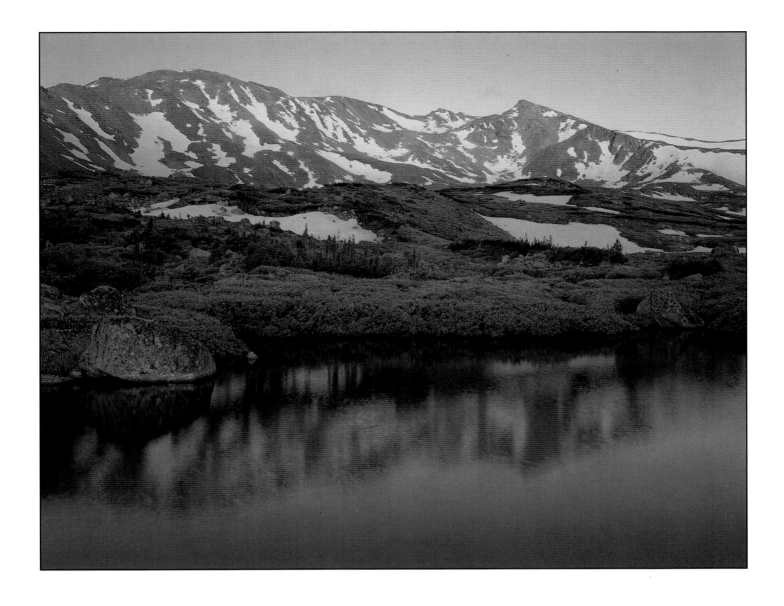

descent so steep that both of my feet end up scrunched into the front third of my boots.

I don't notice the second ascent, which begins near Turquoise Reservoir, until I bump my nose on the trail while cruising along minding my own business. "There must be some mistake," I say to myself, "because there's a trail marker way up there on that cliff."

It is no mistake.

Days later I top out on the ridge. This is a climb of less than 1,000 feet, yet I feel as though I have just done Everest. I am gasping for breath so hard, I inhale two butterflies innocently flying by.

And there are still two more climbs, each higher than the last.

When the CT was being designed, the idea was to keep the grades as mellow as possible so the trail would be something the average out-of-shape hiker would want to and be physically able to enjoy. This praiseworthy goal, by and large, was achieved by hooking into existing trails with relatively innocuous grades and by building new trail with plenty of switchbacks. But some parts of this wonderfully rugged state are too wonderfully rugged

for moderate trails. Much of the Sawatch Range falls firmly in this category.

Earlier I mentioned how the CT follows the eastern flank of the Sawatch. In retrospect, this description sounds far too benign. Each of the Sawatch's innumerable peaks sends ridge fingers to the east, down toward the Arkansas Valley. The trail traverses a multitude of these ridges. Sometimes this means levelly cruising into and out of small drainages, some with water, some without. Most of the time, however, this means climbing up to ridgetops and immediately climbing back down again.

About 4 p.m. I reach North Willow Creek. Along the bank is a tent site that is almost halfway level, which is quite good enough. I am only a mile from where I am to meet Gay in the morning.

I trudge down to the creek, strip, get in, freeze, get out, trudge back to camp, eat vast amounts of something healthy and hit the sack by the time darkness settles.

Outside my tent, about three millimeters from my face, every mosquito on the planet is going into a feeding frenzy. This is fast becoming a bad summer on the insect front. As I was cooking

Sunrise on Mount Massive, Mount Massive Wilderness

Overleaf: Sunrise at Notch Lake, Mount Massive Wilderness

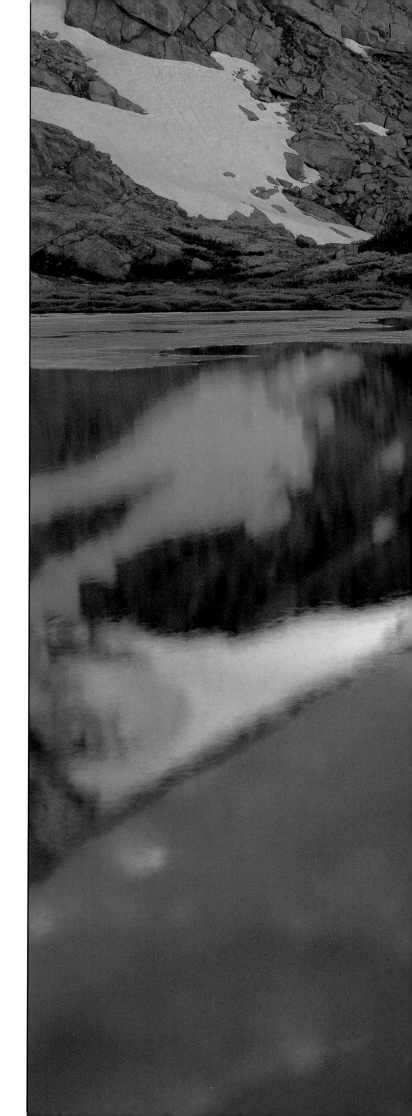

supper, there was a veritable cyclone of mosquitos whirring around *en masse* above my stove, attracted, I guess, by the heat.

When I arise I expect to be unable to move my legs. But I feel fine; no stiffness at all. I eat quickly and get on the trail by 6:30 a.m. This is a section I have hiked before, and it is level and smooth. I make it to the Mount Massive Trail by 7:03. Gay has been here 20 minutes and is on the verge of the kind of foot-tapping that wives did in 1950s TV shows when their husbands were behaving unacceptably.

The "trail" (and I use that term loosely) to the Mount Massive summit climbs 3,800 feet in about four miles. Anytime you start getting into the thousand-feet-per-mile ascent rate, you're in some cardiovascularly captivating territory. Even the easiest of Colorado's 54 14,000-foot-plus mountains are fairly intense. Mount Massive, which dominates Leadville's western horizon, is not among the easier fourteeners. It's straightforward enough, meaning there are no cliffs. But it's steep and the walk is long and the air is mighty thin.

It is also astoundingly beautiful. Within a few minutes we are above treeline. The sky is cloudless and the views of the Arkansas Valley to the east are very easy on the eyes. The whole mountainside is abloom.

In the past few years fourteener bagging has become a mania in Colorado. This should not be surprising, because fourteeners offer everything the average outdoor jock or jockette could possibly ask for in the way of wilderness resume-padding material. There are enough fourteeners to keep even the most driven person occupied for at least several seasons.

Combine all these attributes in an outdoor-activity-oriented state such as Colorado and you have all the makings of a genuine craze. Though no entity keeps track of the numbers of ascents of Colorado's fourteeners, everyone agrees that they are up significantly. Unfortunately, there has been a considerable negative impact from these increased numbers.

"This craze has sort of taken us by surprise," says Dave Stark, a recreation planner with the Forest Service's Rocky Mountain Regional Office in Denver. "We're still trying to develop some sort of scheme or strategy to deal with this increased use of fourteeners. Some of the peaks are not getting that much increased physical impact as of yet, because they have durable routes to the summit. Other peaks, however, are seeing serious impact."

Mount Massive falls somewhere in between. Though there is a mostly obvious trail to the summit, it's one that has evolved through lots of use, rather than one that was built. (Such undesigned footpaths, which are highly susceptible to erosion, are called "social trails.") But the surrounding tundra seems healthy enough. It appears that few people are tromping off the trail. And because the eastern slope of Mount Massive is fairly dry, it's not likely that many people camp alongside the trail.

It takes us three hours to reach the summit. There is only one other person on top. The view is out of sight. It's not like there are any fourteener summits without great views. The ugliest is still awesome. But Mount Massive ranks up there with the very best. Back toward the east we can see the Tenmile and Kenosha ranges. From this one summit I can follow, in very general terms, a big chunk of the CT's route. It already seems like 13 years — not 13 days — since I started the trail.

This is my seventh fourteener and Gay's third. Gay is seriously concerned that the closer I get to my inevitable midlife crisis,

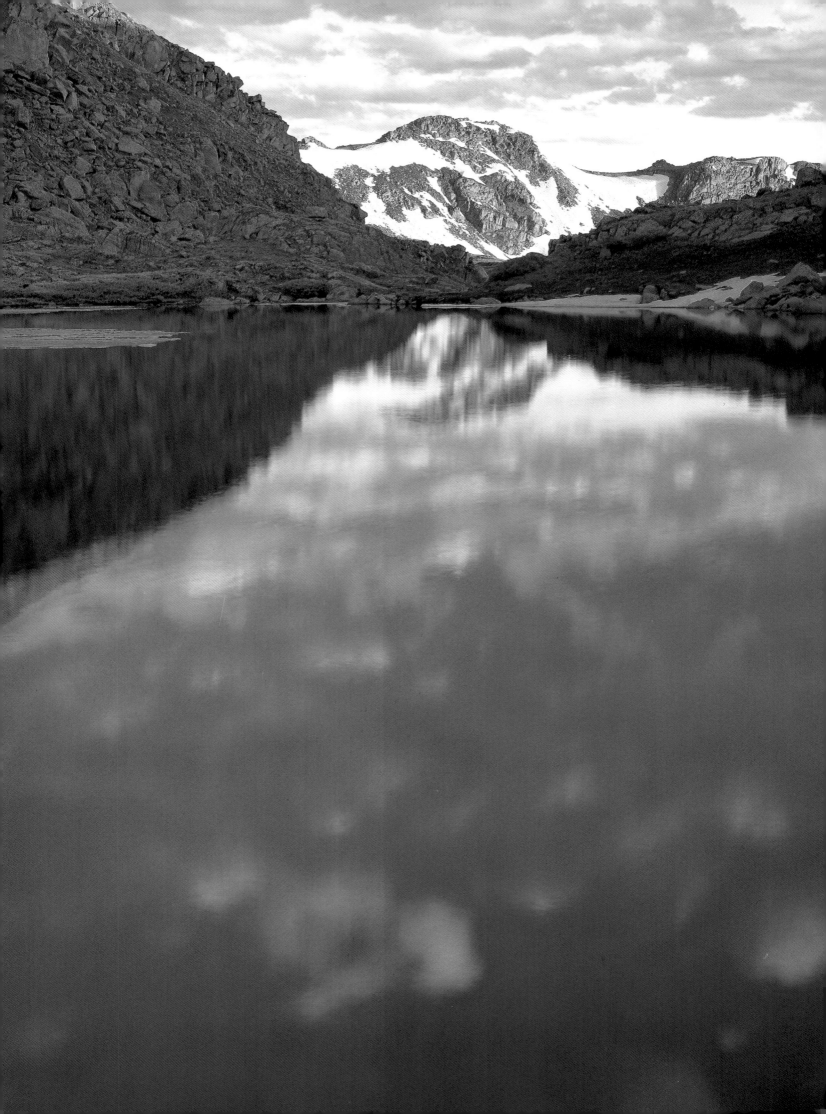

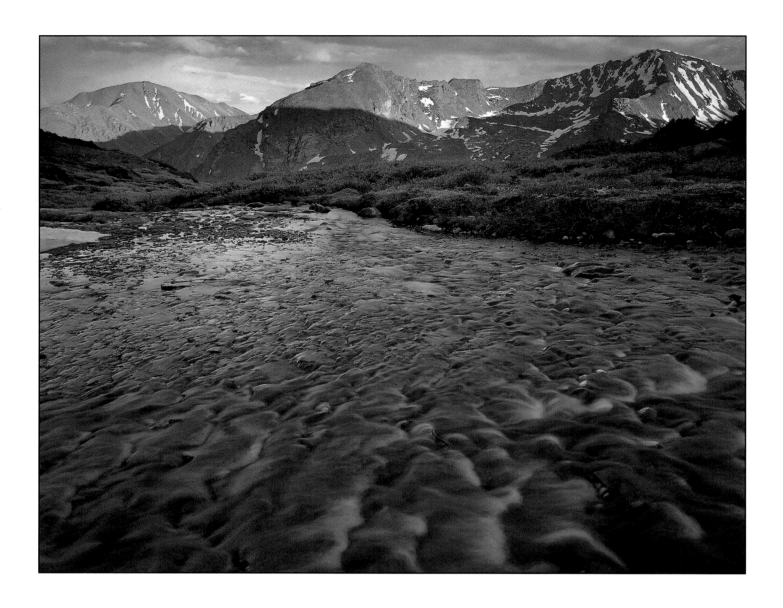

the more obsessed I will become with the notion of bagging the rest of Colorado's fourteeners — meaning her weekends will likely be messed up until my quest is completed.

By midafternoon we get down to Halfmoon Creek, where Gay's car is parked. It has been a long day for Gay, who had to hike three uphill miles just to get to where she met up with me. All told, she has hiked 14 miles with 4,000 feet of vertical gain, topped off by another 4,000 feet of vertical loss.

As for me, I immediately run over to the creek and soak my feet. They sizzle as they hit the water. Right across the road, the CT begins its six-mile meander to Twin Lakes. About a mile from where I am sitting, a side trail heads up to the top of Colorado's highest peak, Mount Elbert. This is certainly one of the best aspects of the CT: it passes close to a whole herd of fourteeners. In addition to Elbert and Massive, there are Harvard, Yale, Princeton, Shavano, Tabeguache and Antero, all in the Sawatch Range, and San Luis Peak in the San Juans.

Days off the trail are wonderful events. Gay has brought along all sorts of greasy and delicious food items. Before bed I have eaten them all with relish. And ketchup.

Early the next morning we get up and drive into Leadville, which, at 10,200 feet, is not only one of the nation's highest-elevation towns, it's one of the most historically interesting places in the state. Unlike many of Colorado's old mining towns, history is not relegated to mere nostalgia and quaintness in Leadville. There is still mining going on and, even though the town has had to turn more and more of its money-making attention to the tourist trade in the past few years, Leadville still feels like a "real" town, as well as a real fun town.

We head straight to the Golden Burro for an all-you-can-eat $5 Sunday breakfast buffet. With most of my fat reserves abandoned back along the CT, I guess my body is calling for caloric reinforcements. I oblige.

After lunch, Gay packs up and returns home. I pack up and head toward Twin Lakes.

From Lakeview Campground, the trail does something that, at least on paper, seems absolutely idiotic: it spends 10 endless miles circumnavigating both of the Twin Lakes. By the time the trail completes this uninspiring near-loop, it ends up about a mile from Lakeview Campground. All that is needed to intersect

Headwaters of Halfmoon Creek and 14,433-foot Mount Elbert, Colorado's highest mountain,

Mount Massive Wilderness

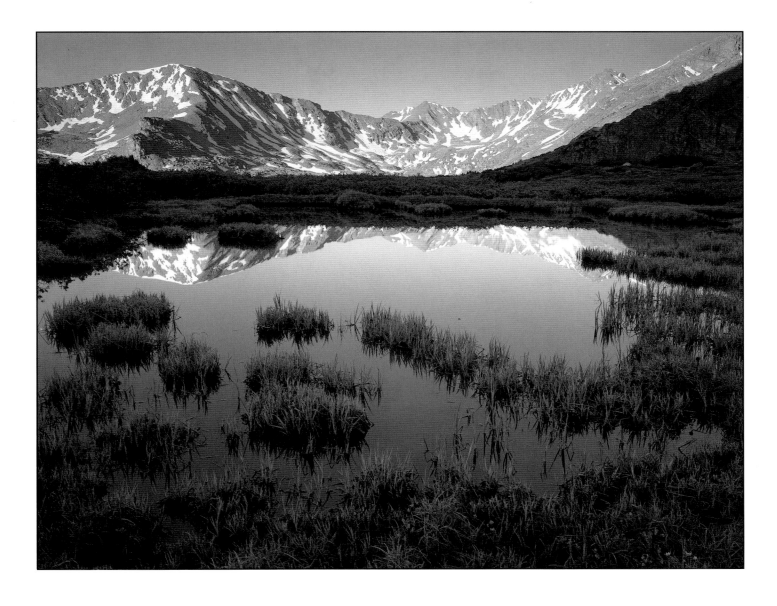

the CT and bypass a very boring 10 miles is to roadwalk that one mile in the other direction and walk through the woods a short distance.

Unfortunately, because of all the private land hereabouts, this is not possible. The Forest Service and the CT Foundation people are in the process of trying to acquire the needed rights-of-way to institutionalize this very convenient short-cut, but no one knows when that will be achieved — if ever it will be. The wheels of government are slow to turn when it comes to lands acquisiton.

This is also where the CT passes close to the base of Quail Mountain, the site of a proposed new ski area. This is too much to believe. Colorado already has 25 or so ski areas, at least six of which are either neck-deep in bankruptcy or on the verge of it. Three of the state's ski areas can't even be given away. Not counting Quail Mountain, there are at least two major new ski areas on the drawing boards here in Colorado — one near Steamboat Springs, the other near Pagosa Springs. Meanwhile, skier numbers have not increased significantly in more than a decade. It is sheer idiocy to think, even for a second, that a new, relatively small ski area such as Quail Mountain could do anything more than set a new state record for losing money. But

few people I know praise the business savvy of folks in the ski industry, so there's no telling what will happen.

By 8 a.m. I have completed the 10 around-the-lake miles, which seemed doubly like a waste of time because I day-hiked that stretch earlier in the summer with my wife. Boring or not, those 10 miles are easy going. And, when they are behind me, almost instantly, I am dealing, painfully, with the CT's single biggest vertical climb for someone hiking east to west. It takes years to crawl the 3,500 vertical feet to the top of Hope Pass, from which there is a wonderful view of Quail Mountain.

Without a doubt, this is the prettiest spot on the trail so far. Apologies to those who think ski runs hacked through the woods are attractive, but as far as I'm concerned, this area doesn't need to suffer from the works of man. It doesn't need neon-clad snowboarders and families-of-four from the flatlands careening down its sides from November to April. It's just fine the way it is.

Two-thirds of the way to Hope Pass, I start running into a surprising number of people. The first two are training for the upcoming Leadville 100-mile footrace. Meaning, of course, they are insane. The next 20 are members of a Colorado Trail Foundation-sponsored CT Trek. Every summer the CT Foundation organizes and runs several week-long, vehicle-supported hikes

Peaks of the Sawatch Range reflect in pool below North Halfmoon Lakes,

Mount Massive Wilderness

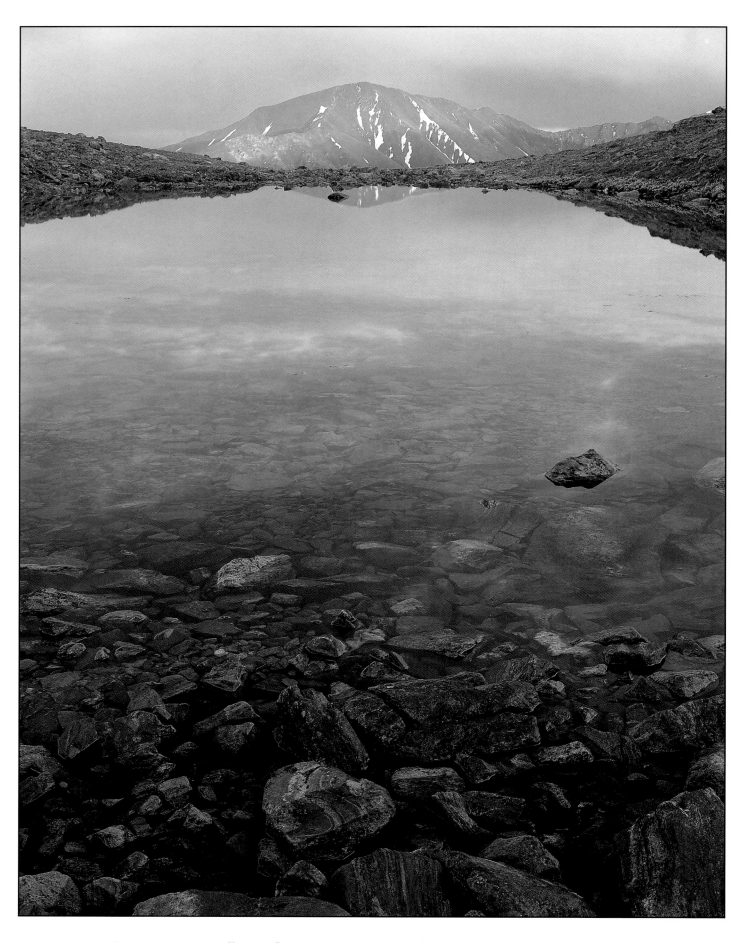

Sunset on Mount Elbert reflects in tarn at 13,020 feet, above North Halfmoon Lakes,
Mount Massive Wilderness

along different sections of the trail. Participants, who come from all over the country, carry daypacks only. At the end of the day they are shuttled to a campsite that is mostly set up, although they do have to pitch their own tents. It's a great way for people who maybe aren't in the best of shape to experience the CT's beauty under the guidance of people who know the trail better than anyone.

My original plan was to camp next to a small lake just north of the pass. But a severe thunderstorm is moving in fast, and even a tundra-lover needs to exercise discretion when the weather is looking like one of the opening scenes from the *Wizard of Oz*.

From Hope Pass the trail does what it will do for the entire rest of the Sawatch: it goes straight back down. At the bottom, after a mere eight miles of hiking, I pitch my tent. By noon, I am as far into my sleeping bag as a person can possibly be. By 2 p.m., it starts to pour. The deluge keeps up for most of the afternoon.

DESIGNING AND BUILDING a 470-mile trail is an undertaking so ambitious that a basically slothful person can barely comprehend even the least complex component of it. I have trouble organizing my life to the point of keeping my kitchen halfway clean. It boggles my mind that there are people out there like Gudy Gaskill who manage to do things like build 470-mile-long trails. I'll even bet her kitchen is cleaner than mine.

Even with the most cogent design and execution, there are still going to be times when Segment A and Segment B do not line up perfectly. This is exactly what happens where the CT intersects Clear Creek Road, a little-traveled dirt road that follows a very pretty, and clear, creek. One day, probably, this stretch will be rerouted into the woods. In the meantime, Segment A of the CT is connected to Segment B by six and a half miles of road.

Though road walking is not my favorite activity because it's fairly hard on the feet, this particular section is rather pleasant.

Icebergs at 13,060 feet, high above North Halfmoon Lake, Mount Massive Wilderness

It heads basically downhill, it's a perfect morning and I make some serious time.

By 9 a.m. I have finished the road-walking stretch. As the trail crosses a half-mile of Clear Creek Ranch property, I'm once again in parched desert land. As I make my way across a pasture, I am attacked by squadrons of mosquitos. I end up sprinting.

The mosquito problem abates as I begin to climb, and I stop for a snack. Since it's hot and sunny, I pull out my tent, which is still soaked from yesterday's rains, and lay it out to dry.

Three-quarters of an hour later I pack everything back up and begin climbing into the most famous part of the Sawatch Range: the Collegiate Peaks. The official CT guidebook is fairly effusive, even gleeful, in its description of this particular stretch, noting that the trail ascends and descends the " . . . magnificent terrain like a giant roller coaster." Wheeee . . .

For the next five miles, the giant roller coaster gains 3,000 high-adrenaline feet. This, of course, is not that significant of a pitch and, even though it is hot as blazes, I knock off the climb in about two hours. The trail tops out on a wonderful ridge just at treeline in the Collegiate Peaks Wilderness. There are great views of Mount Harvard, one of the state's more impressive fourteeners.

Then the roller coaster dips down for a thousand feet to the spot where I intend to camp — Pine Creek. What a place. We're talking a meadow at 10,500 feet with unimpeded views of the Continental Divide.

There are even several wonderful tent sites and a nice swimming hole. This gives me the chance to practice a cold-water diving technique I have been working on for some years now. I dive in fairly normally, then arch my back about 270 degrees, exit the water, turn a midair backward flip, and end up standing on the exact same spot on shore. The advantage of this diving technique is that I maintain body contact with the frigid water for only a nanosecond.

I feel refreshed and head to the tent for a quick nap. A storm moves in while I'm snoozing. It pours for an hour or two, then the storm passes, heading east. When I emerge from the tent, the world is squeaky clean and the wonderful smells of the Colorado High Country are suspended in the moist air. Life isn't too terrible.

Dwarf clover and tundra at 13,000 feet, below Mount Elbert, San Isabel National Forest

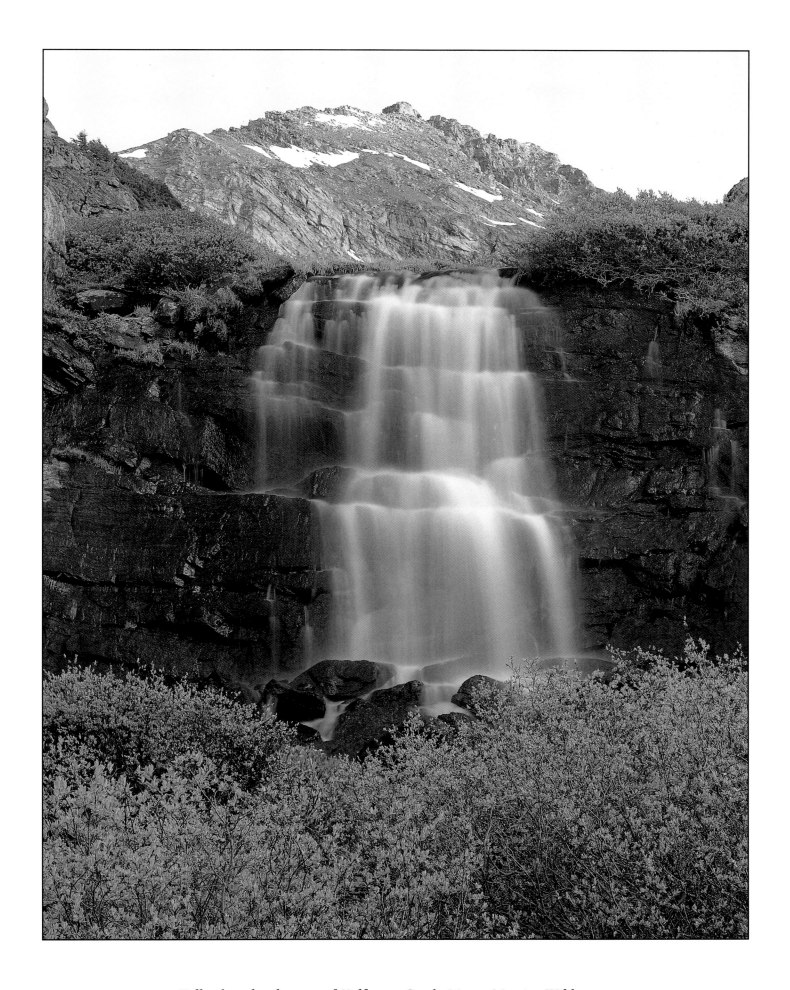

Falls along headwaters of Halfmoon Creek, Mount Massive Wilderness

DAY 19. With just over 200 miles under my belt, I am fast approaching the halfway point. I have decided to camp between North Cottonwood Creek and Silver Creek. This is not the world's best campsite, but neither is it bad. It's simply fairly average by CT standards and very close to the trail. After hiking 12 miles, I hurriedly set up my tent to avoid a thundershower. As much as I love to walk, that love turns sour when it starts to rain.

Just as the last tent stake is being driven in, a wild hailstorm drops in for a visit. Within minutes the landscape is a winter wonderland. My tent, which has so far held up beautifully, sounds like the inside of a snare drum. But it doesn't leak, and I stay warm and comfortable.

When the storm passes, there is a decided nip to the air. Since there are a huge number of downed trees in the immediate vicinity, I decide to build a fire. This is my first CT campfire and the first I have built in Colorado in years.

Like most people, I was raised believing that a roaring fire is the most crucial component of any camping trip — whether to the wilds of my own backyard at age 11 or to the Alaskan outback. Campfires, by definition, have to be at least as large as a Pontiac and so hot that everyone has to stand at least in the next county to avoid being cooked to death. In my past life, campfires always served as a social focal point and conversational impetus. I knew people who said maybe two words a year who bloomed verbally when sitting around a fire with a nice beverage in hand. To my young self, the notion of a campfireless camp seemed far worse than a TV-less home.

Just as the last tent stake is being driven in, a wild hailstorm drops in for a visit.

Then times started to change. Those darned environmentalists started telling us that campfires sterilized the surrounding soil so thoroughly that nothing could grow there for 100 years. We learned that felled timber was, when decomposed, integral to soil regeneration. Every twig we burned was fertilizer going up in smoke, to the detriment of the overall health and well-being of the forest. People who considered themselves bonafide minimum-impact campers started carrying cookstoves. Instead of sitting around a fire till all hours, we just went to bed earlier.

For all the right reasons, I avoid building campfires. But every once in a while, when I'm in an area with a fire ring and an abundance of wood, I break down and rekindle the flames of camping consciousness past, of those innocent days when a fire was the single most important part of any wilderness foray.

Of course, the exact instant I get my little fire going, a group of serious-looking hikers comes by, decked out in the requisite minimum-impact consciousness uniform, which consists of near-equal parts of Synchilla, Gore-Tex, nylon and Lycra. The hikers observe the sinful flames at my feet, turn their noses up and saunter away, looking as though they feel mighty superior.

A few minutes later, just as darkness descends on CT land, several other people crawl by, seemingly near death. These are the very same CT Trek people I passed near Hope Pass. The exhaustion tide has turned. They have just finished climbing 14,200-foot Mount Yale and look as though they've been ridden hard and put up wet. One of them, with a certain frantic edge to her voice, asks how far it is to the trailhead. I am tempted, for the sake of pure meanness, to say eight miles. But I don't. I tell the truth: they are about 100 yards from the road that follows North Cottonwood Creek, where their shuttle awaits.

At this, they all start giggling and thanking God and dancing in the middle of the trail.

The trail they just came down is what I will be going up first thing in the morning. The roller coaster rides again.

I have heard that the ascent up the eastern flank of Mount Yale is one of the most intense climbs on the CT. I hit the sack with the exact same mentality I used to take to the Land of Nod the night before a tennis tournament, back in the days when the closest I came to wilderness was an outdoor clay court. It's not so much that I do anything different before bed, but my concentration level is much higher. And that carries over to the next morning.

At the bottom of the downhill, though, there is a treat: a little store at Rainbow Lake.

I have three miles of steepness ahead of me, wherein I will gain almost 3,000 feet. This is an old pack trail, meaning the switchbacks will be minimal, if not non-existent. I figure it'll take me about three hours to reach the pass.

It takes less than two. That said, this is one steep hill. I am up on the last three molecules of my toes the entire way. Around every bend I pray for some degree of letting up. It is a long time coming.

And when it does, its nasty counterpart, a 3,000-foot, three-mile toe scruncher of a descent is waiting.

At the bottom of the downhill, though, there is a treat: a little store at Rainbow Lake. Safeway it isn't, but I do grab several candy bars and soft drinks, along with a nutritious can of Dinty Moore beef stew for supper.

I still have another 1,000-foot climb — out of South Cottonwood Creek — ahead, but it turns out to be a breeze. I have camp set up and am washing clothes in Maxwell Creek by 2 p.m.

Doing laundry in Halfmoon Creek

Next day, after stopping for breakfast at Mount Princeton Hot Springs, where I learn that the Dodgers have somehow managed to lose their big lead over the Braves, I pass the geological oddity of the Chalk Cliffs and start on an 18-mile section that Gay and I hiked last summer. Though the Sawatch Range roller coaster is still rolling and coasting, it is figuratively all downhill from here to U.S. 50.

More than half of the CT is now behind me.

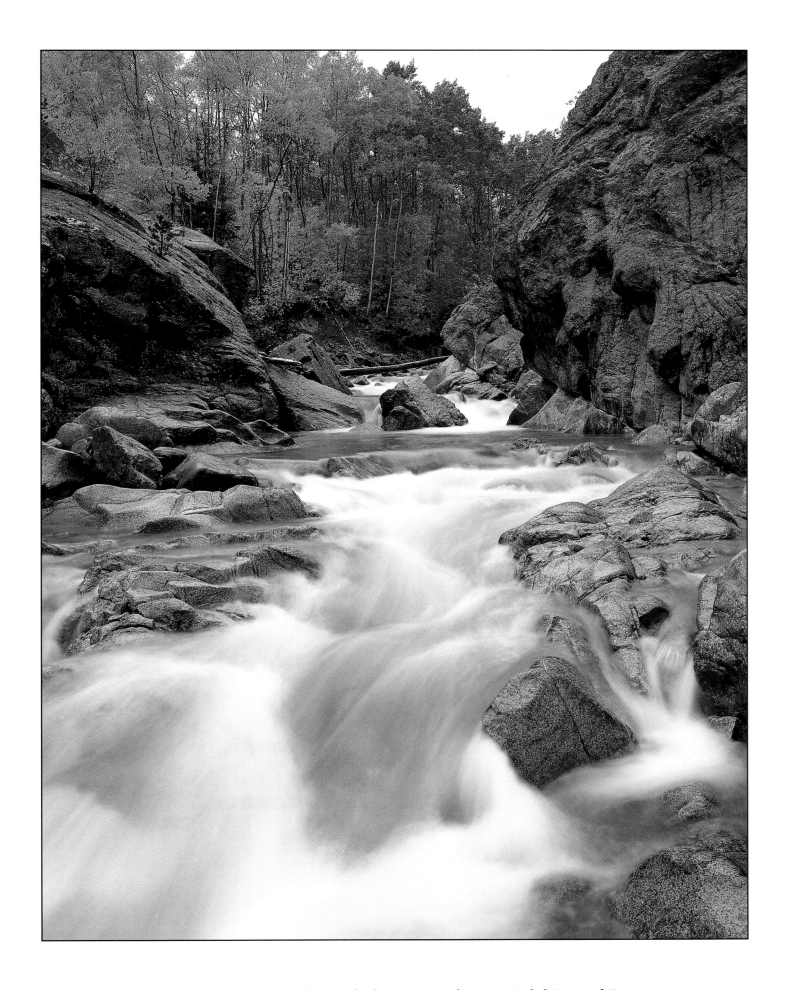

Autumn aspen decorate Lake Creek above Twin Lakes, San Isabel National Forest

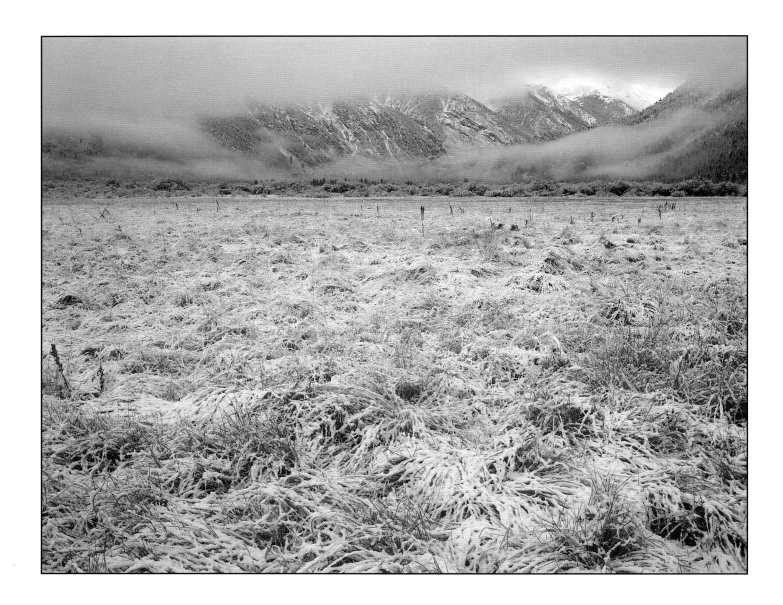

I ARRIVE AT U.S. 50 several hours ahead of my designated 6 p.m. food drop and spousal rendezvous. I settle down on the side of the road for a rest and repose. Gay shows up at 4 p.m., figuring I will arrive early. After a mere eight years, this woman is beginning to know me, and she knows I am a fast walker. We drive to a nearby campsite. As usual, Gay has brought all manner of culinary treats. She barely recognizes me, as I have lost so much weight. Halfway through, and my belt has become ineffectual; I can't tighten it any more.

I am overjoyed by my fresh stash of granola bars, instant oatmeal, dried beans, instant oatmeal, pasta and instant oatmeal. Believe it or not, I am getting a tad tired of instant oatmeal. There isn't a single flavor that I haven't eaten, at minimum, 400 packets of so far on this hike. I've done everything I can think of to make myself less nauseated when I so much as think about this breakfast food item. I've experimented with provocative Peaches & Cream and Maple & Brown Sugar mixtures. I've dumped shovelsful of cinnamon and honey and wheat bran and raisins and chocolate chips, jointly and severally, into bowls filled with "flavors" that, by themselves, don't seem quite, well,

right. Just last week I was awarded the Nobel Prize in chemistry based upon my instant oatmeal-alteration research.

No matter what I do, I still sit each day in the early morning chill, staring down at a bowl of something that, if left unattended in the Amazon Basin for a year, could still be chowed down as if fresh off the stove. During that year, no creature — not a rodent, not a bird, not even bacteria — would recognize this stuff as anything even remotely edible. And it certainly would not decompose. Every tree within a 100-yard radius could wither and die, but the bowl of instant oatmeal would be just fine.

Most CT through-hikers are, at this point, singing the heavy-pack blues because it's something like 100 miles to the next potential resupply point. Even there, you have to walk off the trail eight or 10 miles from San Luis Pass to Creede.

My slender self, on the other hand, is carrying a scant four days' worth of supplies. Gay is planning on meeting me again at North Pass, which is located on a boondock stretch of state highway between Saguache and Gunnison. I am the only hiker I have met who is fortunate enough to have this long section broken up by two food drops.

Early autumn snow near Twin Lakes, San Isabel National Forest

54

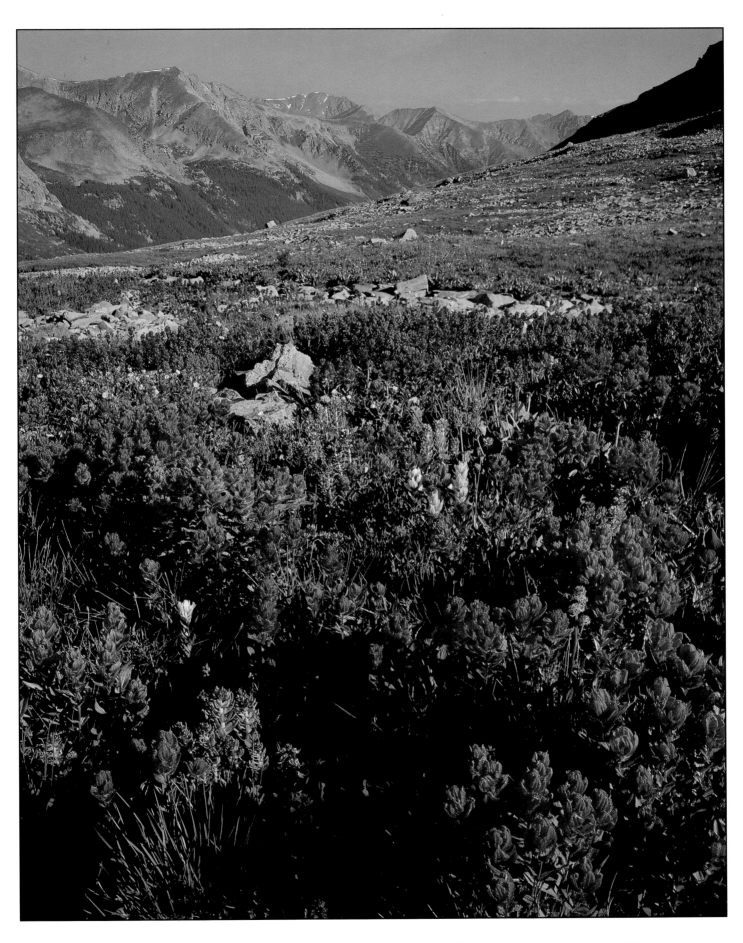

Indian paintbrush wildflowers below Missouri Peak in the Sawatch Range, Collegiate Peaks Wilderness
Overleaf: Reflections of the Sawatch Range from Missouri Basin, Collegiate Peaks Wilderness

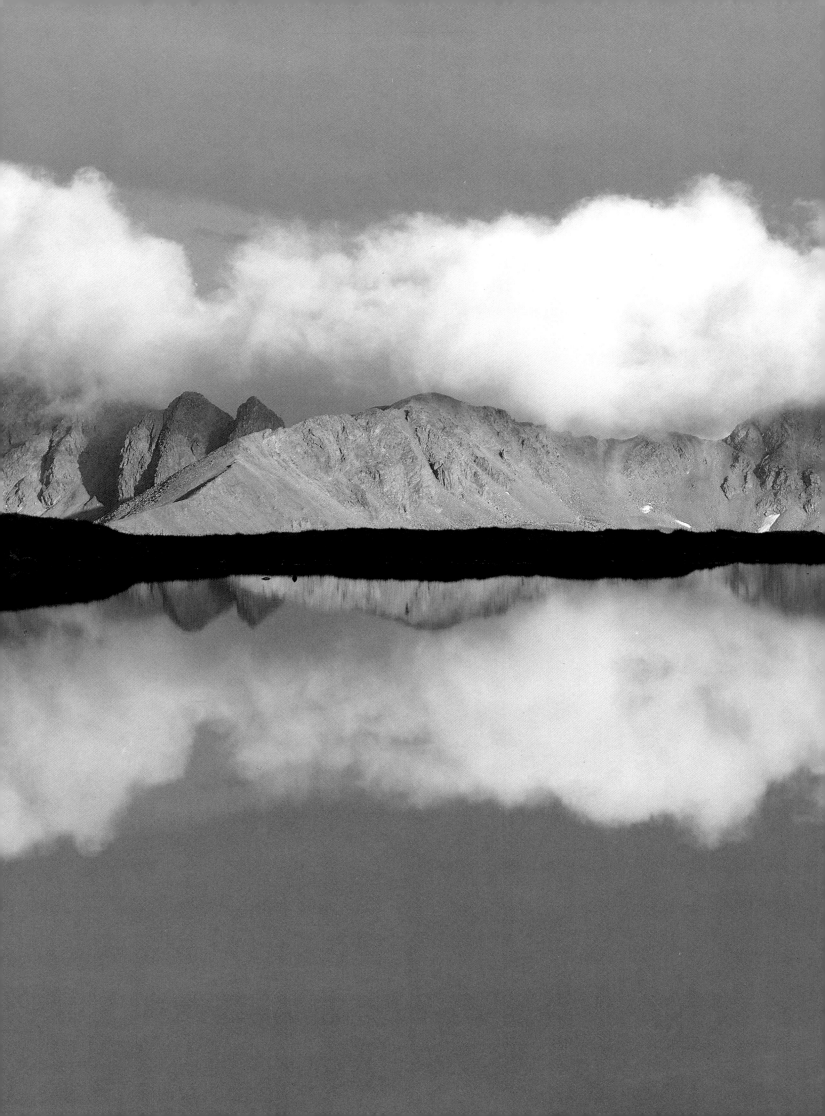

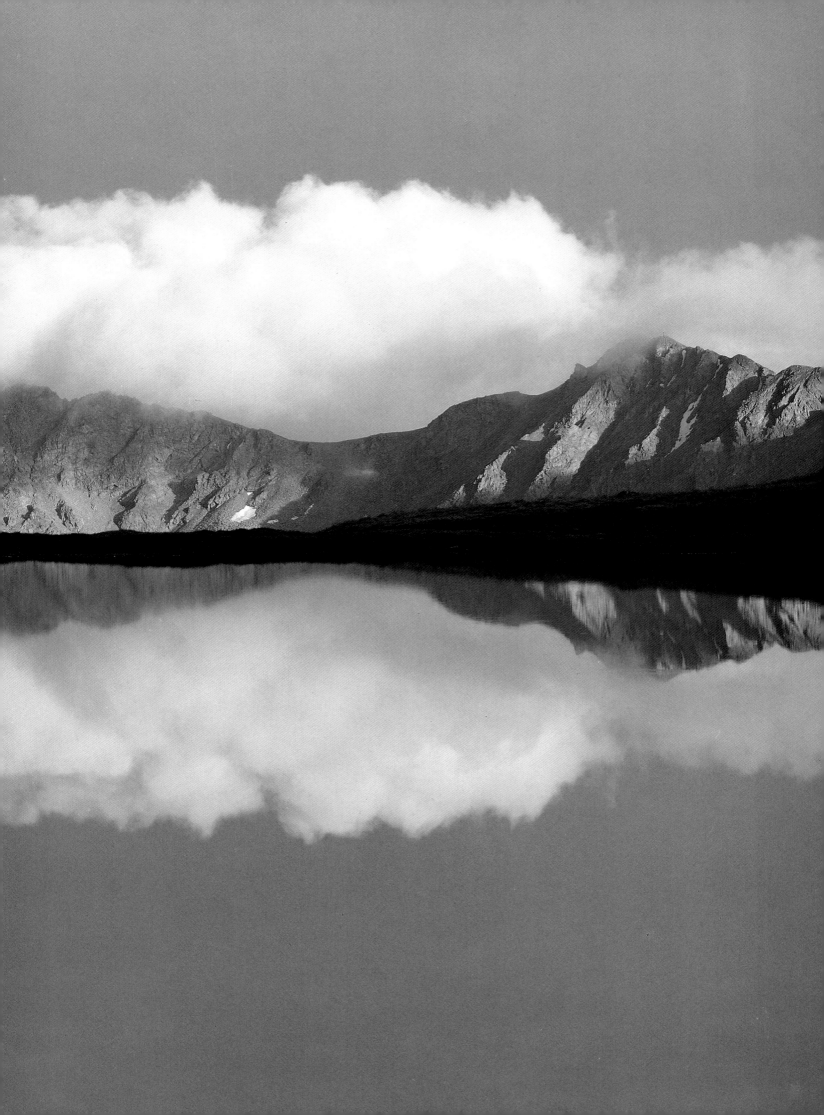

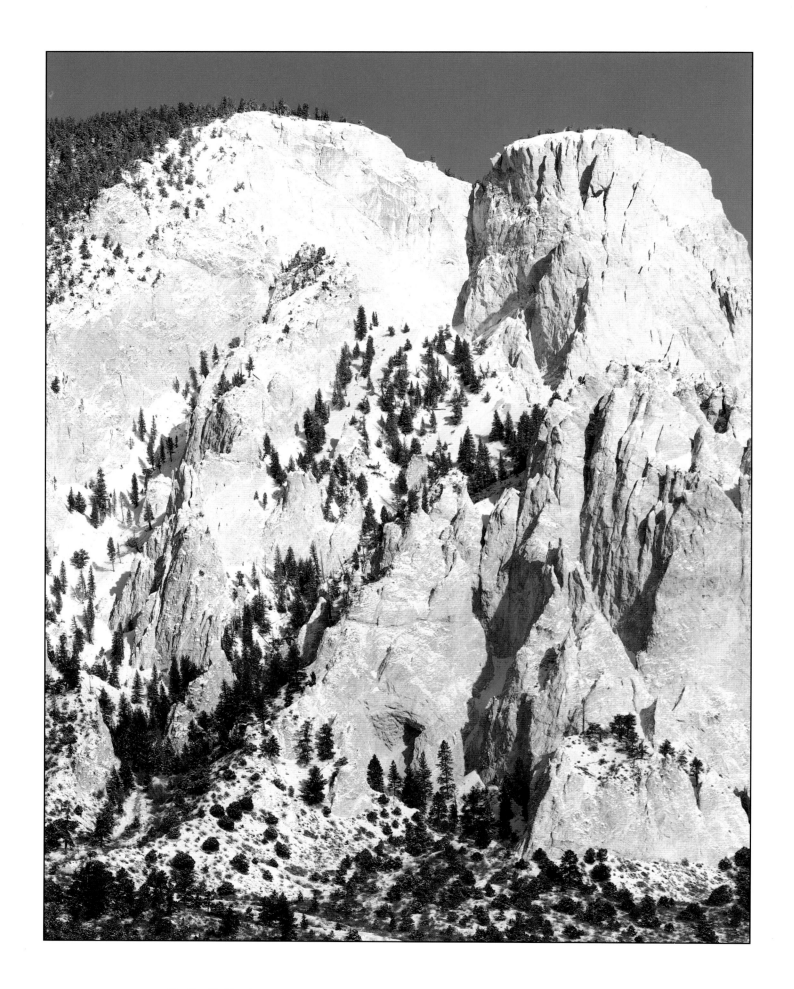

Chalk Cliffs above Mount Princeton Hot Springs, San Isabel National Forest

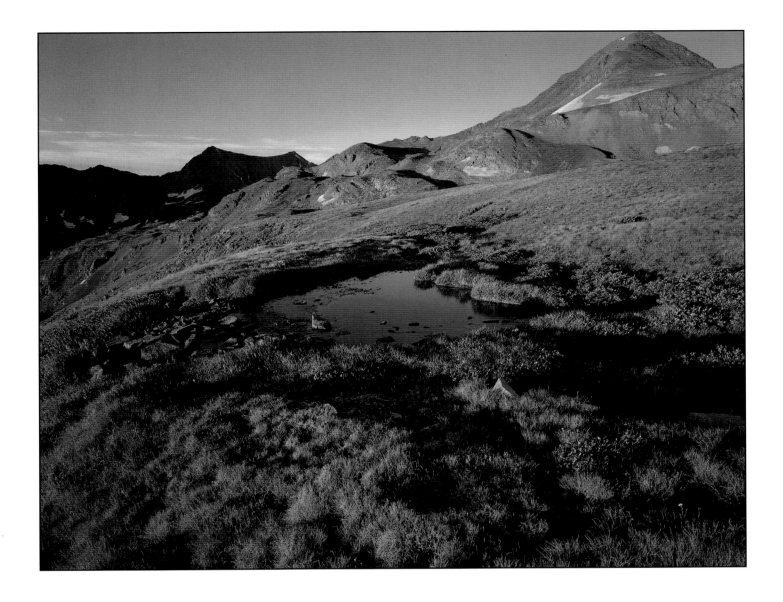

Right now I am inside the only trailside shelter on the entire CT, just above Marshall Pass. The hike from U.S. 50 up South Fooses Creek was wonderfully uneventful. A mile back, the trail tops out on the Continental Divide. This marks the fourth time the CT crosses the Divide. It is also the point where the CT and the 3,200-mile Continental Divide Trail (CDT) become one, a coexistence that continues for the next 100 miles.

The CDT, which stretches from the Mexican border in southwestern New Mexico to the Canadian border in Glacier National Park, is considered, by far, the toughest trail in the country. It is a dream of mine to hike it from end to end. Unfortunately, the CDT is still many years from completion. Right now it follows a very generalized route, utilizing, for the most part, existing trails and jeep tracks.

I don't know the story of how this trailside shelter came into being. And I really don't care. What worries me is that many people are hoping to see a whole series of such shelters littering the CT all the way from Denver to Durango. The CT Foundation has even appointed a committee to hobnob about this issue, though I don't believe much has been accomplished. As many

people know, the Appalachian Trail has more than 200 trailside shelters, which makes for an average of one every 10 miles. Using that same average, the CT would have 47.

I vociferously oppose this idea. The main attraction of the CT, in my mind, is its wildness.

Wildness is one of the many, many things that separate the Colorado Rockies from places like the Berkshires. I don't want to see the wonderful backcountry of this wonderful state civilized any more than it already is. This is not Europe. This is not the eastern United States. We don't need our backcountry tarnished with any more man-made structures. Leave it the way it is.

I am taking a half-day off today, which I haven't done for a while. As I eat lunch, several groups of mountain bikers ride up. It turns out that I share mutual acquaintances with several of them, and a couple more know me from my work with *Backpacker* magazine. The conversation winds its way through the usual outdoor range of topics until, at last, it lands firmly on what seems like a potentially delicate subject, given the company. Someone asks me, point blank, why hikers hate mountain bikers so much.

Morning light in tundra of Missouri Basin, Collegiate Peaks Wilderness

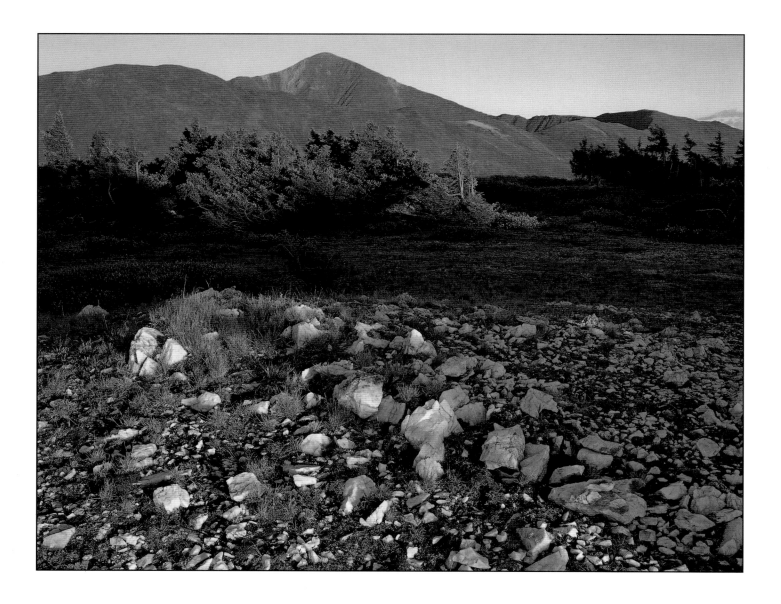

I go through the usual litany of how mountain bikers are, in the minds of many hikers, aggressive and discourteous. I relate how, though I have passed at least 500 mountain bikers on the trail thus far, only one has offered to yield the right of way to me, even though, stupid as it is, that's the protocol on national forest trails. I further state that even though mountain bikes do as much or more damage to trails than hikers, mountain bikers are notorious for not joining trail-building and maintenance crews. I have interviewed several groups — including the Friends of the Colorado Trail and Volunteers for Outdoor Colorado — and everyone has agreed that mountain bikers are underrepresented on volunteer trail crews.

As I sit above treeline surrounded by wildflowers in the Colorado noonday sun, my audience seems genuinely interested in my observations. I am very much enjoying our chitchat, as I really like lines of communication being opened, even on a small scale, among members of the various backcountry user groups. I would like to see harmony achieved, because the backcountry is no place for tension and anger.

Without warning, the conversation suddenly hits upon the subject of wilderness designation in Colorado. "We don't want our favorite riding areas designated as wilderness," says one biker, as I load my crossbow with poison-tipped darts.

This attitude, I have come to understand, is fairly widespread in fat tire circles, just as it is fairly widespread in off-road-recreational-vehicle and all-terrain-vehicle circles. This attitude looks at the Colorado backcountry as a workout/recreation facility with a view. It is a perspective I cannot readily abide by, and I point this out to these people as the main reason many backpackers dislike mountain bikers. Shortly thereafter, they take their leave, seemingly chagrined.

B Y 2 P.M. THE RAINS start. I crawl into my tent and read the afternoon away. At 7 p.m. it is still pouring. I go into the shelter to cook and eat dinner.

Philosophical arguments notwithstanding, it is mighty nice to have a shelter close at hand when rain is drenching the entire planet. This is one serious and long-lived deluge. For the first time, my tent says, "No *mas!*" The rain continues to

Falling sun colors quartz vein and 13,972-foot Mount Ouray, along the Continental Divide

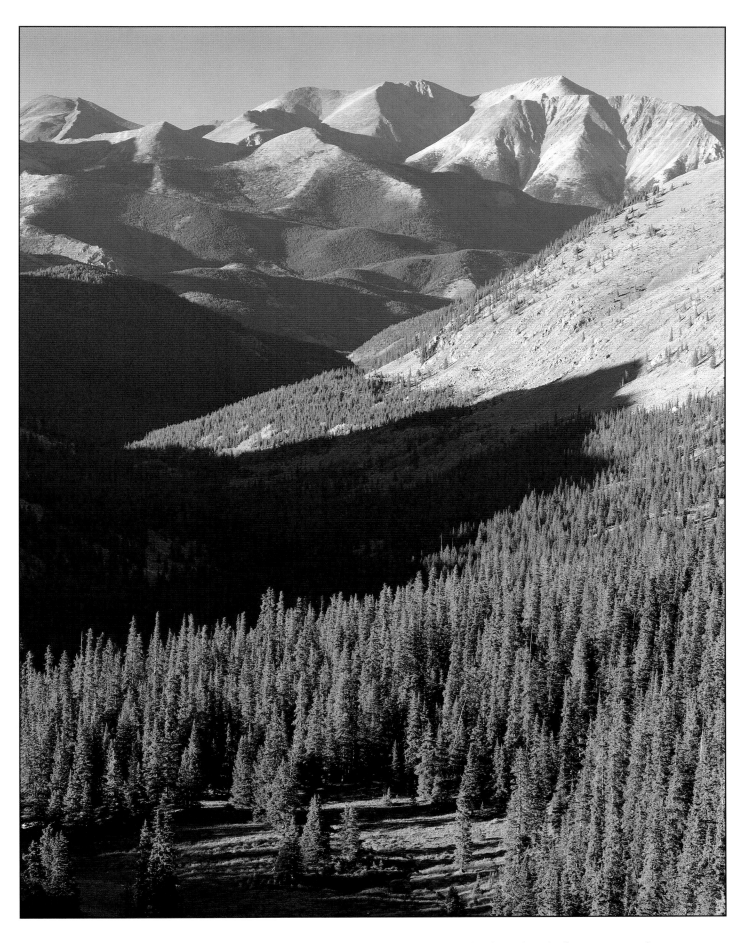

View of 14,155-foot Tabeguache and 14,225-foot Shavano peaks from head of Fooses Creek,
San Isabel National Forest

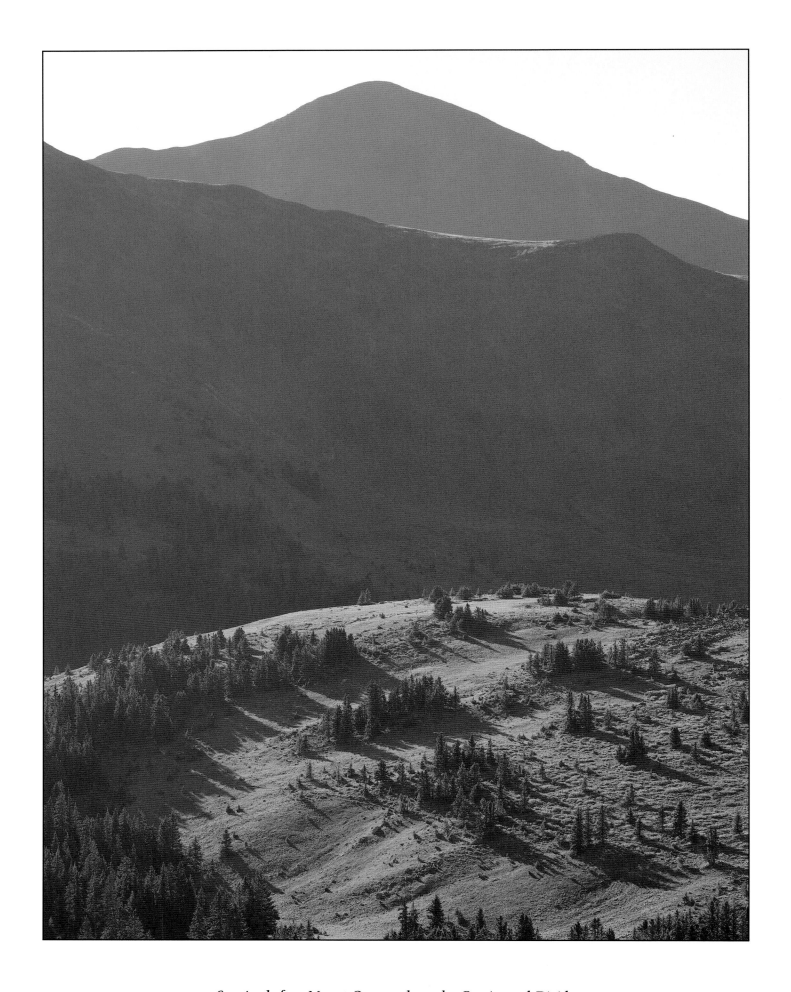

Sunrise before Mount Ouray, along the Continental Divide

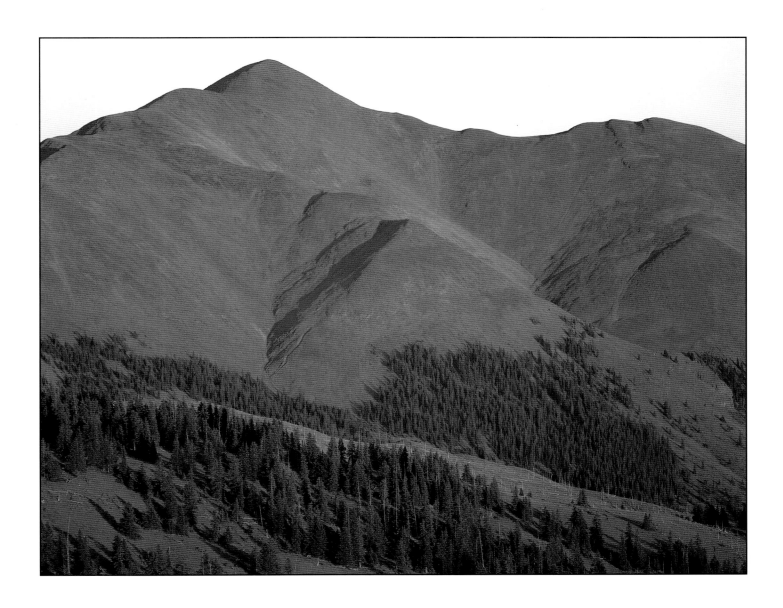

pour all night. I don't get soaked, but there are definitely a few wet spots on the tent floor when I awake.

As I hoist my pack the next morning, I hear and feel a loud POP. Mother of God, I think, my gosh-darned spine has popped out of its spine place. There is no pain at all, which certainly means every nerve ending in my entire body has been severed. I lower the pack gingerly to the ground and sit down, sweating, shaking. How far am I from rescue? How much do rescues cost? How can I keep this unfortunate incident from getting back to my friends in Summit County?

I run my hands up my back as best I can and feel nothing out of the ordinary. Then my eyes travel down to my pack, lying there limp in the mud. I notice that one of the shoulder straps is no longer attached to the frame. On the one hand, this is good news, insofar as I am no longer a medical emergency. On the other hand, this is a pain, as I can't quite envision hiking the four miles to Marshall Pass, let alone all the way to Durango, with a pack lacking one shoulder strap.

I compose myself and attempt several variations on the field repair theme, to no avail, except that I stick myself in the thumb with a leather punch.

I sit down and wait for the Swedish Bikini Team to come to the rescue. This is not the first time they have failed to materialize at a time when I could certainly use their help. I hoist the pack and play around with the approximately 1,900 other straps, most of which I have never figured out what they're for. I am surprised to find that I can't even tell now that my pack is broken. The shoulder straps on most packs these days actually connect to the pack at two points. My strap blew out at the point that carries a minimal amount of weight when the pack is on my back. The damage was actually done when I lifted it off the ground in such a way that every ounce of weight was focused on that one strap.

I hike the four miles downhill to Marshall Pass, where I know several dozen members of another CT Trek are camped. This is a completely different group than the one I passed in the Sawatch Range, but I met most of them when they hiked past the shelter yesterday.

CT Trek co-leader Lynn Mattingly arranges a ride for me down to the town of Saguache, where I call my wife and ask

Sunset reddens 13,269-foot Antora Peak, from Windy Peak, along the Continental Divide

Lodgepole pine trees in the Cochetopa Hills, Rio Grande National Forest

September's aspen trees decorate the Colorado Trail, Cochetopa Hills

her to bring my old pack with her to North Pass, which, at this point, is 47 miles away. Forty-seven miles through the Cochetopa Hills with a pack that could go any time. A multi-hundred-dollar pack, I might add, growling.

After the Sawatch Range, the Cochetopa Hills are fairly small in the topographic sense. And they are about as remote from Colorado's population centers as any place in the state. For these two reasons, this is the loneliest stretch of the CT. And for these reasons the CT Foundation has rightfully put its trail-making

Along the Colorado Trail, near Monarch Pass

and trail-marking emphasis on other, more heavily used sections. I hear from the CT Trek people that the stretch from Sargents Mesa to North Pass is poorly marked and hard to follow. They also tell me that earlier in the summer, even Gudy Gaskill got lost in the Cochetopa Hills.

I am excited by the route-finding challenge. Thus far the CT has been marked almost perfectly. From Denver to here, you would almost have to try to lose your way. I dust off my compass and set forth with guidebook in hand. Hiking along with my nose neck-deep in Randy Jacobs's detailed directions, I look like one of those crazy people who read while driving.

The key to directional success in the Cochetopa Hills lies in the fact that, by and large, the CT stays right on the Continental Divide. The trail follows an old logging road for several miles.

Then, as forewarned in the guidebook, comes the very first place on the CT where I have to follow directions closely, as there is no trail. I am instructed to walk 800 feet across a gravelly saddle, where I will then cross a faint trail heading down toward the drainage to the west. I am supposed to ignore this trail, cross it and ascend a small hill directly in front of me.

After hiking what I think is about 800 feet across what I think is a saddle gravelly enough to be the right one, I come upon a stretch of extremely high-quality though signless trail. A half-mile or so directly in front of me there is, indeed, a small hill that

I am excited by the route-finding challenge.

fits the guidebook's description perfectly. But because this trail is anything but "faint," I am faced with a multi-leveled dilemma. Did this new trail used to be faint? (Meaning I should cross it and proceed to the hilltop before me, as per the guidebook's instructions.) Or, is this a new stretch of CT that bypasses the small hill entirely? (Meaning I should follow it downhill.) Or, am I even in the right half of the state? (Meaning I should turn

in my compass and go home.)

No matter what choice I make, it will be wrong. The best I can hope for at this point is to not get too lost. I opt to take the new trail, which heads downhill into Long Branch, some 1,800 miles below. If I made the wrong choice here, I will have to hike back up to the Divide. After 30 or so minutes of going down, I throw in the towel and bushwhack up to the Divide, where, of course, the trail awaits. I feel *really* good about having gotten a little extra exercise.

This section of trail is where all the loose rocks in the world go on vacation. "Walking" is not how I would describe my efforts at perambulation. I slip, slide and stumble my way the remaining four miles to the Baldy Lake Trail. My ankles feel as though someone has spent the last two hours thumping them briskly with a two-pound hand maul.

The best I can hope for at this point is not to get too lost.

Baldy Lake is half-a-straight-downhill-mile off the trail. Ordinarily I don't like to go that much out of my way to find a campsite. But ridgetops are notoriously dry places and the Continental Divide through the Cochetopa Hills is no exception. Plus, I've heard from several people that Baldy Lake is one of the prettiest places on the entire trail. So I head down to what ends up being a heavenly spot.

The Cochetopa Hills are subtly attractive, by and large. There are plenty of pleasant views of the Gunnison Basin, but that's about where it ends — at "pleasant." Baldy Lake is the one exception. I've not been to the hills of Scotland, but this is how I picture them looking. The whole Baldy Lake area is surrounded by misty rock fields. To the south, the lake is framed by a picture-perfect cliff.

More fresh water!

Despite its remoteness, Baldy Lake is a popular fishing destination. From the looks of things, the people who come here to engage in a battle of wits with trout don't have the wits to take their trash home with them. Under most circumstances I carry

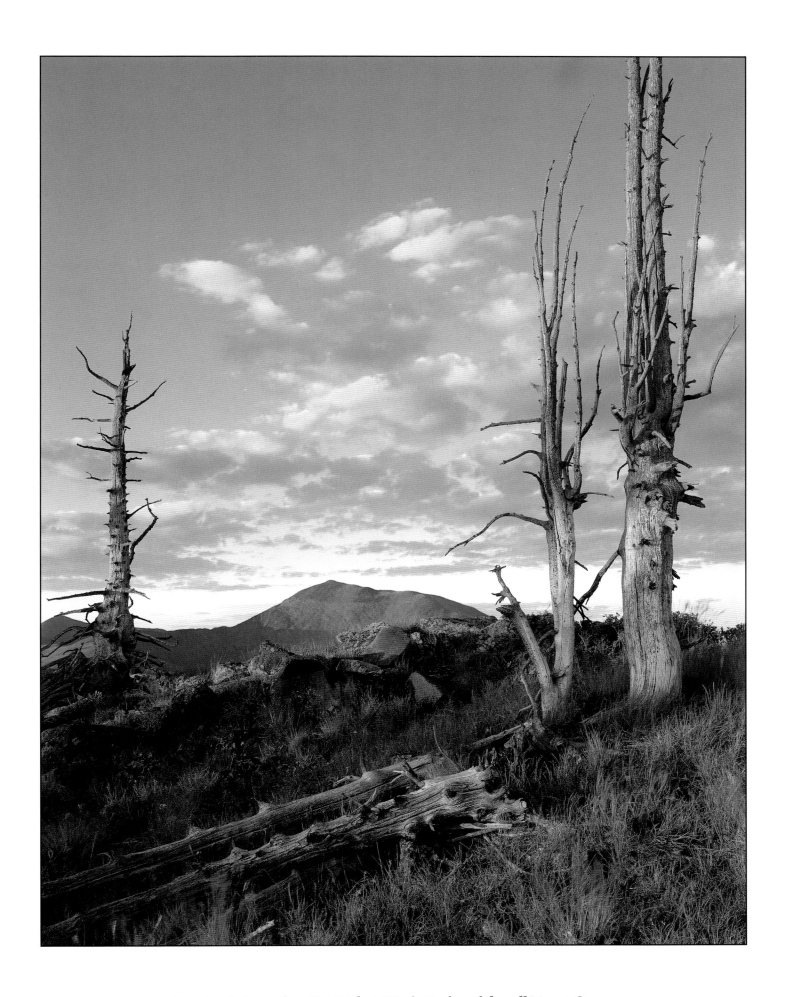

Evening light catches 11,885-foot Windy Peak and far-off Mount Ouray

out whatever garbage I find along the trail. In this case, I wouldn't know where to begin. For one thing, I would need a pickup truck.

I sleep rather fitfully, dreaming all night long about getting hopelessly lost. I hit the trail shortly after dawn, figuring that if I am going to spend the entire day trying to extricate myself from my inevitable directional miscues, then I better leave myself plenty of time before dark.

It is 14 miles to North Pass. Once again, I hike with my nose in the guidebook. So far, so good as I ascend Middle Baldy. So far, not so good as I descend the other side of Middle Baldy. Based upon my little side trip yesterday, I am paranoid about taking the wrong trail down to a place I don't want to be. I know that I want to pass through a place called Razor Park, so I take a compass bearing off the only park I can see in the direction I am supposed to be going. I start bushwhacking through the thick woods. There are so many downed trees that I am unable to stay on my directional track. And the woods are so dense, it is impossible to take another compass bearing. I feel a little panic beginning to rise.

Just as I decide I ought to backtrack to Middle Baldy, an apparition, in the form of another hiker, appears before me. Only it is no apparition. It is a Continental Divide Trail hiker going the opposite direction. I have walked right onto the trail.

One side of me is tempted to consider myself the baddest orienteer ever to tromp through the Colorado mountains. The side of me that doesn't dwell in a fantasy world knows exactly what has happened: First, of course, I messed up. All I had to do was continue hiking down Middle Baldy on the trail I was on all morning and I would have found the CT easily. After all, I learn later, there is a sign. I need not have bushwhacked at all. Secondly, I know I am one lucky guy. I could just as easily have found myself stumbling out of the woods in Albuquerque nine weeks from now on the verge of starvation.

The CDT hiker tells me the trail is well marked and easy all the way to North Pass.

Easy as pie.

Earth's shadow well before sunrise, near Marshall Pass, Gunnison National Forest

Baldy Lake, just below the Continental Divide, Gunnison National Forest
Overleaf: Southern Sawatch Range, from Windy Peak

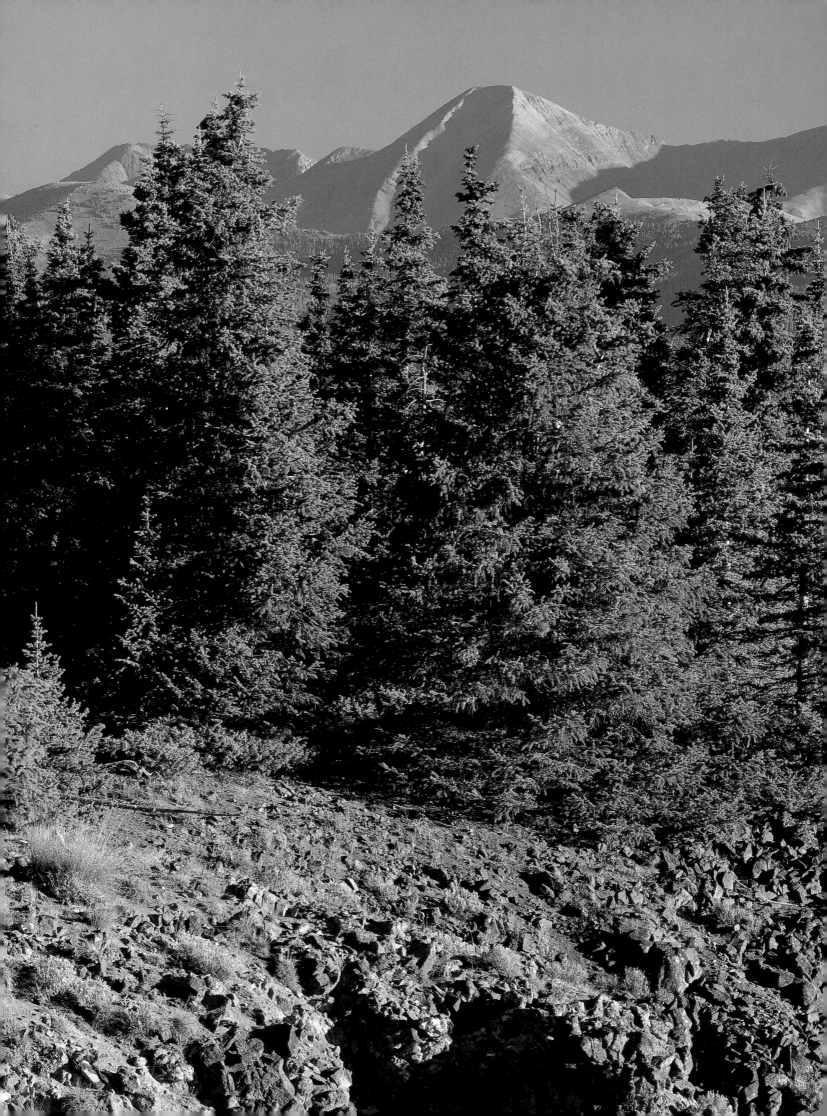

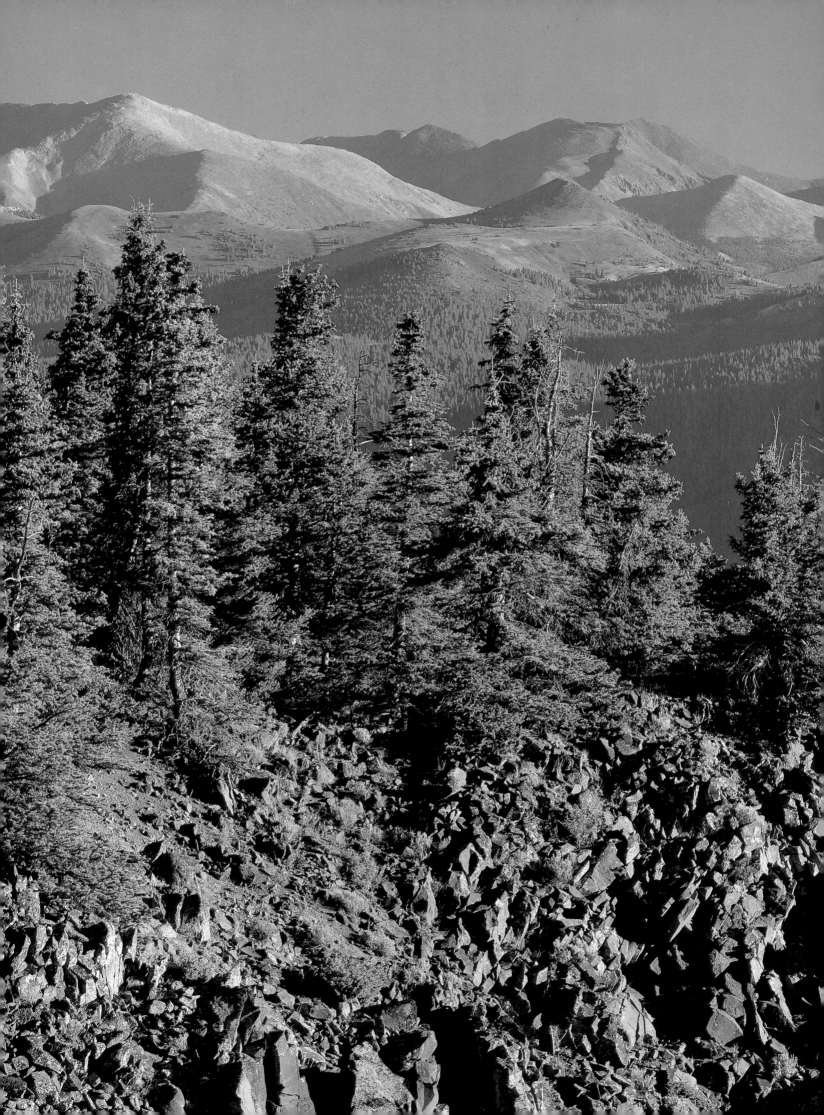

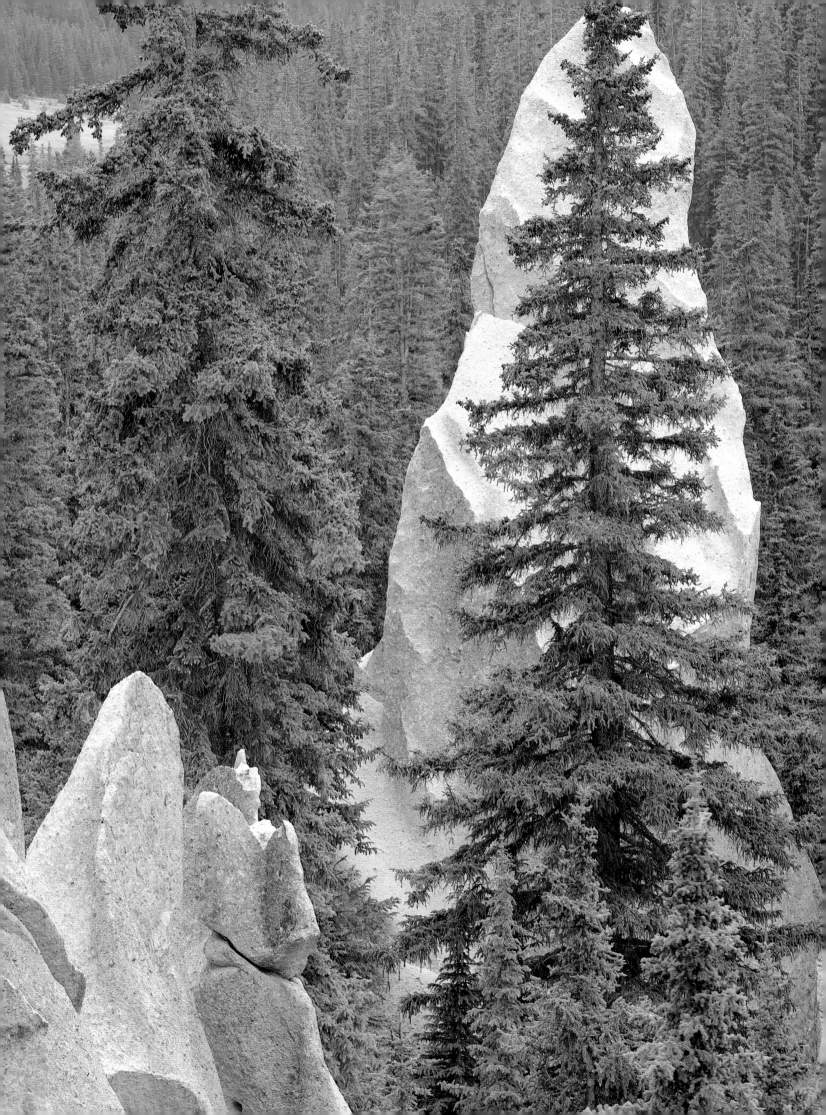

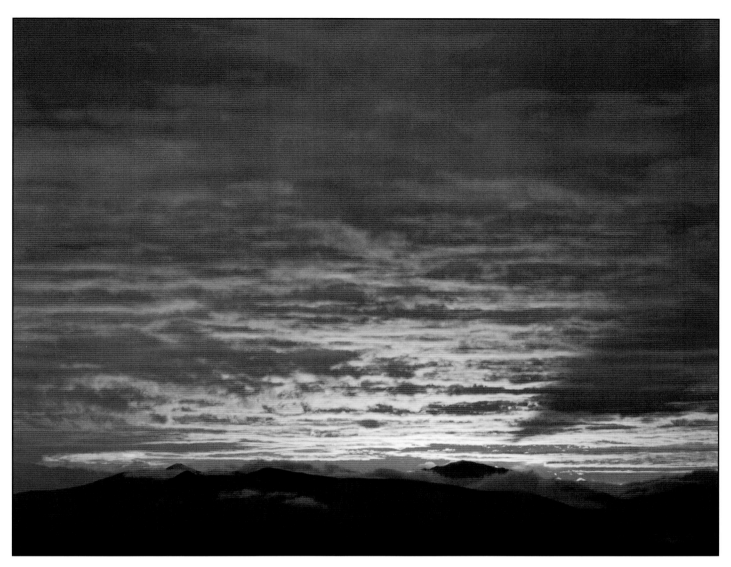

North Pass to Molas Pass

COLORADO TRAIL

I T HAS TAKEN 28 DAYS and almost 300 miles to reach the point where ahead of me lies *terra incognita*, a part of the state that is totally unfamiliar to me. I have lived in Colorado for almost nine years and have come to understand that, if nothing else, this is a mighty big state. Delaware it is not. My wife and I have traveled thousands of miles exploring every nook and cranny we possibly can, yet each year we seem to lose exploratory ground. The job of getting to know our home state is an excitingly endless task. The more places we visit, the more we learn there are to visit.

Gay dropped me off this morning at Lujan Creek just west of North Pass. We spent yesterday together, driving 30 miles into the little town of Saguache to do laundry and eat a couple of wonderfully greasy burritos. My parents-in-law came up from Cañon City to camp with us at Buffalo Pass Campground. All told, it has been a restful few days, and I am hitting the trail refreshed. Which is good, because my maps might as well say, at this point, "Here there be dragons." With the exception of

one short day-hike to Spring Creek Pass last summer, I have never stepped foot anywhere near the last 170-plus-or-minus miles of the CT.

At this point, I am in the best shape I have been in since I completed the Appalachian Trail in 1980, back when I was a young man. Having finished with the Sawatch Range and the Cochetopa Hills, I finally feel as though CT boot camp is over, just in time for the most majestic and wildest mountain range in the entire state: the San Juans.

There is, unfortunately, one distraction. I have a new pack on my back. Actually, I have a near-ancient pack on my back. In a way, it's great to be back on the trail with an old friend. The pack, an internal-frame Wilderness Experience Arête, has been with me in China, the Dominican Republic, Mexico and all over Central America. But it is small and not designed to carry the amount of gear needed in the Colorado High Country even in the dead of summer. My other pack, which is on its way to the shoulder strap infirmary, is able to accommodate all

Sunrise from 12,010-foot Jarosa Mesa, Gunnison National Forest

Left: Eroded volcanic ash formations at head of Oso Creek, Rio Grande National Forest

my gear, even my tent, with enough extra room for a complete set of encyclopedias.

With this pack, however, my tent and several pieces of clothing have to be strapped to the outside. I look like a backpacking version of Mr. Haney on "Green Acres." Already I have stopped at least five times to try different packing combinations. Not only is weight distribution a problem, but because this is an internal-frame pack, I have to arrange my gear so I'm not constantly getting poked in the spine by things such as my fuel bottle.

The next 35 or so miles — from North Pass through Saguache Park and up Cochetopa Creek toward San Luis Saddle — may very well be the easiest stretch of the entire trail. I should be sprinting, but because I have to stop every nine steps to deal with my pack, I'm making ridiculously slow time. Once again I'm in a parched part of the state and, par for my karmic course, I don't see so much as a single cloud.

Fielder camp at 12,460 feet, La Garita Wilderness

This stretch of the CT has only recently been marked. It follows a series of jeep tracks for almost every one of those 35 miles. If I had remembered to pack my truck, I could be driving along instead of hiking. The biggest climb I face today and tomorrow is a couple hundred feet in elevation gain. Today I plan on hiking only 10 miles to Los Creek, as I got a very late start. Gay and I tarried over breakfast with her parents.

I arrive at 1 p.m. in the blazing heat of midday and decide immediately to hike on. Los Creek is actually a very nice place, but there is absolutely no shade and the biting flies are working overtime to make my life miserable.

Saguache Park resembles a high-desert version of the world above treeline. It is a huge, undulating park with rippling heat waves and views at least 10 miles in every direction. I've never seen anyplace quite like it. The hiking is still almost unbelievably easy. But I'm getting drained from the direct sun and the heat. After looking at my map, I decide to stop for the night at either Ant Creek or Sunshine Creek.

Sunshine Creek turns out to be appropriately enough named, as it offers about all the sunshine a person could possibly want in a creek. It is, sad to say, a little lacking in the creek department. It is as dry as my sun-scorched forehead. So it's off to Ant Creek, another mile away. Plenty of ants. No creek.

After 16 miles on the trail, *desperation* is still too strong a word for my emotional state. It will definitely not be too strong, I decide as I drink the last of my water, if I get to Van Tassel Gulch, a mile and a half farther on, and find another stream

sans moisture. After Van Tassel Gulch it's almost four miles more to Cochetopa Creek, which I know has a flow. But I'm not really in the mood for a 21-mile day, despite the ease of the terrain. My overburdened pack is beginning to feel like a medieval torture device.

As the trail descends into Van Tassel Gulch, I can see that there is indeed a trickle: what appears to be a mid-gulch spring is flowing a few feet into a small, scummy-looking stock pond. This is exactly why I carry the most effective water purification device money can buy. Hurriedly I drop my pack in the middle of a huge meadow and run over to begin the bothersome process of purifying several liters of water.

Even though the flow at Van Tassel Gulch looks a tad strange from the sidelines, it is some of the clearest water I have come across so far. But clarity of water is absolutely no indication of anything save, well, clarity of water. I am frequently amazed at the amount of ignorance that remains in the backcountry regarding drinking water. The focal point of this ignorance is a protozoa called *Giardia lamblia*. Just in the past decade or so has giardia become a hot topic on the backcountry scene. No one I have talked with knows whether this is because it has spread wildly in that time or because of increased efficiency in diagnosis.

Giardia is spread by contaminated warm-blooded creatures such as cattle, elk, deer and beaver. Any place these animals dwell, which in the Colorado mountains pretty well covers every place, water should be treated as highly suspect. It doesn't matter whether water is clear, or passes over sand or rock, or goes underground for whatever distance. All backcountry water these days must be boiled, iodinated or filtered. The only exception is a spring and, even then, water should be taken directly from the outflow rather than from a pool below the spring.

I have heard people say, "I've never had any problems with wilderness water in the past" or "I don't have to worry because I have a strong stomach." What both of these statements translate to is, "I have been very lucky — so far." Luck or strong constitution aside, anyone who drinks water contaminated with giardia will regret not having taken proper precautions.

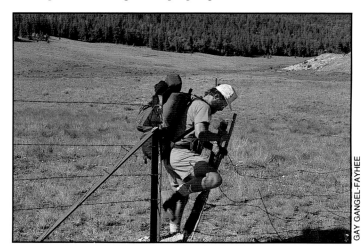

M. John Fayhee in the Cochetopa Hills

I set up my tent right where I dropped my pack — in the middle of an exposed expanse of dry grass. Despite the fact that there is a ranch house only a few miles away, this place feels very lonely. I like lonely places and I like being alone in them.

Friends and strangers alike have asked me many times if I am afraid to be out in the mountains by myself for such long periods of time. Though the response implies more bravado than I care to imply, I always answer, fairly bemusedly, "No."

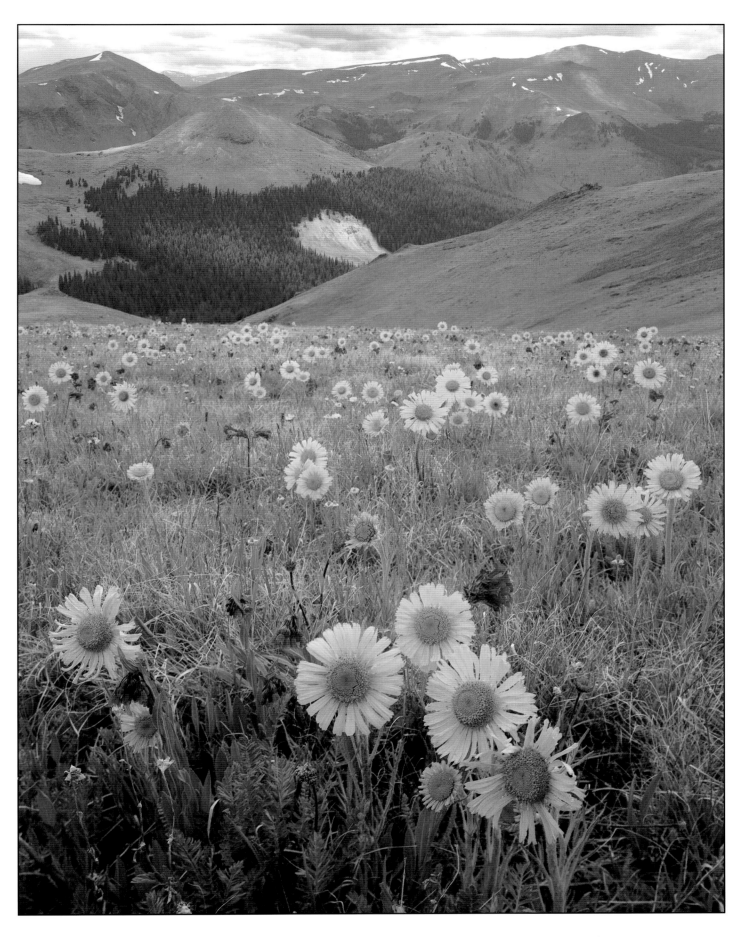

Alpine sunflowers (rydbergia) at 12,460 feet, below San Luis Peak, La Garita Wilderness

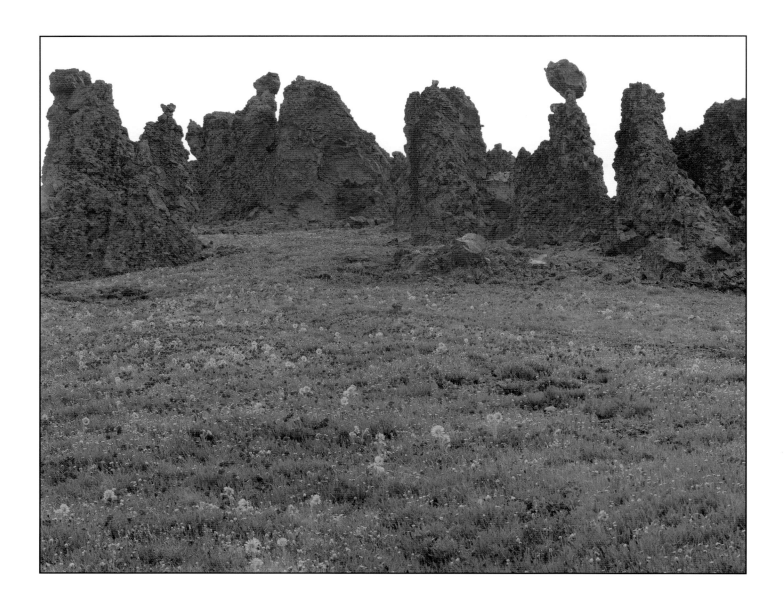

I am certainly aware and cautious enough while out in the woods, but I also try to be aware and cautious even when I'm with 12 other people. If I were afraid to be out in the wilderness by myself, I would not venture forth without company. It's that simple.

I've been asked about this fear thing enough over the years that I've actually given it some thought. There are two variations on this afraid-to-be-alone-in-the-woods theme. The first is the medical emergency part, wherein people such as my wife are concerned that I will slip and break my ankle miles from nowhere with no one around to run for help, or that I will get hit by lightning, or that my stove will explode in my face.

Of course, these are proper things to fret about when your husband's off on the CT by his lonesome. But I, the husband-in-question, do not spend much time worrying about these sorts of scenarios. I'm experienced and have enough confidence in myself that I won't get hurt.

The second variation on this fear theme, and the thing that I believe is on most people's minds when they bring up the subject, concerns the anxiety of lying in a tent utterly alone in the silent night.

In a long career of camping alone, only once have I had trouble sleeping because I was scared. My college roommate, who was working on a paper about vampire legends, had left about 20 books about Dracula and his ilk lying around on the kitchen table for a month. My skeptical self checked most of these books out. In detail. Shortly thereafter I was camping alone, without a tent, in the New Mexico boondocks during a full moon. Just before dark a bat, of all things, started circling my camp. It continued to circle for hours. With my neck tucked carefully under my sleeping bag, I lay there most of the night, my eyes wide with fear.

The fact that that sleepless night in the woods was a unique case does not mean that I haven't come awake fast plenty of times in the middle of a new-moon night, wondering what on earth was running by my tent. Nonetheless, wilderness is where I feel most at ease. It's where I sleep the best. It's in cities that I lie awake all night, wondering if that creaking noise I think I hear is someone named Vito creeping through my living room.

It is dusk now. As I lie in my tent reading, I really most sincerely hear a strange noise several hundred yards away. It sounds like a combination of a bark and a loud grunt. I fumble

Eroded volcanic formations along the Continental Divide, La Garita Wilderness

Ancient pine trees above Stewart Creek, La Garita Wilderness

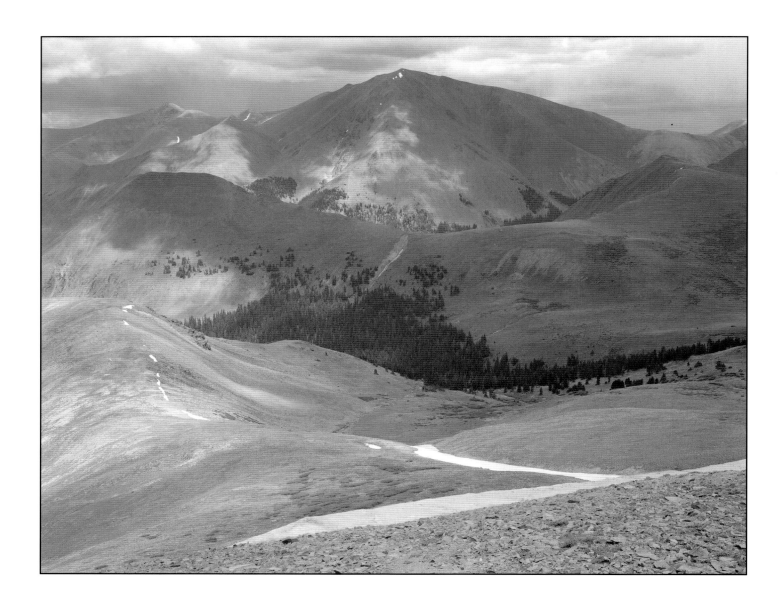

for my glasses and poke my head out to investigate. In the encroaching darkness I see a lone bull elk giving me the hairy eyeball.

Since leaving Denver, I have had a very strong feeling that I will enjoy at least one intense wildlife viewing opportunity while on this trail. Near Top of the World Campground I saw a coyote. Near Mount Princeton Hot Springs I ended up following a porcupine down the trail. I've also seen several mule deer, and now this elk. But ever since Waterton Canyon, the "inner me," whatever that is, has been saying to prepare for something bigger.

Right now, famed grizzly bear researcher Doug Peacock is out in the San Juans trying to track down rumors that the grizzly still lives in these parts. I would go to the grave a happy man if I could lay eyes on a grizzly in Colorado, where they've supposedly been extinct for many years.

I don't know why — maybe it's because I smell bad, or because I have a tendency to talk to myself while hiking, or because I simply don't pay enough attention — but I have never been a very fortunate or successful wildlife viewer. This is not to say that I have never laid eyes on anything more interesting

than a chipmunk or a river rat. I have seen plenty of critters, including, but not limited to, bison, moose, black bear, monkeys and poisonous snakes. But almost without exception, if I saw it, so did the rest of mankind.

All this, I suspect, is about to change.

It is 10 a.m. I am hiking along at a four-mile-per-hour pace alongside Cochetopa Creek, which the CT follows for more than 18 miles. This is, just like yesterday, some very easy walking. It is a beautiful morning, with nary a cloud to be seen. I'll hike another 17 or so miles today. By afternoon I'll be in the La Garita Wilderness on the fringe of the San Juans.

I DON'T KNOW WHY I looked up, because there was no noise at all, just a predatory tension in the air. And there it was: not only a mountain lion, but the mother of all mountain lions. Waist-high, it was dashing from one willow patch to another, about 35 yards to the right of the trail. Its size came as something of a high-adrenaline surprise, at least when viewed from the perspective of something that

View of 14,014-foot San Luis Peak from head of Cascade Creek, La Garita Wilderness

resides in the food chain.

What really stunned me was how fast this magnificent animal was moving. It was like bipbipbip, she was here, then there, then long gone up the side of the far bank, into the aspen. My heart jumped clear up through my throat, exited my mouth and ran screaming away. It was the most dramatic moment I have ever experienced in the outdoors. I was literally shaking with a strange combination of fright and well-being. In that one fraction of a second, my entire CT trek was validated.

Also in that one fraction of a second, my brain instinctively went through the very useful litany of things I am "supposed" to do — and not do — when I suddenly find myself toe-to-toe with something that very well may be disposed — to say nothing of able — to catch me, kill me and eat me.

I "know," for instance, that I am definitely not supposed to run, even if a cat the size of a Honda Civic charges me.

And I "know" I am supposed to yell loudly, which would happen anyhow, whether I am supposed to or not.

And I "know" I am supposed to raise and spread my arms so I look bigger, which, in theory, makes the cat think it shouldn't tangle with me because, after all, I might actually be a buffalo that just happens to be wearing a backpack and glasses. I have always been concerned, however, that this attempt to look bigger might accomplish nothing more than to get a cat to thinking, "Oh boy, more to eat."

Today marks the first time I have ever seen a big cat at close range in the wild. Over the years, it has been my greatest hope to have such an encounter. In that time I've seen plenty of bear and even had a couple of close calls with them. I have seen the mountain lion's close relative, the Central American puma, in zoos. And I once saw several hunters dancing exuberantly over the carcass of a mountain lion that minutes before had been shot and killed.

I cannot imagine, by the way, what kind of person would kill a large cat and I cannot believe that lion hunting is still legal in this predator-poor part of the world. However, I understand on all levels, including the most visceral, that mountain lions are perfectly capable, in both prowess and disposition, of killing humans. Witness the teenager who was killed near Idaho Springs in 1990 by a 90-pound female lion.

Sunrise, La Garita Wilderness

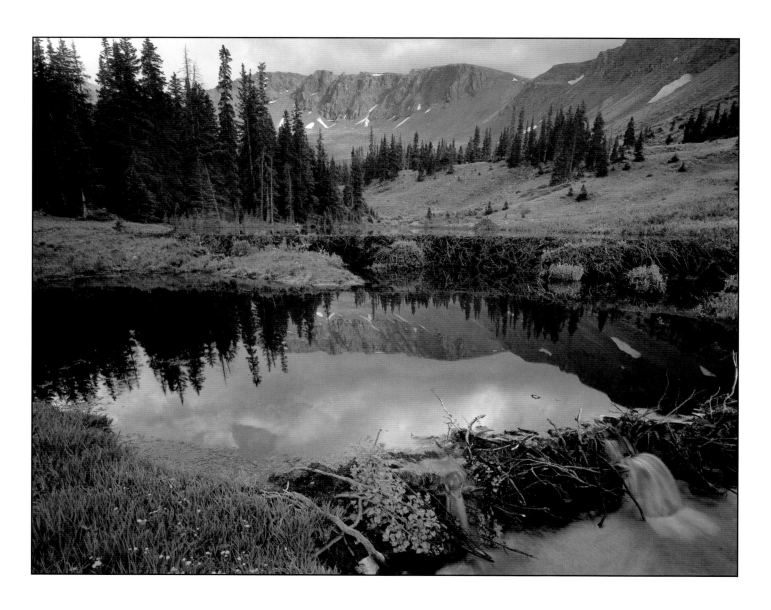

I also understand, as well I should, that when confronted by man, lions almost always turn and make tracks in the opposite direction. Which is exactly what happened today.

Will this incident change my response when people ask if I'm afraid to be out in the woods by myself? No, it won't. Not by a long shot. What this incident has done is remind me why we should fight to have more wilderness areas set aside — places where lions and wolves and bears can dwell in peace. I am reminded why I come to the wilderness: to rub elbows with that which serves as the root of both the word and the concept of *wilderness*.

I set up camp right inside the La Garita Wilderness. After dinner, I take a short pre-bed stroll up the trail. I am surrounded by the peaks of the La Garita Mountains, which are part of the San Juans. Cochetopa Creek is full of beaver ponds, and I am lucky enough to spend half an hour watching a beaver working on its dam. This little workaholic proceeds to spend the entire time swimming back and forth, building its home and further flooding the stream banks.

I hit the sack and sleep soundly. Tomorrow I begin my ascent into Colorado's version of Nirvana. The literal and figurative high point of the CT is upon me, and I am finally upon it.

I T HAS BEEN MY INTENTION since I started planning this hike to climb 14,014-foot San Luis Peak. As the CT tops out at San Luis Saddle at the head of Cochetopa Creek, it's less than two miles to the summit. I make the saddle by 10 a.m., but the weather is not cooperating. Usually when I climb a fourteener, I like to be on my way down by this time. With a heavy heart, I decide not to risk it. I have never been alone atop a fourteener, an experience I was looking forward to mightily.

At this moment I am standing in the prettiest spot I have ever seen. I don't mean to indicate that the earlier parts of the CT are anything but splendid. But the San Juans are in a league by themselves. Covering an area of more than 10,000 square miles with an average elevation over 11,000 feet, this part of the state is home to the mountain gods, Colorado style.

Many people make the mistake of lumping all of Colorado's mountains together, believing that they all basically look the same. Nothing could be further from the truth. Most of Colorado's mountain ranges are very different geologically from one other. Each of our major ranges — San Juan, Sawatch, Gore, Elk, Sangre de Cristo, Front — has its own unique lineage, topography and personality.

Beaver ponds on East Mineral Creek, La Garita Wilderness

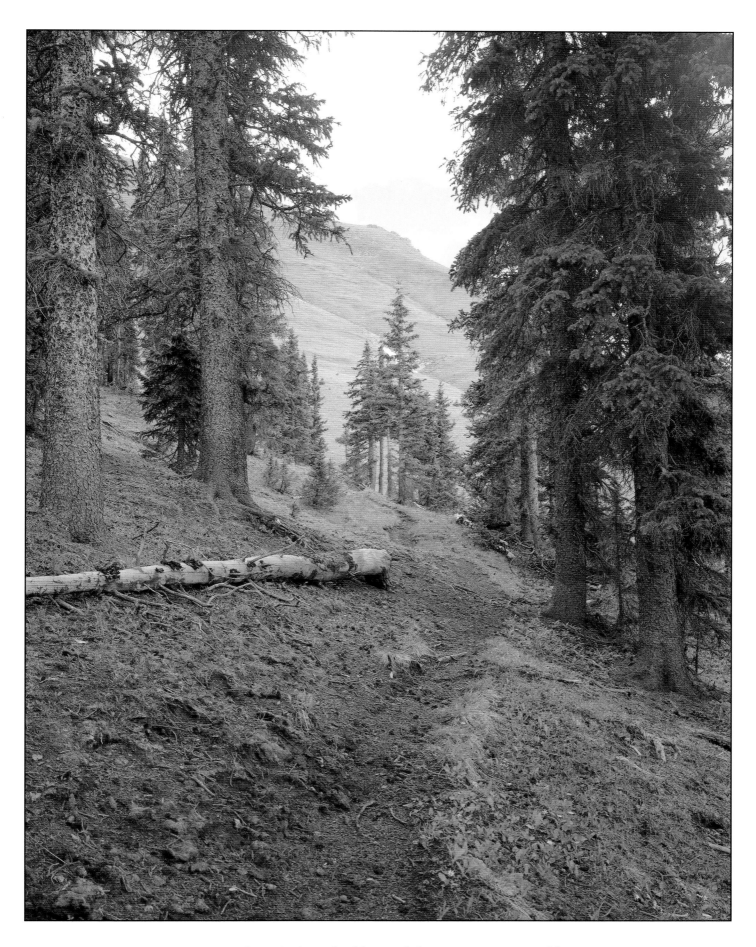

Colorado Trail winds through old-growth forests, La Garita Wilderness
Overleaf: Frozen August pond beside East Mineral Creek, La Garita Wilderness

The San Juans are the youngest mountain range in the state, and they are rough. There is no symmetry here. No predictability. Only extreme ruggedness. And extreme beauty. In less than one day, I feel at home. My wife is quick to point out that I am not the world's biggest fan of subtlety, much to her chagrin. I like directness and extremeness in movies, literature, people and places.

By noon I have camp set up at the headwaters of Spring Creek. Today I hiked only eight miles. I plan to continue at this leisurely pace for the remainder of the trail. This is contrary to my nature, as I tend to get bored if I get to camp too early. Here though, I want time to simply sit back and savor the San Juans.

Today I am doing just that. After a brief but intense above-treeline storm, the clouds have passed. I sit in the high-altitude sun, reading John McPhee's *Coming into the Country*. Though the book is about Alaska, a place I've not visited, it seems applicable to Colorado. *Coming into the Country* deals with the kind of person who is attracted to wild places, and the effect wild places have on this type of person.

I am interrupted by the sound of a rock slide on the cliff face just east of me. I stand and concentrate on where the noise came from. Silence. Ten minutes later, another slide. I focus, looking for any movement. Nothing. Finally, I see them: a herd of eight bighorn sheep, moving across a fantastically steep talus slope. Several babies are among them. In the height of summer, life to young sheep must be one long play period. They bound with reckless abandon from boulder to boulder, from promontory to ledge. I hold my breath each time they jump. I've heard that, every once in a good while, a young sheep makes a major misjudgment and falls to its death. With a nod of the head to natural selection, I hope this doesn't happen while I'm watching.

The herd soon passes out of sight. Just before dusk, though, it returns, passing by in the other direction, still jumping in the gathering darkness.

I crawl into the tent and immediately find myself dealing with a considerably less glamorous wildlife problem: seems I must have put my pack down on an anthill when I got here. When I put the pack in my tent, several hundred ants came in with it. They've been partying in my food bag ever since. The last thing I expected was to find ants at 11,500 feet. I spend 30 minutes earning a fearsome place in ant mythology.

E VEN THOUGH THE TRAIL is playing the roller coaster game again, today is the best hiking day of my life. It is so wonderful that I walk along giggling and not quite believing what a cool place this is.

I spend almost every minute today above treeline. The views are constantly stupendous — in all directions at once. I have been to only a few other places in my life that boast an amount of sensory input that comes even close to that which dwells in the San Juans. This is the mountain version of the Grand Canyon. No matter which way I face, there is something not only beautiful, but uniquely beautiful. It may be the long view out toward the Black Canyon. Or it may be a flower-covered meadow, a babbling snowfield-fed stream, a talus slope, a cliff face, a rock spire, a grove of ancient bristlecone pines, a herd of sheep or elk, or the simple elegance of a marmot arguing with a pika.

By midafternoon the weather is souring, but even this seems

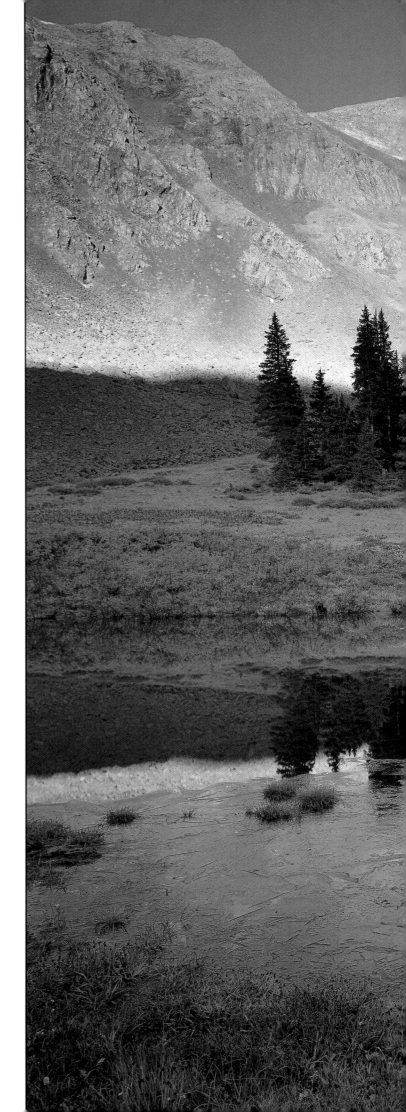

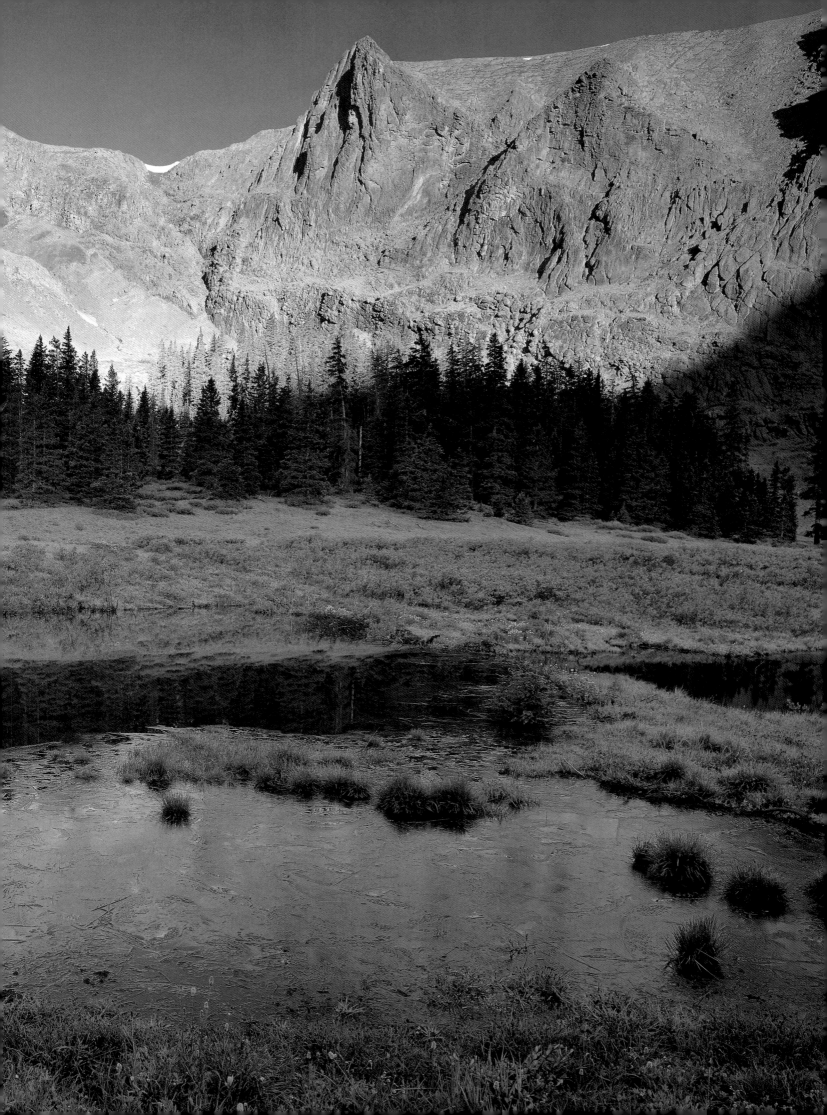

more beautiful than anything I have ever seen. Beauty aside, I am faced with a choice. I can risk my life by heading out onto the moorish, treeless and highly exposed expanse of Snow Mesa, where my tent would play a dual role of shelter and lightning rod, or I can sidetrack a mile or so off the trail to a small lake at the head of West Mineral Creek.

Because it's only eight miles from here to Spring Creek Pass, from where I'll hitchhike 17 miles into Lake City for a food drop tomorrow, it doesn't really matter whether I stop here for the night. I'll make it to Spring Creek Pass early either way. I can see a shepherd's tent near the small lake. A little company tonight wouldn't be bad, so I decide to head over.

The shepherd is chopping wood in front of his tent when I walk up. I ask where he is from. He answers, Tepic, Mexico, a town I have visited several times. His name is Nabor and, when he learns I speak Spanish, he becomes the happiest man in the mountains. For the next five or six hours, we chat in Spanish about every single subject in the world.

Nabor, who works for a man out of Montrose, has been coming to Colorado to work — legally, I might add — for six years. He stays from March till December, then heads home

with his earnings. His dad died 10 years ago, and he supports his mother and six siblings back in Mexico. He is in his early 20s and is not yet married. Nabor does, however, have a *novia* — a girlfriend — named Maria. He shows me her picture and tells me he misses her very much. I show him a picture of Gay and say that I, likewise, miss her very much.

Though Maria is only 16, Nabor may ask for her hand this winter. The man he works for, whom Nabor tactfully describes as *un poco viejo* — a little old — has decided to retire from the sheep-growing business. Nabor is confident he will be able to get another job lined up for next season before he returns home for the winter, but when you grow up in the poverty of Mexico, you understand that nothing in this life is certain, save death. And he wants to make certain he has a job before he asks Maria to marry him.

Nabor cooks dinner for us both: mutton, beef, potatoes and bread. He says he loves his work, especially compared to his employment options in Mexico. In his opinion, the San Juans are the most beautiful mountains on earth. "*Muy tranquilo*" is how he describes living here above treeline — with two dogs, two horses and 2,200 sheep for company. He gets weekly resup-

Eroded volcanic ash formation below Snow Mesa, Rio Grande National Forest

84

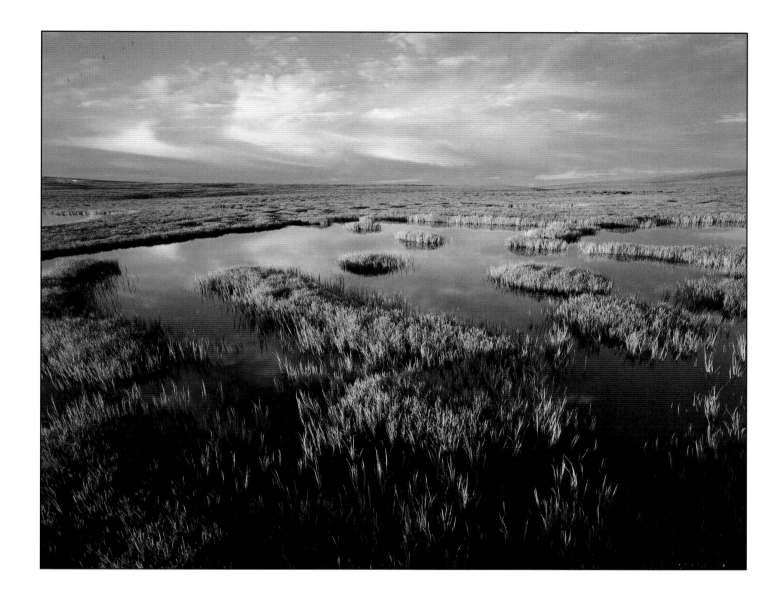

ply visits from his employer, and every so often, hikers stop by to visit. Nabor also has a radio, and at eight sharp each night he can tune in a station from Juarez.

Nabor dozes off on his cot with the mountain wind blowing outside his canvas tent. The familiar strains of mariachi music play on through the night. I can't help but wonder if I wouldn't mind working as a shepherd.

At night the sheep huddle close to Nabor's tent. Before dusk they are noisy, though Nabor tells me they will stop bleating when it gets dark. Because coyotes follow and sometimes attack the herd, sheep are genetically programmed to understand that silence is a good nighttime survival tactic.

By the time I hit the trail, the sheep herd has already crossed the ridge to begin its day's grazing. I hike back up to the CT and shortly run head-on into all 2,200 sheep. They've cut me off at the pass, and I have to wade through an ocean of wool. Last night I thought about modifying my views about grazing on public lands. Sitting there drinking coffee with Nabor, the whole setup seemed so pastoral I was tempted to ask what harm a couple thousand sheep could possibly do to the environment, especially when there is a Maria waiting patiently back in Old

Mexico for her man, who would not have employment without his boss being able to use national forest lands to graze his herd.

I regain my senses as I hike along through sheep-fouled mud. It really bothers me to have to deal with livestock in the wilderness. I could live, as I already live, with grazing on public lands if legally designated wilderness areas were off-limits to cattle and sheep. Grazing, sad to say, is one of the few extractive uses allowed within wilderness boundaries under the 1964 Wilderness Act.

There has been a lot of recent debate in Congress about raising grazing fees significantly enough that, according to the Colorado Cattleman's Association, a high percentage of the state's ranchers would be forced out of business. The result would be a *de facto* elimination of grazing on most of our public lands.

Needless to say, this is a very emotional issue in the Rockies. If grazing fees are raised fourfold, as has been proposed, then much of rural Colorado would economically wither up and blow away. Even though there is very little debate that grazing has a negative environmental impact, I don't know if I'm ready to see the entire Western Slope of Colorado become one huge string of ghost towns.

Sunrise on 12,295-foot Snow Mesa, Rio Grande National Forest

I AM A LITTLE PREOCCUPIED as I make my way across Snow Mesa, which is one of the most unusual places in the state. The mesa is comprised of 20 or so square miles of near-perfect flatness at an elevation of 12,000 feet. There is no trail, only trail markers. From the mesa, the summits of two of Colorado's most dramatic fourteeners, Wetterhorn and Uncompahgre, are easily visible.

The walking is easy and I let my mind wander. All through this hike, which is quickly winding down, I have been on a fast track to health and well-being. I have stepped off that fast track for a day here and there, but by and large, I am at the point where, if I could feel the way I do now for the rest of my life, I would be quite pleased with myself. As would my wife.

I understand that this is impossible. Under no real-life scenario that I have been able to come up with in the last month could I possibly manage six or eight hours of hard daily exercise. And there's no way to fabricate the kind of deprivation that comes with being out in the woods for 44 days. When I make my return to Grim Reality, I will do so with an opportunity I haven't had in years. That opportunity is centered on the fact that I no longer need to fight inertia to change my ways. My ways have changed. Of course, they have been changed by default. There is no way to hike the CT and not lose weight, get in shape and become more focused, relaxed and aware.

This afternoon I'll enter Lake City, one of the nicest little towns in the state. I'm here a day early. My friends Greg Wright and Tara Flanagan are coming with my food drop late Friday — the day after tomorrow — which means I have three days off in one of the most fun towns in Colorado. I hope I spend these days wisely. Failing that, I hope I do not spend them too unwisely.

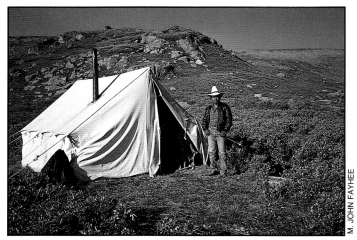

Sheepherder's camp, Jarosa Mesa

THIS PART OF THE CT is where hikers begin to understand that their re-entry into civilization is near. Only about 115 miles remain. The guidebook says this is the section for "extremes" and "lasts." Between Spring Creek and Molas passes, hikers cross the CT's high point at Coney Summit. They make the trail's only potentially dangerous river crossing when they ford the Rio Grande. And they ascend the Continental Divide for the last time above Elk Creek.

Greg and Tara, a husband and wife who live in Red Cliff, have been close friends of mine for years. They are also textbook-case workaholics. Tara is a writer and Greg is an artist. For years, I have tried to make them understand that people gravitate to these professions so they can have more time off. Somehow they have managed to get it all wrong. This is the first weekend they've taken off all summer.

We drive to Spring Creek Pass and hit the trail by the crack of 10:30 a.m. Blame the delicious biscuits and gravy at the Lake City Cafe for our tardiness. Hitting the trail this late may very well have negative consequences. So far on this trip, I have yet to actually hike in a downpour. I've set up my tent a few times just as the rains have hit and I've walked for a few minutes through a light sprinkle or two. But I've not had to don my rain gear while hiking. This will assuredly change today.

Photographer's shadow and circular rainbow

The storm begins to move in as we cross Jarosa Mesa. There is electricity in the air. To the north we see two elk herds pass, each so large it is like a brown cloud moving across the landscape. We estimate there are 200 elk in each herd.

We're getting very worried about the weather, as Jarosa Mesa is as exposed as any part of the CT. When lightning starts to crack around us, we drop our packs and dive for cover. Except there is no cover. We end up lying on the ground under several foot-high willows, getting drenched by the cold rain. Tara can feel static electricity all around us. This is not good and may be even bad. To add insult to discomfort, we look totally ridiculous. We sincerely hope no one else hikes by right now.

At the first slight letup in the rain, we dash for a grove of trees, where we build a small fire. I don't think anyone is even close to hypothermia, but we're all pretty cold. When the rain abates, we make a run for it. We have only about a mile more before Big Buck Creek, where we plan on camping.

It turns out to be a great campsite. Even though it rains off and on for the rest of the night, we are well protected. We collect firewood and manage to dry out pretty well. The weather is not cooperating, but it's still great to share an evening around the campfire with two old friends.

And there's no way to fabricate the kind of deprivation that comes with being out in the woods for 44 days.

The next morning, Greg and Tara take their leave. They have to get back to work, and I have a date with Coney Summit.

"With an average elevation in excess of 12,000 feet," the CT guidebook informs me, "this segment has the distinction of being the loftiest single portion of the CT." Easy to believe. About a mile past Big Buck Creek, the trail crosses treeline. From the looks of things up ahead, it will be quite some time before the trail returns to the trees.

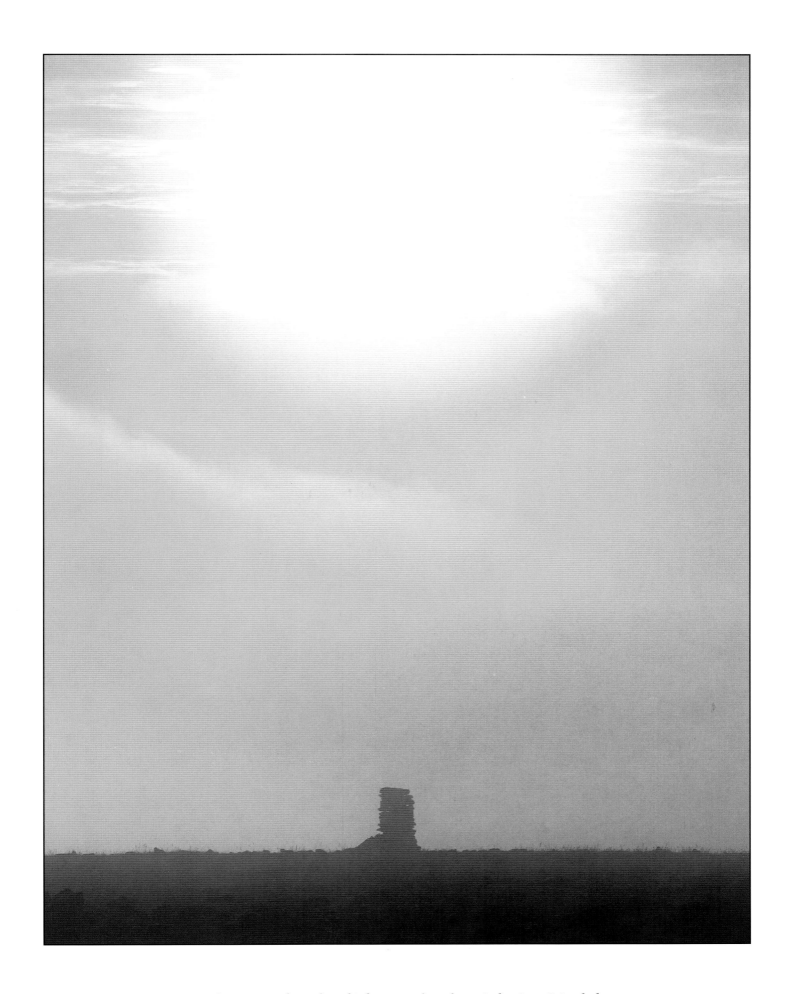

Rock cairn trail marker, high on tundra above Lake San Cristobal

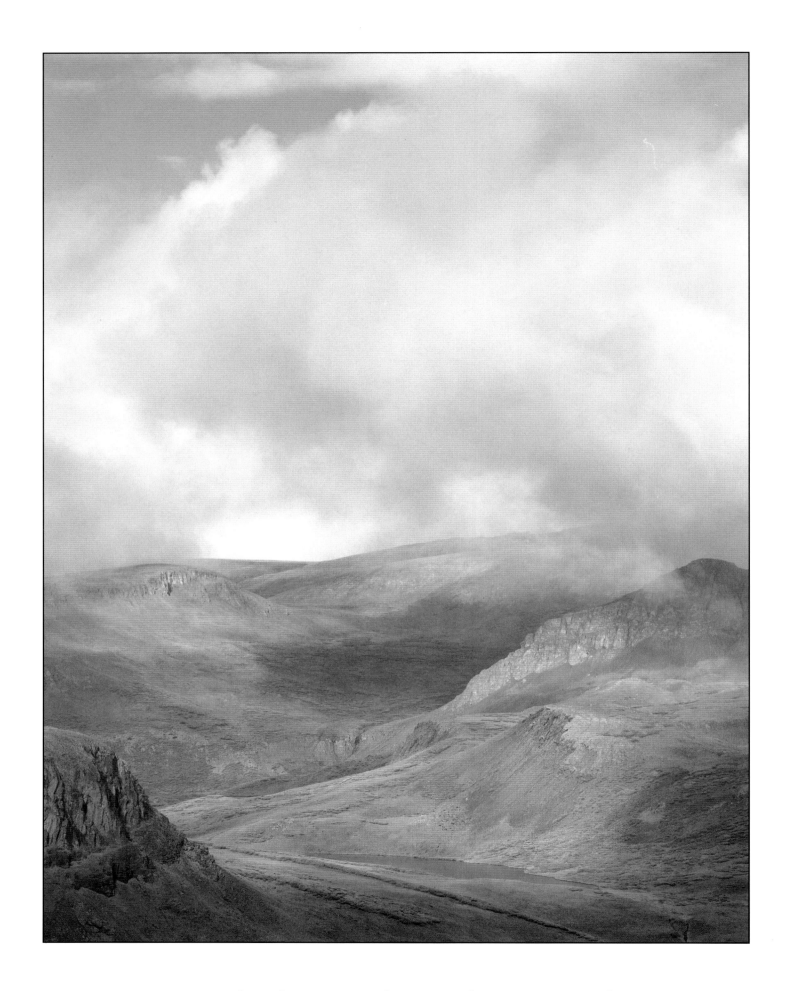

Morning storm clears above Cataract Lake at 12,080 feet, Gunnison National Forest

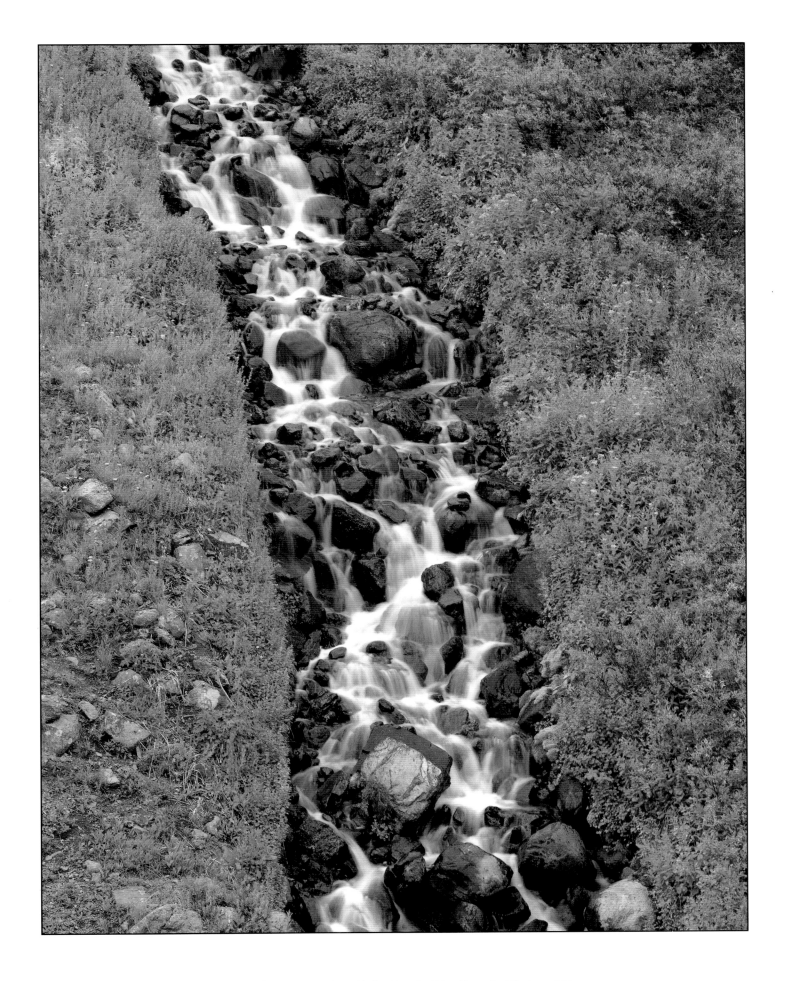

Steep cascade empties into Pole Creek, Rio Grande National Forest

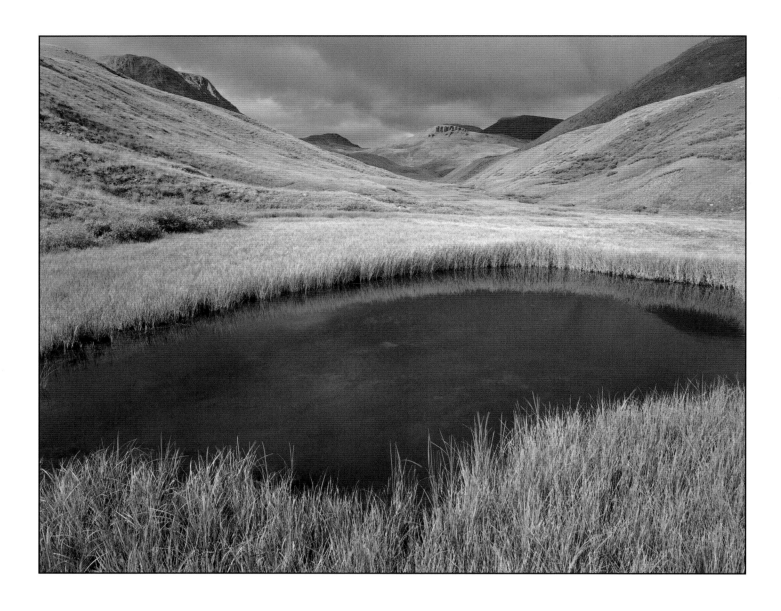

At 13,334 feet, Coney Summit is not only the CT's high point, it is the CT's high point by at least 200 feet. My only question is, which of the myriad cone-shaped hills before me is Coney? From here, they all look alike. I realize it may seem a little odd to call something over 13,000 feet tall a "hill," but given that I'm already standing at about 13,000 feet, that's exactly what they are.

There is no trail here for the most part, only CT markers driven into the ground. In places, there are rock cairns. The problem with following cairns is that several old stock driveways crisscross the CT through the San Juans, and these driveways are usually marked with cairns. I really have to be on my toes, direction-wise.

As foolish as this sounds, I'm starting to get a feeling for the CT or, better stated, for the philosophy of the people who designed the CT. What this means is that when I have to stop to scan the horizon for a trail marker, as I have about nine times so far this morning, I find myself having a pretty good idea where my search should begin.

I meet up with two hikers from Tucson who are out for a week. They are arguing over which way the trail goes. I point out the top of a marker — about 100 yards away and just barely visible from behind a drop-off — and tell them that, without a doubt, it's a CT marker. They dispute my claim. The male of the couple tells me with absolute certainty that a huge rock cairn, located in the exact opposite direction of the CT marker, is "definitely it, man." He further tells me that he's spent an awful lot of time hiking.

I shrug and head on up the next hill. An hour later I look back and see the couple heading my direction.

For three straight climbs now, I've felt certain that "this must be Coney." Each time I was wrong. *This time*, though, I am *sure* I am right. I follow a set of small cairns heading east. After making my way around the hill, I find myself facing yet another hill that, judging from the shape, looks like it could be named Coney. A well-traveled dirt road heads steeply downhill to the right. There are no CT markers to be seen. I know I have to descend to the right sooner or later. But is this the place? There's nothing worse than going down, only to find that I need to go right back up because I made a bad decision. What to do?

Pond and storm clouds along Pole Creek, Rio Grande National Forest

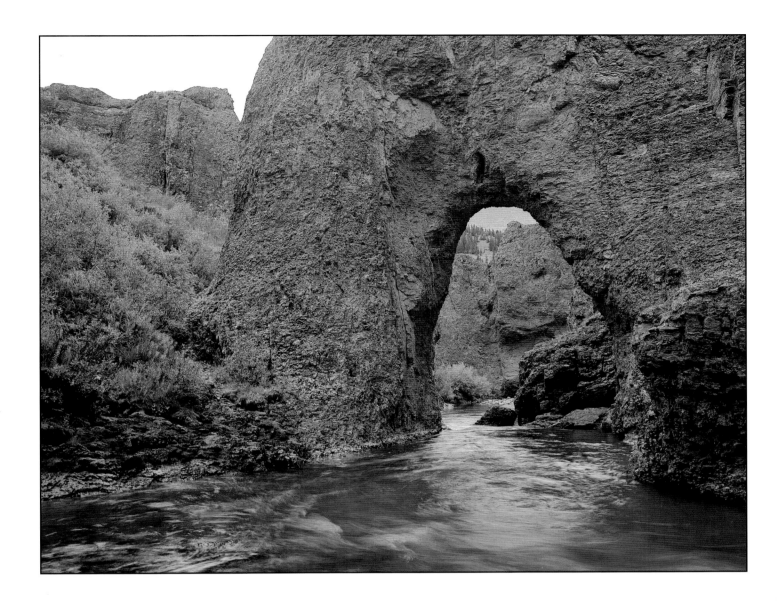

Suddenly I am joined by a half-dozen dirt bikers, who have just ridden up the hill that maybe I should be hiking down. This is the very definition of humiliation, to have to ask directions from a bunch of dirt bikers. While taking aikido several years ago, I was told many times that an extra dose of humility would do me good. I ask these people if they happened to pass any Colorado Trail markers on their way up. They did not. They did, however, pass a couple who said they were hiking the CT.

I sprint down the hill, which is so steep I can scarcely keep my footing, acting like I knew all along where I was going.

The couple, who hail from the small town of Pitkin, Colorado, are halfway up the hill, huffing and puffing. They are the first Durango-to-Denver hikers I have met. We don't talk long because the weather is once again turning ugly, and they want to make Big Buck Creek by nightfall. I still have nine more miles to go myself.

My plan is to hike up Lost Trail Creek and cross the Continental Divide once again, before heading down the Pole Creek drainage to Cataract Lake. By the time I enter the Lost Trail Creek drainage, I know I won't be heading above treeline again today. The weather simply looks too nasty. I set up my tent in a great spot right next to the trail. My water source is a little side stream 100 feet away.

When the storm hits at about 2 p.m., I lazily tuck in for what I think will be a nice nap, but ends up being a three-hour trek through the bowels of Deep Fear. I've been in and around a few lightning storms in my time, but nothing like this. I stop counting the number of flashes when I reach 100. No exaggeration. At least 20 times I hear the sharp crack of thunder before the flash is gone.

When the rain finally stops, I sheepishly stick my head out of the tent for a little reconnoitering, expecting to see mayhem and destruction all around me. I don't have my glasses on, but even old eyes such as mine can see, down in the valley below, the prettiest rainbow in the history of the world. It looks as though it is actually lying on the ground. Hurriedly I pull out my camera. Of course, I have but one frame left on the roll of film. I snap the shot and search frantically for another roll. By the time I reload, the rainbow is but a memory. But what a great memory.

One of only two natural bridges in Colorado, formed in eroded volcanic flows along Pole Creek

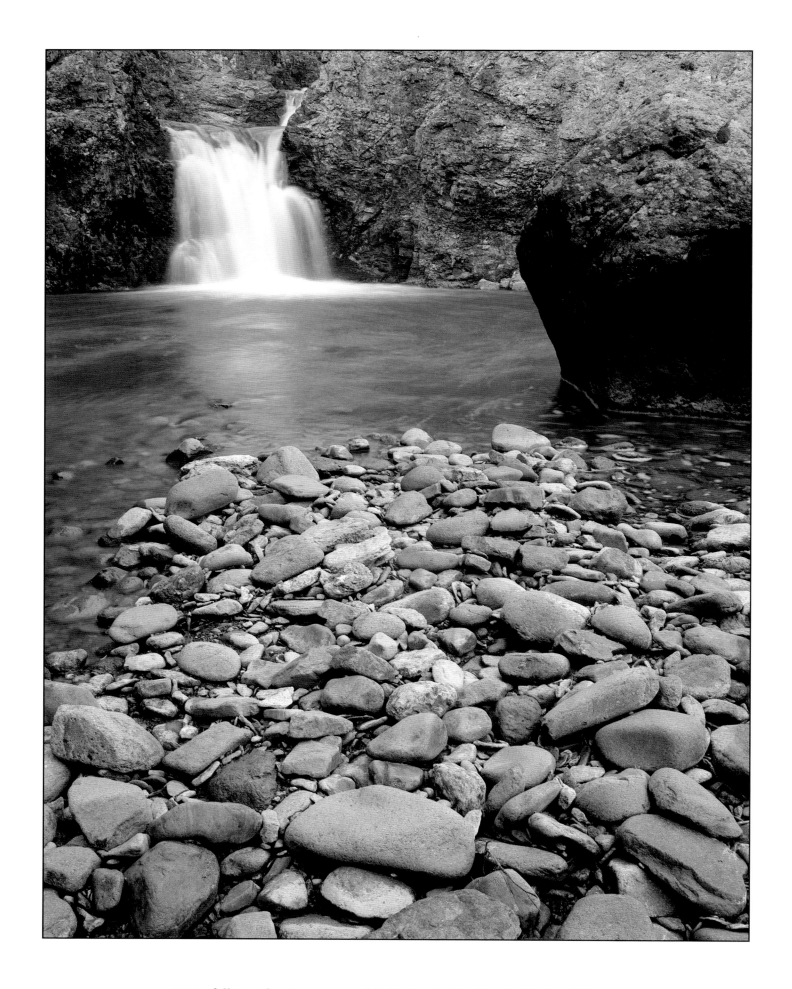

Waterfall in volcanic canyons of Pole Creek, Rio Grande National Forest

SOONER OR LATER, when out in the woods hiking by yourself for miles and miles and weeks and weeks, you naturally start running out of interesting things to think about. You've already solved most of the world's major problems, decided how to make a million bucks, pretty much given up on making contact with the Swedish Bikini Team, and pretty well convinced yourself that you're going nuts babbling on to yourself like this. Out of the process of elimination, if nothing else, you end up, somewhere along the line, thinking about religious things, matters of great theological import.

Today was my day for these kinds of thoughts. I can easily sum up my religious beliefs heretofore: I have never disbelieved in anything. At the same time, I have not actively believed in anything. But I have always felt spiritual in many ways and have always respected people whose beliefs are more specific than mine. Today I determined for myself, once and for all, that there is a God. Unfortunately, I also determined that God entertains himself by toying with the psyches of individual CT hikers, namely me. This is not something I hold against God, mind you. As a matter of fact, if I were suddenly invested with divine powers, I would certainly amuse myself by picking out somebody

like me and causing him a little grief once in a good while.

Yesterday, God realized that I was almost done with the CT and that he had not tinkered with me a single time. Can't have that, now, can we?

I was camped, once again, in one of the most beautiful spots I have ever seen. This time it was the Beartown site, between the Rio Grande and the Continental Divide. Although Beartown was a rowdy mining town back in the 1880s, there's really not much to it now, except a few cabin remains and, of all things, a picnic table beside the jeep track that the CT has followed since crossing the Rio Grande.

I had just hiked 18 miles, arriving at Beartown in the middle of one of the few sunny afternoons I had seen in weeks. A Boy Scout troop was already there. Even though I was once the senior patrol leader of what was, at the time, the largest rural troop in the country and, even though I am in most ways a big supporter of Scouts and Scouting, I do not usually go out of my way to camp in the midst of groups of teenagers, Scouts or not. The older I get, the more age-chauvinistic I become, and these days the cutoff point of my tolerance level seems to be somewhere around age 25.

Elephant head wildflowers in San Juan Mountain showers, along the Continental Divide in the Weminuche Wilderness

Overleaf: Wildflowers above Elk Creek, Weminuche Wilderness

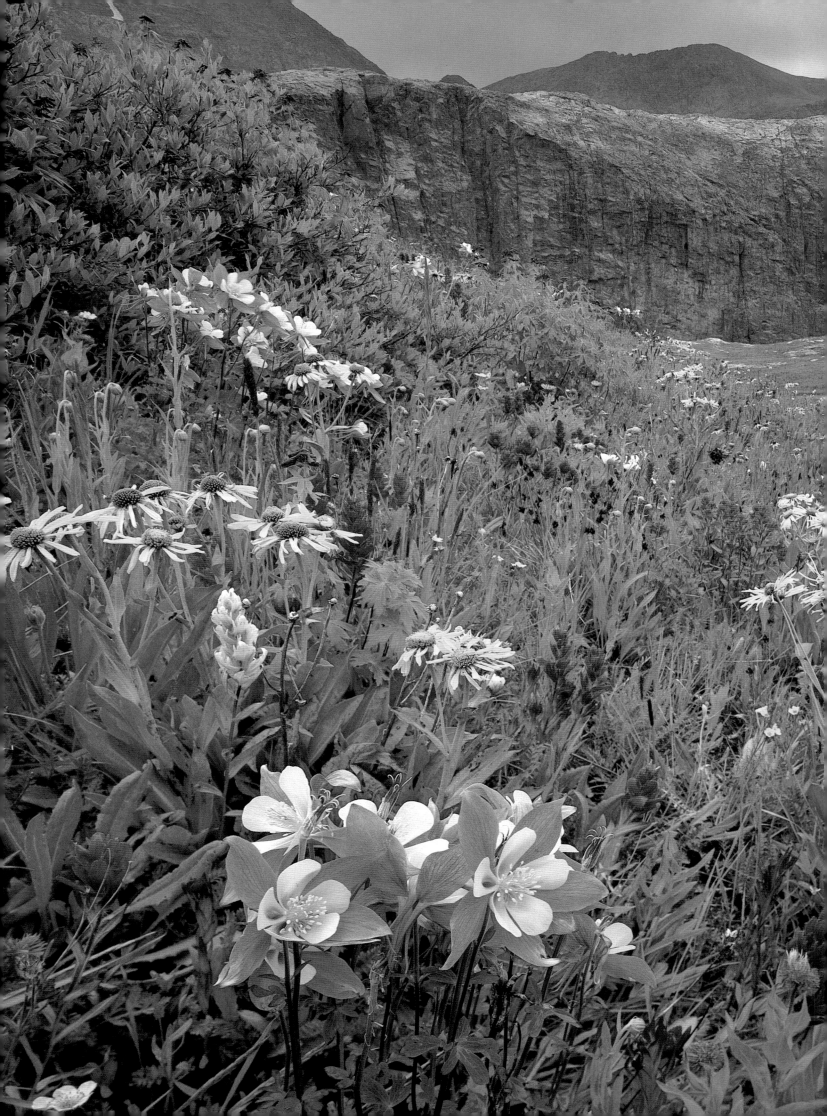

But I was tired and didn't feel like hiking any more. So I camped with seven Scouts and four Scoutmasters, part of a troop from Fort Collins. They were on the second day of a week-long hike from Elk Park — where I would be camping the next day — up through the heart of the huge Weminuche Wilderness to Vallecito Reservoir.

As I looked at the top-of-the-line gear these people were carrying, I got to thinking about my own Scouting roots. Scouting is what got me involved in hiking and camping in the first place. I joined not just to go camping, but to go on a specific camping trip. Our troop overnighted at the side of a highway, near the beginning of the 13-mile Wa-La-Ha Trail near Frankfort, Kentucky, where my family lived at the time. It was my first non-backyard camping trip.

A week or so before, my parents had bought me my first camping gear from — where else? — the local Army-Navy surplus store. My pack, which still smelled like World War II, was faded green and about the size of a wallet. In it went my new "mess kit," which I always thought was a good name, considering what we cooked in it.

My sleeping bag was one of those flannel numbers with renderings of pheasants and elk on the inside. When rolled up, it maintained the diameter of a 55-gallon drum. It weighed 200 pounds and, despite its bulk, would not have kept an Eskimo warm on a beach in Barbados. And it didn't carry very well when tied to the outside of my diminutive pack.

Our troop consisted mainly of poor farm boys whose parents either could not afford or could not justify buying sleeping bags even as nonfunctional as mine. Since our trip took place in the middle of winter, at least half the troop brought two blankets, as per *Boy Scout Handbook* instructions. They folded them in the intricate "heat saving" manner explained in patient detail over the course of several pages, which were placed, if I remember correctly, right before the chapter describing how to treat people for hypothermia.

We all ended up spending the night — with teeth chattering — telling ghost stories around the campfire, which, by midnight, was as large as Mile High Stadium.

The next day we completed the Wa-La-Ha Trail, which, come to find out, followed paved roads for its entire length. We had a great time, and I've been hooked ever since not only on the out-of-doors, but on the camping experience in nearabouts all its manifestations. Camping is as much a part of me as my name.

None of the Scouts at Beartown were wearing uniforms, they seemed to know all about the backcountry, they didn't pray before every meal — as my old troop used to have to do — and they never ever repeated the Scout Oath while I was present. All told, a decent enough troop to camp next to.

Plus, they were suitably and dutifully impressed with my backpacking prowess. It's amazing how quickly I can come to tolerate — even like — those few people in the world who think I have my act together on whatever level.

I told these boys numerous times that, yes, I am indeed the baddest hombre ever to trek through the hills and, if they started now and practiced hard and often, they, too, could one day in the far-off future be just like me.

This is the part of the conversation that woke God up. It snowed most of the night.

I awoke to one of the prettiest scenes I have ever seen. All of the surrounding mountains, and there were many, were winter

white. I was feelin' good and energetic, and I hit the trail with a spring in my stride at about 10 a.m.

It was less than three miles uphill to the Continental Divide. From there it was eight miles, all downhill, to Elk Park. All told, a very easy day. This is about when God really started giggling.

M. John Fayhee at sunrise

Within an hour I started thinking that something was Badly Wrong. According to my maps, I was supposed to ascend to the Divide, then, after taking about one step, begin a descent so steep it would give me a nosebleed.

But I was not descending. I was positive I had already reached the Divide, yet I was continuing to stay up high, at almost 13,000 feet. I had not seen a CT marker in years. I was definitely following a well-defined trail that was well-marked with rock cairns. It just didn't feel like the *right* trail, which is something I generally consider fairly important.

A storm moved in fast from several directions at once. Soon the clouds were down to waist-level. Lightning cracked all around me. Hail, rain and snow began a competition to see which could get me the wettest and most miserable. For the next three miles I hiked at a pace that only an in-shape and scared-stiff backpacker can hike.

All told, a very easy day. This is when God really started giggling.

At last I overcame my stubbornness, turned around and hiked back, figuring I had simply blown by a CT sign somewhere. I couldn't find anything that even resembled a trail junction. So I re-hiked the three miles I had just re-hiked. Visibility was about two inches. This was fast getting ridiculous.

Finally, I had to admit to myself that I was off-the-map lost for the first time in my life, right at the time when I thought I had the CT figured out. I sat down and laughed. It's awfully hard to find your way back onto a map when you can't even see far enough to focus on your compass, much less take a bearing.

Just then, two good ol' boys from Silverton rode out of the mist on horseback. I asked — sort of casually, as though I was barely interested — whether they had seen any Colorado Trail markers recently. They looked at me like I was so dumb I must be from back East somewhere. I was at least two miles from where I needed to be, they told me, off in a direction 90 degrees from anything I would have guessed. Half grinning, half shaking their heads, the horsemen moved on.

Within half an hour I was descending into Elk Creek at a place I should have passed at least three hours earlier. The weather started clearing, now that God was done with me. I was so wet I had to strip completely beside the trail — there was nowhere else to stand — and wring out every single garment I was wearing. Of course, the exact instant all my clothes were off, another Boy Scout troop happened by, this one 35-strong and from Texas, going the opposite direction.

THE HEADWATER AREA of Elk Creek is, far and away, the *crème de la crème* of the CT. This is the waterfall capital of Colorado. There are literally dozens of falls, some of them hundreds of feet high. There's even one spectacular double fall.

This is also the busiest stretch of trail I have hiked in some weeks. Several miles down, where Elk Creek flows into the Animas River, is the route of the famous Durango & Silverton Narrow Gauge Railroad. The train stops at Elk Park, essentially in the middle of nowhere, and lets hikers on and off. I pass more than 50 people going the opposite direction. This is fairly amusing, as this part of the CT is one of the longest, hardest climbs in the state, except for people hiking the direction I'm going. Then it's eight miles and 3,500 vertical feet down to the Animas. Every single person I pass looks like death warmed over, sort of like how I must have looked 400 miles back, when I first cruised out of Denver.

How can I let them know . . . that I have just finished hiking 23 miles . . . ?

I arrive at Elk Park a few moments before the day's last train passes by. It is overflowing with tourists, every single one of whom seems to have a video camera. They are crawling all over each other to get footage of a genuine hiker, who, at this moment, is resting peaceably against a tree.

At once, everyone begins yelling for me to jump up and start hiking, so they can film me. How can I let them know, without offending anyone, that I have just finished hiking 23 miles, at least 12 of which qualify me for membership in the idiot-of-the-month club? How can I make them understand that I am not a prop hired by the railroad to enhance the ambience of their journey?

When I refuse to shoulder my pack, several tourists implore me to at least wave. Which I gladly do, because it doesn't require standing up.

They don't even throw me any money.

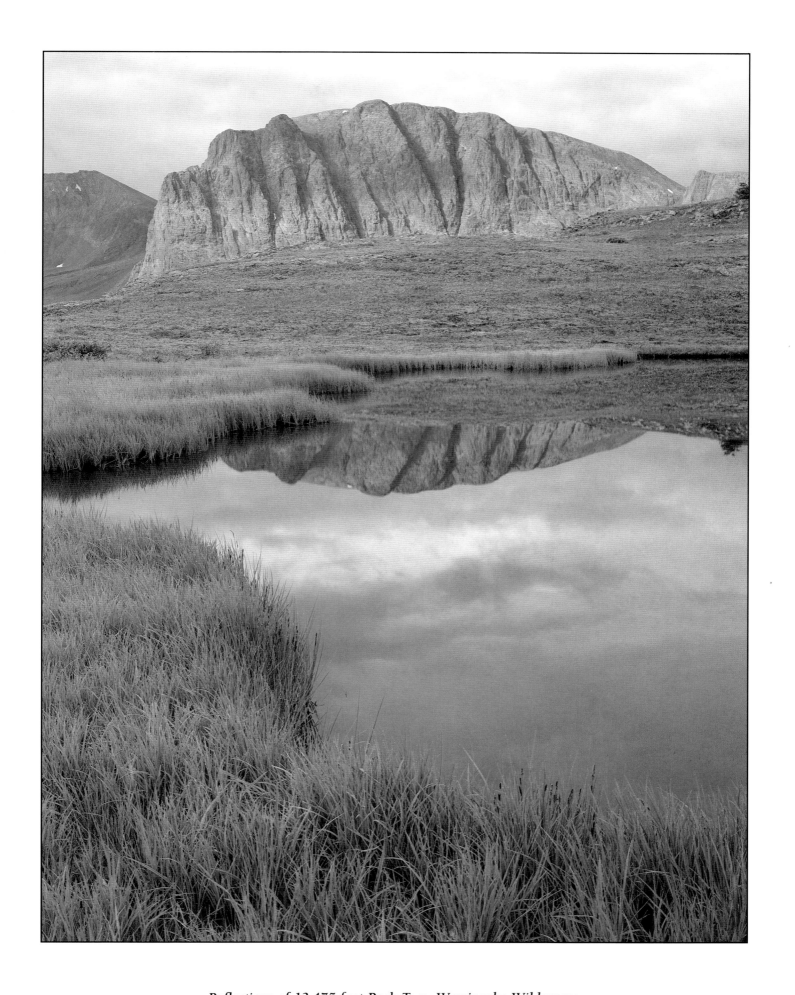

Reflections of 13,475-foot Peak Two, Weminuche Wilderness

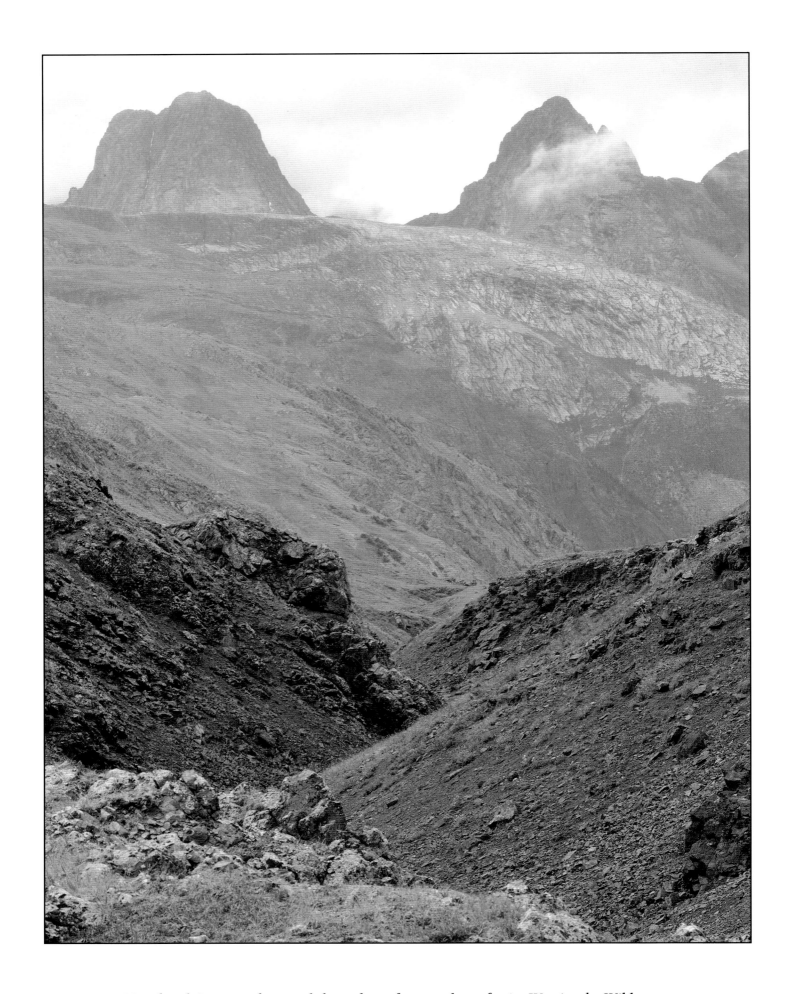

Vestal and Arrow peaks reveal themselves after two days of rain, Weminuche Wilderness

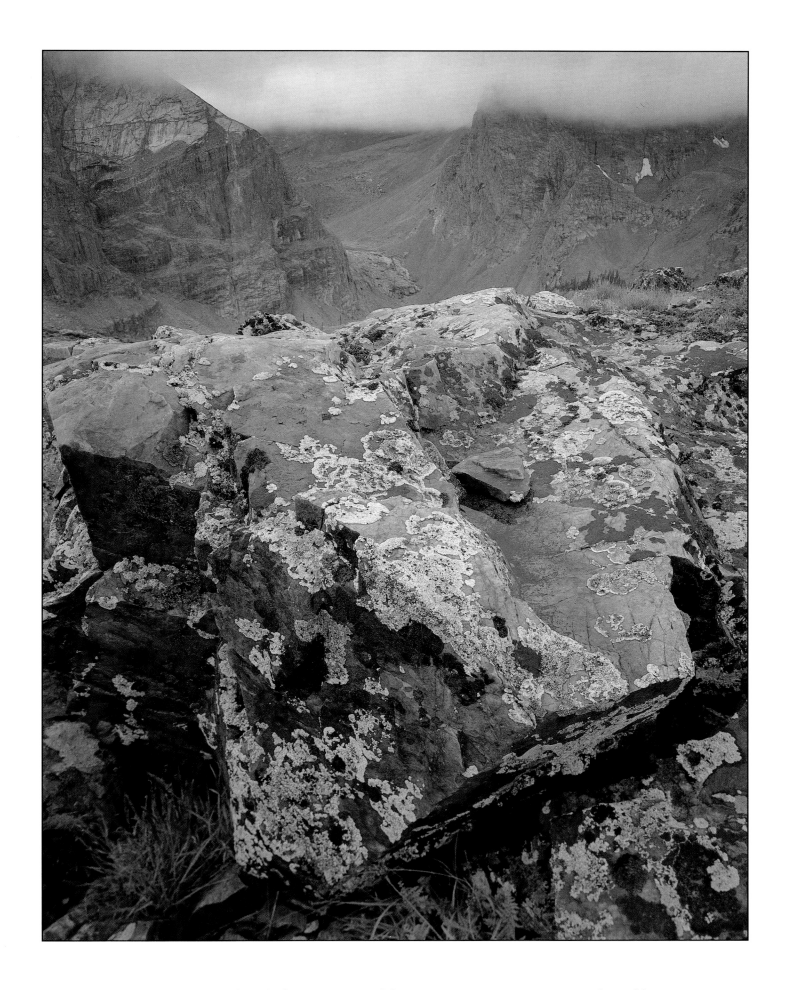

Lichen provides colorful relief in monsoons of the San Juan Mountains, Weminuche Wilderness

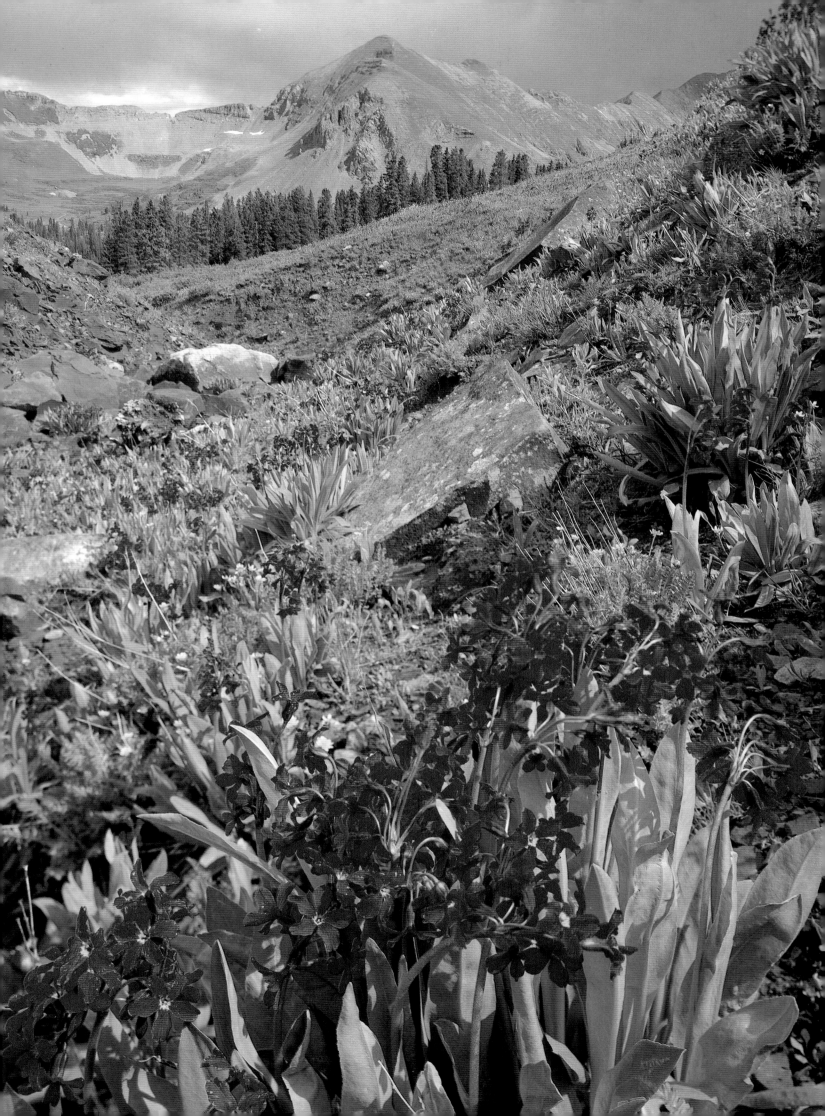

Molas Pass to Durango

COLORADO TRAIL

YESTERDAY, AS I made the 32-switchback, 2,000-foot, five-mile climb from the Animas River to Molas Pass, I passed the CT's 400-mile mark. It seems as though this should be significant, and I guess it is — mainly because I now have only 65 miles remaining until this chapter of my life fades to black. The more I think about it, the sadder I become.

Since leaving Denver, I've been concentrating on the simple (and sometimes not-so-simple) task of making my way up the trail each day. Though I've certainly focused and reflected on individual incidents as they've arisen along the way, only now, as I hike west from Molas Pass, am I beginning to think of this voyage in a "macro" sense. Earlier today I passed a day-hiker who asked if my trip has been "fun." It's hard to believe, but I'd not yet thought about it in those terms. Now, as I begin the CT's very last stretch, I realize the experience has been a gas.

Usually I have mixed emotions when I get ready to re-enter civilization after a backpacking trip. It doesn't matter whether I'm winding down a weekend hike or a 470-mile odyssey. Half of me wants to sprint into the closest town with the specific intent of taking 200 consecutive hot showers and eating every cheeseburger in sight. The other half (my better half) wants to chain me to a tree and refuse to leave the woods ever again.

At the moment, my emotions are far from mixed. I wholeheartedly wish the CT were 300 or even 400 miles longer, so I could spend at least another month out here in the Colorado wilds. That condominium in far, faraway Frisco — where lie my wife, my truck, my canoe, my furniture, my word processor, my sound system, my VCR, my books, my recent history, and my pre- and post-trail life — seems, with the obvious exception of my wife and my sound system, an intimidating place, a bastion of responsibility, a not-necessarily-so-appealing alternative to what has been, for the past 39 days, a fairly simple existence.

I certainly don't mean to indicate that every minute on the trail has been peaches and cream. At various times I have been stiff and sore, drenched with rain, unable to get a good night's

Earth's shadow silhouettes peaks of the Needle Mountains, from Jura Knob

Left: Parry primrose wildflowers, La Plata Mountains

sleep, and — earnest personal hygiene efforts notwithstanding — dirty from head to toe, sometimes absolutely beyond belief.

Nonetheless, I'll gladly take any form of trail life over getting up and actually going — of all places — to work. In less time than I care to think about, after a month and a half of hiking through some of the prettiest turf in one of the prettiest states in the Union, I'll be back to doing just that.

You can see why I'm looking to savor these last 65 miles.

Yesterday I hitchhiked from Molas Pass into Silverton, where a prepackaged food box awaited me at the post office. This marked the first time on this trek that friends or family did not bring my supplies to me. It felt sort of lonely entering town, knowing I wouldn't be able to have a beer with someone I know, someone who, on whatever level, is really supportive of my hiking the CT, someone whose first inclination upon seeing me is to pat me on the back and ask how I'm holding up. In Silverton I was anonymous. And that felt OK.

Usually I look forward mightily to town days. This time I was reluctant to leave the CT, even for 24 hours. I spent a quiet night in that lovely little town, mostly watching a Broncos preseason game, and by 11 the next morning was back on the trail with a belly full of Chattanooga Cafe eggs and hashbrowns.

Trail crew making trail

E VEN THOUGH I MAKE the final push to Durango with a fairly heavy heart, there is scenic solace, as the views here are proving to be as beautiful as anywhere along the trail.

I head out from Molas Pass, pass by Little Molas Lake and almost immediately get directionally discombobulated. Unbelievable. I follow a well-worn trail up a hill, only to realize, at long last, that this is not the CT. So, I put 'er in reverse, reconnect with the CT a mile or so back at a point I should have noticed the first time, and follow the trail to within 100 feet of the exact same spot I was just a few minutes ago. Yet I'm not bothered in the least. After all, I'm only planning on hiking a little more than six miles today — to Lime Creek.

This is an easy stretch of trail that is slowly gaining altitude as it winds into and out of several small drainages and meadows. The weather is more perfect than perfect. As several people have "forewarned" me, this area is indeed as scenic as anything I have passed so far. I am beginning to understand that, somehow or another, I need to figure out a way to move to this part of the state.

It's not as though the place I live is anything but gorgeous. Hundreds of thousands of people spend billions of dollars to visit my home county every year. But — apologies to the Summit County Chamber of Commerce — the southwestern part of

Colorado is without equal in a state that boasts more than its fair share of superlative turf.

Looking down to the valley below, I see an area that seems out of place. In the late 1800s, a huge fire consumed a vast amount of forest hereabouts. For some reason, reforestation efforts have failed. And those failures look much worse than if the Forest Service had just left the valley to its own regenerative devices. Gnarled little trees stand nearly lifeless in straight rows, mute testimony to man's sometimes paltry understanding of the workings of nature.

So, I put 'er in reverse, reconnect with the CT a mile or so back at a point I should have noticed the first time . . .

I stop for lunch at the small saddle between the Bear Creek and Lime Creek drainages. This is one of those spots where I have trouble deciding which way to face while I eat. The views are splendid in every direction, so I end up taking turns.

When I reach Lime Creek, I decide to hike a few miles farther. Nothing against Lime Creek and environs. It's just that I feel particularly energetic today and I'd just as soon take advantage of that fact by putting in a few more hours on the trail. After all, tomorrow I could be lazy as all get-out. I also want to take advantage of today's fine and clear weather. The trail heads above treeline soon, so I'll probably camp somewhere out on the tundra.

As I pass beneath Twin Sisters Peaks, I run into a group of teenaged Colorado Outward Bound students who have been climbing on some nearby cliffs. They look seriously bedraggled. In fairly exasperated tones of voice, they tell me they still have to pack up and hike to a new camp by nightfall. I've always been intrigued by programs like Outward Bound, which assume that people of any age or circumstance will become better and healthier — however you want to define those words — by rubbing elbows with wilderness as intensely and as often as possible.

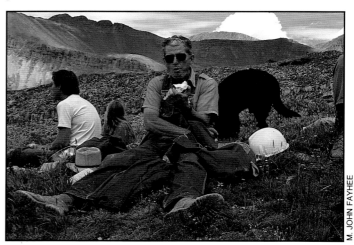

Lunch break

I used to work for a Tucson-based juvenile rehabilitation company called VisionQuest. The VisionQuest kids were, unlike Outward Bound kids, most often fairly serious criminal types. The program — which was, at the time, the most successful juvenile rehabilitation entity in the world — focused on high-impact wilderness experiences. The kids learned climbing, hiking, camping, sailing, orienteering, survival skills, teamwork and

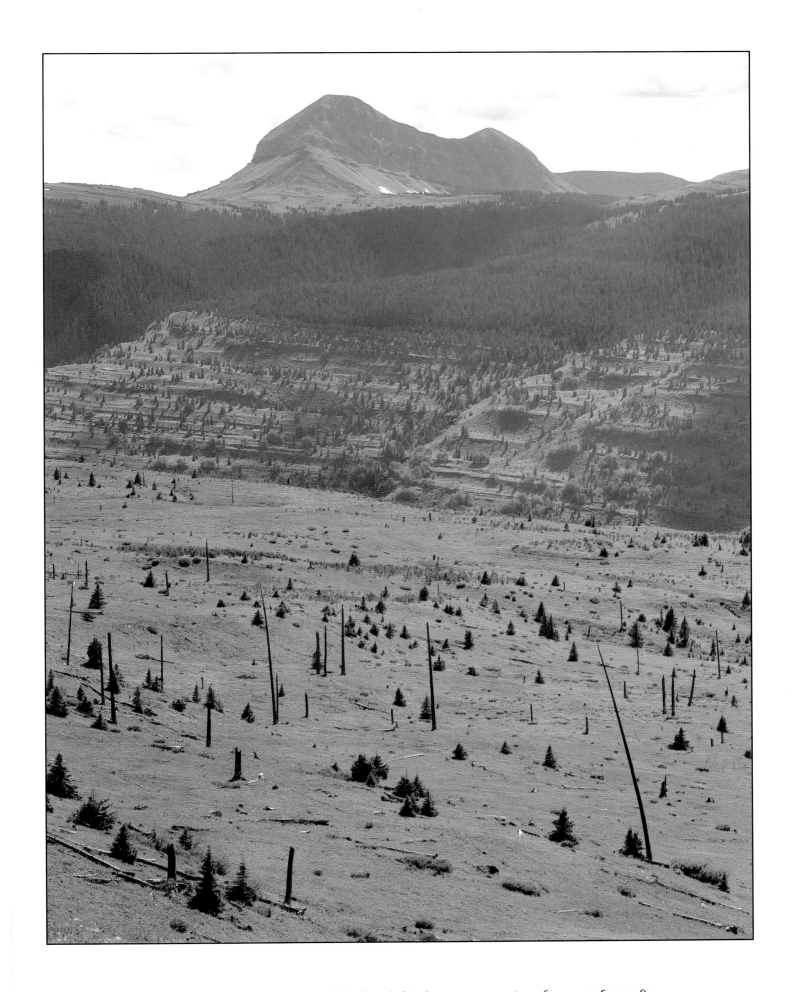

Engineer Mountain rises to 12,968 feet, behind meager remains of a great forest fire

first aid — in places such as New Mexico's Gila Wilderness and Texas's Big Bend National Park.

Certainly, VisionQuest chose wilderness settings at least partially to get kids away from the aspects of civilization — drugs, gangs, abusive parents — that contributed to their becoming criminals in the first place.

But there was a lot more to it than that. The company believed that wilderness has both preventive and curative powers. Their contention, which I support, was that spending time in the out-of-doors — the longer and more intense the experience, the better — makes it easier to cope with the problems that society lays on just about every single one of us just about every day of our lives.

I don't think these Outward Bound kids are thinking in these terms right now. They tell me they are tired and hungry. Several say they were scared to death up on the cliffs, which is a sure sign of well-developed intellect, as far as I'm concerned. I proceed to tell them that, in my opinion, they are very lucky people, that they should savor every morsel of this experience, and that one day they will look back on this time as a very special period

in their lives.

At this, the Outward Bounders roll their eyes, as if they've heard all this before. They must think I'm a typical "old person" to even bring up these points. One asks if I have been talking to his parents anytime recently. After deciding I am an unwelcome emissary of adulthood, they head off one way; I head off the other. I am smiling; they are not.

TODAY IS JUST ONE of those days when I feel like walking, walking and walking some more. Soon I am high enough in the tundra that I know water will be hard to find until I descend again. After an hour more of climbing, I begin to lose my momentum. I start wishing I had parked it for the night a few miles back.

Just before Rolling Mountain Pass, I come across a few hundred yards of brand-new trail. And I mean brand-new. I know this area will see a lot of volunteer trail crews in the next few weeks. This I know because I am scheduled to work on a crew headquartered hereabouts starting a few days after I finish this hike. Mine

Aptly named White Creek descends with alacrity, San Juan National Forest

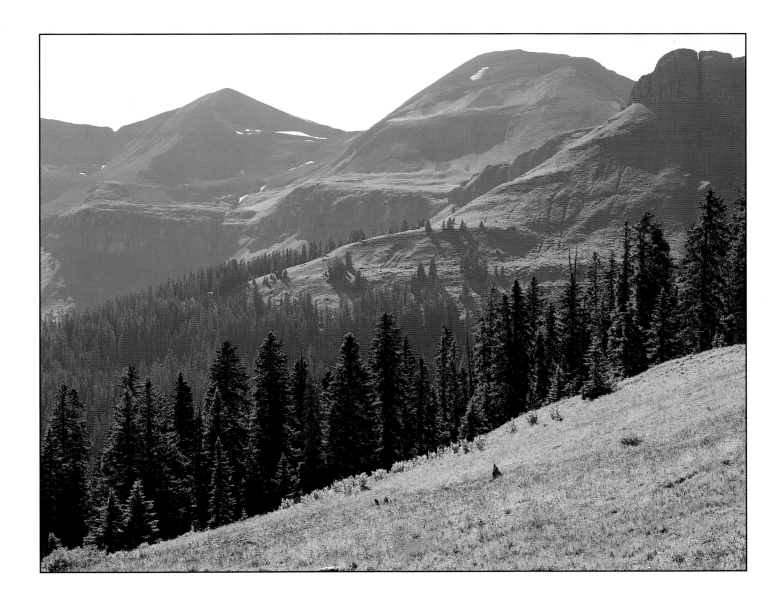

will be the third of three Rolling Mountain crews, so, hopefully, all the hard work will be done by the time I return in two weeks.

Shortly after I wearily top out on the pass, I see the crew hard at work right below. It is led by Lynn Mattingly, the woman who arranged for me to call my wife from Saguache after my pack strap broke near Marshall Pass.

Lynn is a quilter who lives near Boulder. She is also one of the prime movers and shakers in the Colorado Trail Foundation. Every summer, Lynn and a handful of other CT Foundation activists spend several months involved in CT things, such as leading treks and trail crews.

I think it's pretty fair to say that I have come to love the CT. At the same time, I think it's fair to say that the CT Foundation's core group loves this trail in ways I can scarcely begin to comprehend. These people are definitely the black belts of the Colorado Trail.

Lynn invites me to stay the night near the trail crew's camp, about a mile down from Rolling Mountain Pass. I accept, telling myself it will be good to have company. Which is actually the way I feel. At the same time, I suspect there will be lots of extra food on the crew's table.

I suspect correctly.

The next morning I spend considerable time discussing what to expect up ahead with the two Forest Service employees assigned to the CT trail crews operating in the Animas Ranger District of San Juan National Forest. In the past three years, a lot of rerouting has been done on the trail between Molas Pass and Durango, to the point that the guidebook has become fairly obsolete for this section.

Water will be my big concern during the next couple of days. The Forest Service people tell me that starting around Bolam Pass, a mere seven miles away, water gets a little scarce for the next 27 or so miles.

I am faced with another one of those "in between" choices. After a half-day of hiking I can stop at Bolam Pass, where there is a little lake, or I can continue on to Straight Creek, eight miles farther on. I don't know if I want to hike 15 miles today. I am feeling particularly lethargic, the flip side of yesterday's coin. I suspect this is because I strayed from my dietary path for two consecutive meals.

Backlighted slopes of 13,432-foot Twin Sisters, San Juan National Forest

Overleaf: Reflection of 13,693-foot Rolling Mountain in primrose-laced waters

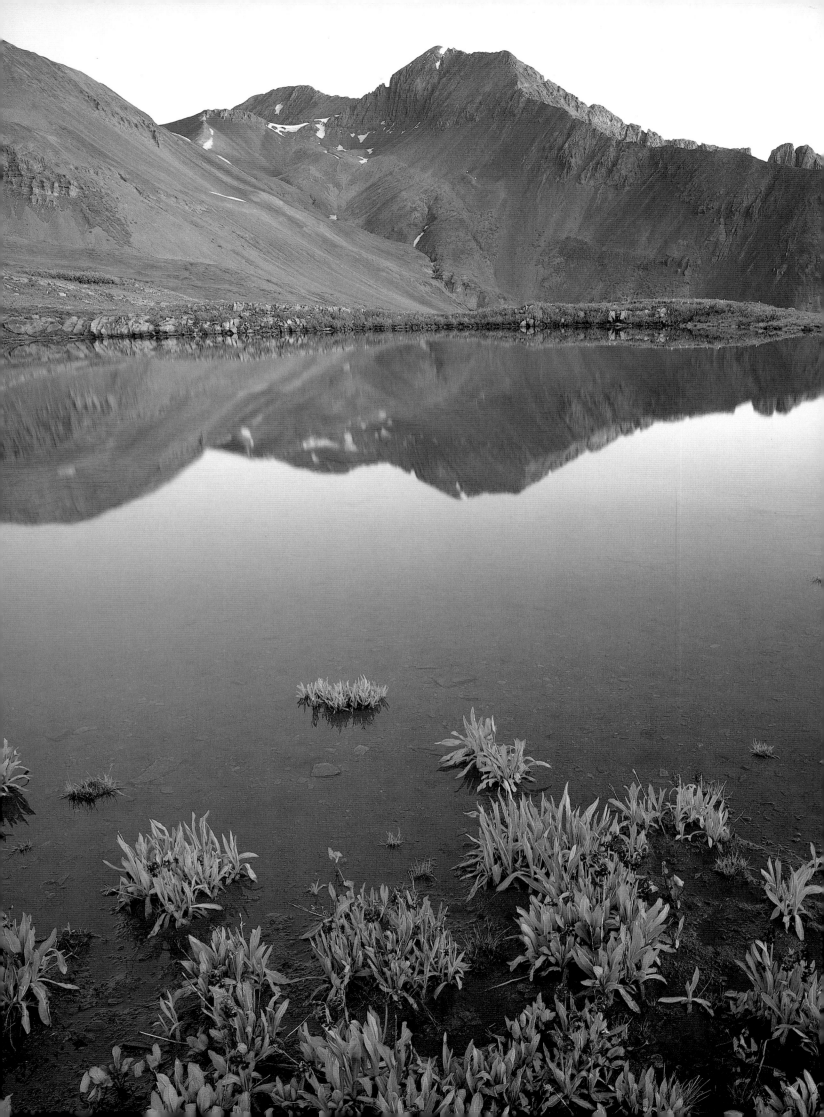

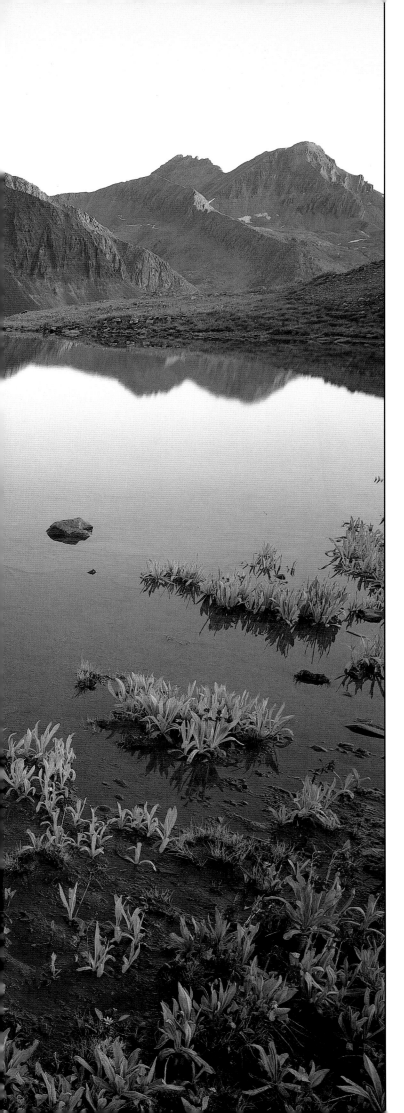

When given my choice of victuals, I will always eat meat, potatoes and sugary foods, which is what I gratefully accepted from the trail crew people last night and this morning. This was a mistake, and I knew it. Long-distance hiking is a seriously strenuous activity that requires vast amounts of not just calories, but calories derived predominantly from complex carbohydrates, to fuel a body that's working hard to make its way up and down mountains all day. This fueling process is an ongoing thing. A gap of even two meals can have dire consequences in the energy department.

Although I arrive at Bolam Pass before noon, I decide to stop for the night.

Big mistake. Maybe even my biggest mistake of the entire trail, for reasons that have little or nothing to do with the pass itself. Bolam Pass is not a bad spot. But that's not exactly a heavy-duty compliment in this neck of the woods.

The little lake at the pass is pretty enough, but there's also a four-wheel-drive road. I spend much of the afternoon reading in my tent, feeling stuporously lazy, as dozens of vacationing families drive up, jump out of their vehicles, scream and yell things such as, "Hey, look, Mom, a tent!" for 15 or so minutes, before moving on to the next scenic spot.

I am on the trail by 6 the next morning. After lunch I will enter the longest waterless stretch of the CT. Of course, this I did not really realize until I was checking out the guidebook during breakfast. This was when I came to understand what a tragic error it was to stop for the night at Bolam Pass. I knew I was coming up to a stretch that was a little dryer than most, but 19 completely waterless miles. Damn. I don't know why I don't study the guidebook better. Perhaps I prefer to keep as much of a sense of the unknown as possible in this adventure.

Today's plan, I guess, is to hike 13 miles to the headwaters of Corral Draw. To find water, it looks as though I will have to descend as much as 1,000 vertical feet from the ridge. I decide to put the pedal to the metal, just in case the Corral Draw water option does not pan out.

Several things separate long-distance hikers from short-distance hikers. The most obvious is physical condition. People who have been hiking for several straight weeks tend to get in pretty good sport-specific shape. This has positive implications that exceed simply being able to hike farther in less time with less fatigue. It means being able to daydream while hiking. It means not needing to concentrate every single moment on basic perambulation. It means losing the interface between mind and legs, at least on a conscious level.

My trail daydreams tend to take me far away from the turf I am passing. Sometimes I don't even notice basic things like mountain ranges while tooling along, oblivious to the world around me. I am reminded of the old hippie slogan, "Be here, now," and the Zen adage, "When you're chopping wood, only chop wood." Neither applies to me in my current state.

I am cruising along at flank speed along the northern base of aptly named Hermosa ("Beautiful") Peak, with its tremendous views of Lizard Head, one of the state's most unusual and recognizable geologic features. I am headed for Blackhawk Pass, where views of the Rico and La Plata mountains dominate the western and southwestern horizons. I am daydreaming about leaving the Rockies for some tropical paradise like the Bahamas, where I, along with my wife, who has not yet been consulted about all this, would live a simple, nonpolluting life aboard a sailboat.

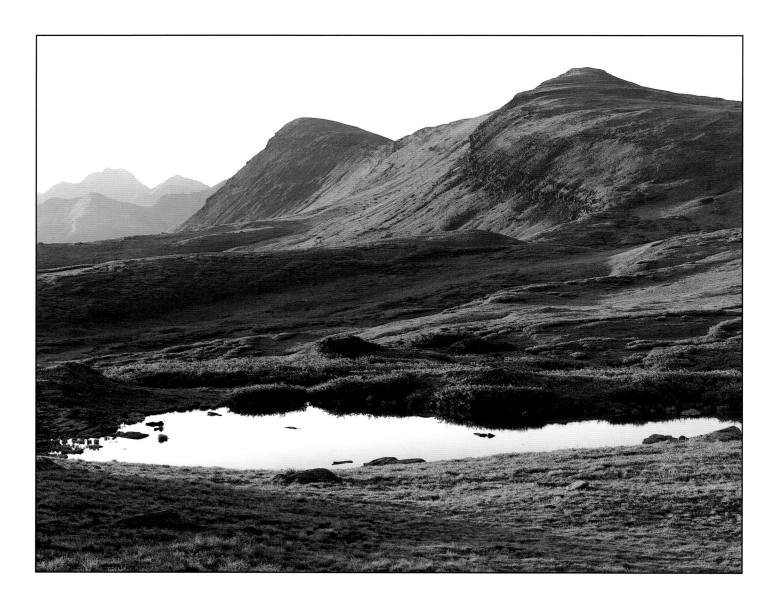

I wonder why I am not fantasizing about, say, building a little cabin right here in the San Juans and never ever venturing down to the lowlands again. After all, I love this neck of the woods more than any place I have ever visited. I've never even been near the Bahamas.

The only explanation I can come up with is that, with less than three days left on the CT, I am starting to think about my post-CT life options. My biggest fear is that when I return home, life will instantly resume its pre-CT course. On the subconscious level, perhaps I am telling myself that I cannot allow that to happen. Perhaps I am telling myself that, in order to avoid becoming the M. John Fayhee I was before starting this trip, I need to leave Colorado.

This I cannot accept.

I do manage to notice while hiking along that there is water water everywhere. I could easily have hiked a few more miles yesterday and found myself not only farther along the trail, but in a more attractive camping spot. By about tenfold.

I make Straight Creek by lunchtime. As far as I can tell, this is my last on-trail water until I reach Taylor Lake sometime

tomorrow afternoon.

The weather starts to turn quickly for the worse, so I hustle through lunch, making certain I hit the trail with absolutely full water bottles.

Soon after leaving Straight Creek, the CT enters what has to be one of the largest clear-cut areas in the state. For several miles, the trail passes through denuded hills, crisscrossed by muddy, abandoned logging roads — all paid for by our tax dollars. Fortunately, this section of trail has been marked sometime in the past couple of years. In times past, this was one of the hardest stretches of the whole CT to navigate, because of all the roads intertwining with the trail.

It's hard to say that this is an ugly place, because the views of the surrounding mountain ranges are great. But, in my mind, few things are more depressing than rubbing elbows with the offal of the timber industry. I understand there are plenty of so-called experts who argue, sometimes forcefully, that timbering, in all its permutations, is ultimately beneficial to the overall health and well-being of the forest. I just happen to think these arguments are pure bunk, put forth primarily by folks who are

Sunset on Twin Sisters, San Juan National Forest

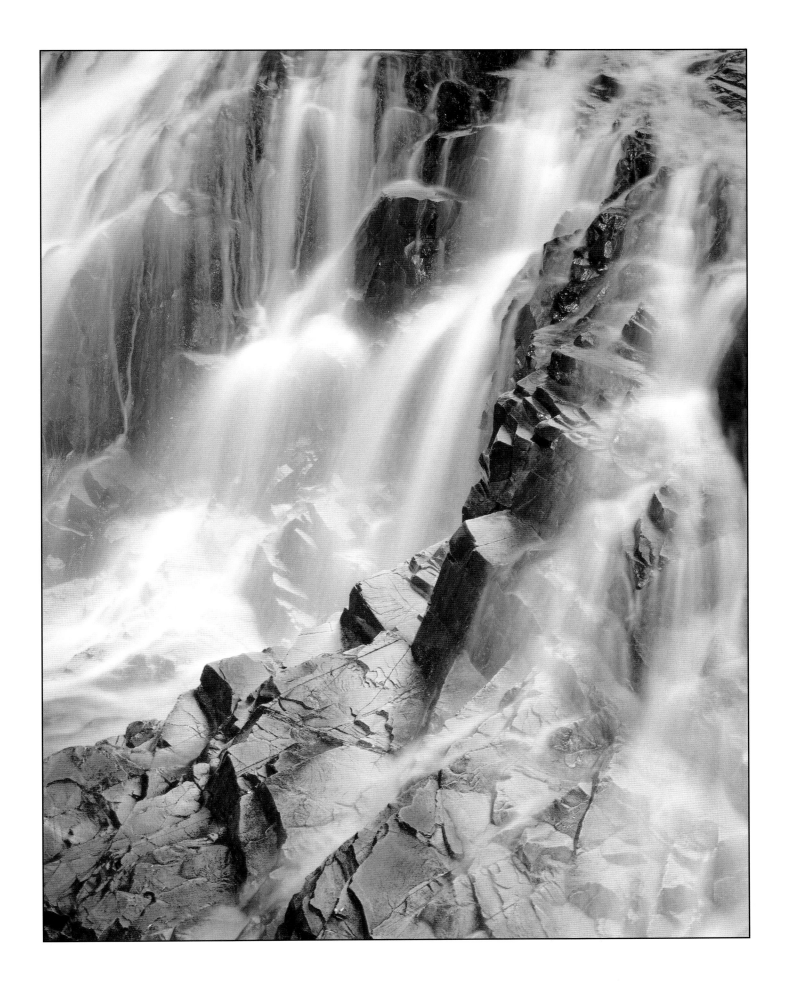

Cascades along aptly named Cascade Creek, San Juan National Forest

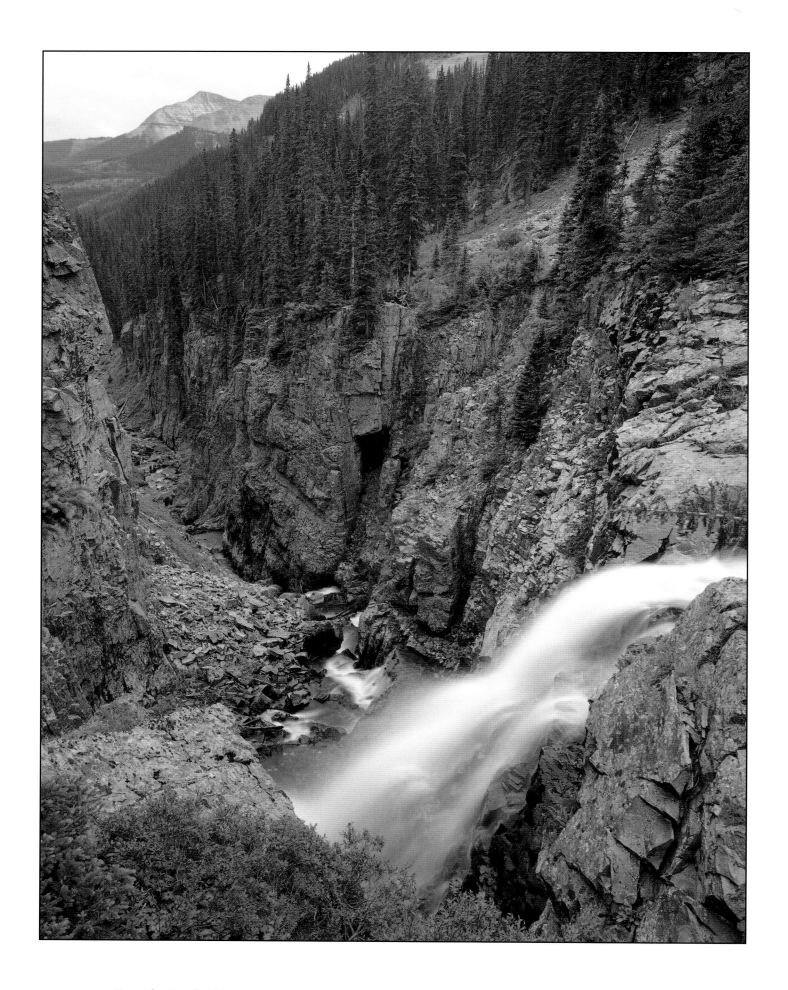

Cascade Creek plunges toward rendezvous with the Animas River, San Juan National Forest

educated by a system that is set up, at least partially, to kowtow to the timber industry.

I'm not so naive as to believe our national forests and parks can be managed as though mankind does not exist, as if the entire continent has not been pretty much mowed down in the last 300 years. Our national forests, national parks and BLM lands are islands in a sea of humanity. Certainly, this reality affects — and must affect — management policies. Because our forests are isolated islands, their natural evolution must be manipulated occasionally — by timbering, by fire, by lack of fire, by whatever. But they do not need to be clear-cut so a few thousand people can make a living in rural Colorado. Or Idaho. Or British Columbia. Or Thailand.

. . . I awaken feeling like someone spent the vast majority of the night beating on my legs with a pipe.

Just before the rains hit full force, I cross paths with a mountain biker making his way to Denver. He is the first through-biker I have met. "You're John Fayhee, aren't you?" he wants to know.

Now, you have to understand, when you've been writing for a living as long as I have, there are several tonal variations to this question. Some are good, some are very bad. Some indicate the questioner loved my article in *Backpacker* on hiking through China; some indicate the questioner did not appreciate my mentioning in the local newspaper I write for that he was convicted of drunken driving.

Since the mountain biker is out of breath, I can't decipher his tone. He doesn't seem to have any weapons close at hand, so I reluctantly answer in the affirmative. He starts smiling big time. He tells me he bought a book I wrote about Mexico's Copper Canyon region and, based on the book, recently took a trip down there and loved every minute of it. He wants my mailing address so he can send me his copy for autographing.

I love unexpected ego boosts.

Five minutes later, one of the worst lightning storms of the summer hits. And I am right in the middle of the monster clear-cut. I sprint up a hill and into an isolated grove of trees.

Some people say it's a bad idea to hide under a tree during a lightning storm. Some say it isn't. A meteorologist I camped with at Beartown, for instance, told me that under a tree is as good a place as any to hide. In any case, nearly everybody I know instinctively heads for cover when lightning shows up.

I remain in the grove of trees until the lightning stops. Then I hike as fast as possible through the remainder of the clear-cut. It ends with the ascent of Indian Trail Ridge, the CT's very last mountain range.

PAR FOR MY KARMIC COURSE, I have set up camp almost exactly in the middle of the 19-mile waterless stretch. After 13 miles, I reached the trail for Corral Draw, took one look at the seriousness of the descent to where I might find water, and decided to hike on, knowing full well I would be dry camping tonight as a result of my decision. This means granola bars for supper and breakfast, since I don't have any water for cooking. My biggest concern is that I won't be able to have coffee in the morning. A day without coffee is a sad day indeed. Caffeine is, by far, my worst addiction.

When I hit the sack just before dark, I have a little less than a liter of water. For several hours now I've been taking only the smallest of sips.

About six seconds after I bed down, I hear a mountain biker approaching. I climb out of the tent, and we chat for a few minutes in the failing light. It slowly dawns on me that I know this person. I ask his name. It's Randy Jacobs, the author of the official CT guidebook. We met several years ago when I was writing a story for *Backpacker* on the dedication of the trail.

Randy is out and about gathering information for an updated version of the guidebook. He tells me there has been considerable trail work up ahead and that neither the guidebook nor the maps will be of much help, though he believes the trail is well-marked all the way to Durango.

I ask if there is any water whatsoever on the trail ahead. Randy says there is a trailside seep spring just above the Cape of Good Hope, though he can scarcely imagine anyone being thirsty enough to drink out of it.

He asks where I started today. His jaw drops when I say I camped last night at Bolam Pass, 18 miles back. I tell him I plan to arrive in Durango, now 33 miles distant, early in the afternoon two days from now. He doesn't think I can make it that far in that amount of time. He counsels that I not underestimate the difficulty of the next 10 miles.

Well decorated trail!

Randy takes his leave in almost total darkness. He still has eight miles of pedaling to get back to his car.

In the morning I awaken feeling like someone spent the vast majority of the night beating on my legs with a pipe. This is the stiffest I have been since I left Denver. I feel like a very old man as I hit the trail. Hiking caffeineless does little to improve a mood that is bordering on foul. I plan on making it at least 18 miles today. Tomorrow I will end this hike, one full day

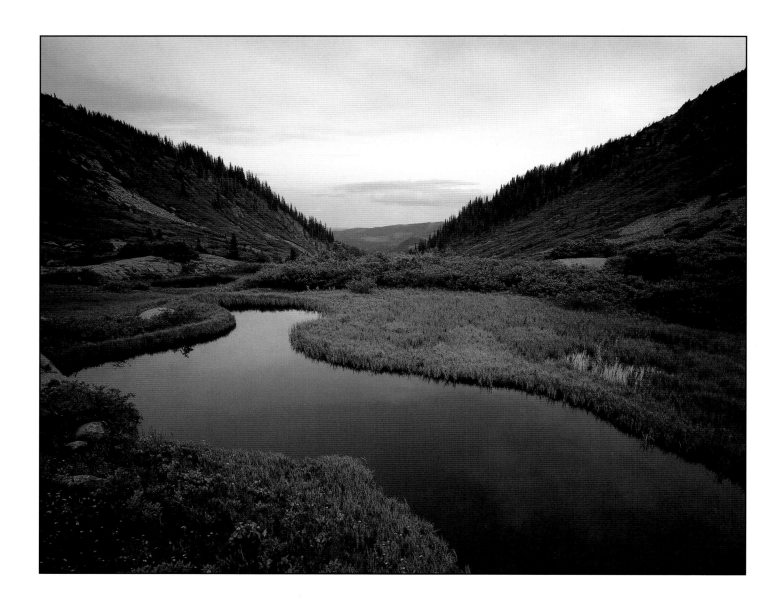

earlier than planned. All of a sudden I am sprinting to Durango, and I don't know why. I guess the nearly constant rain is finally getting to me.

Midway through my ascent of the Cape of Good Hope, along the new trail Randy Jacobs described to me, I come across the seep spring. I am surprised by Randy's lack of enthusiasm about this welcome water source, which I find quite sufficient to meet my almost-dry needs. I drink two liters on the spot, fill my water bottles and speed on toward Durango.

The weather, clearly, will not be clear for long. I have at least five miles of above-treeline trekking ahead of me, so I quicken my already quick pace as I climb toward the crest of Indian Trail Ridge. To the west, the clouds are flowing like liquid over the magnificent La Plata Mountains.

Flowers are in the height of summer bloom all around me. Indian Trail Ridge is the crescendo of what has been the best wildflower summer I have ever seen. Whole mountainsides look like Van Gogh paintings. I feel as though I should be spinning around, singing "The Sound of Music."

But, the way the sky is looking, I'll just be moseying along.

Randy was right about this stretch of trail. It is a lot harder than the maps seem to indicate. Five times I am sure this is the last summit before the trail drops down into Cumberland Basin, where Taylor Lake awaits. Finally I get to a point where I can see the rest of Indian Trail Ridge. From here, there looks to be at least two more summits to cross. I would kill for a cup of coffee right now.

Suddenly, Taylor Lake appears below me. As it turns out, the CT doesn't cross those last two summits. The seemingly endless 19-mile stretch is behind me. After making the short climb to Kennebec Pass, it's downhill all the way to Durango.

Kennebec Pass marks, for me, the most poignant of the CT's "lasts." It is the last time the trail passes above treeline. In the past six weeks I have spent more time in the tundra than in my entire pre-CT life. Even though many of my above-treeline minutes were spent dodging lightning bolts and getting rained on, my love of the highest of Colorado's High Country has only been intensified by this 470-mile experience.

After one of the steepest descents of the entire CT, I make camp. The guidebook is right: finding campsites along the Flagler

Sunrise on headwaters of Cascade Creek, San Juan National Forest

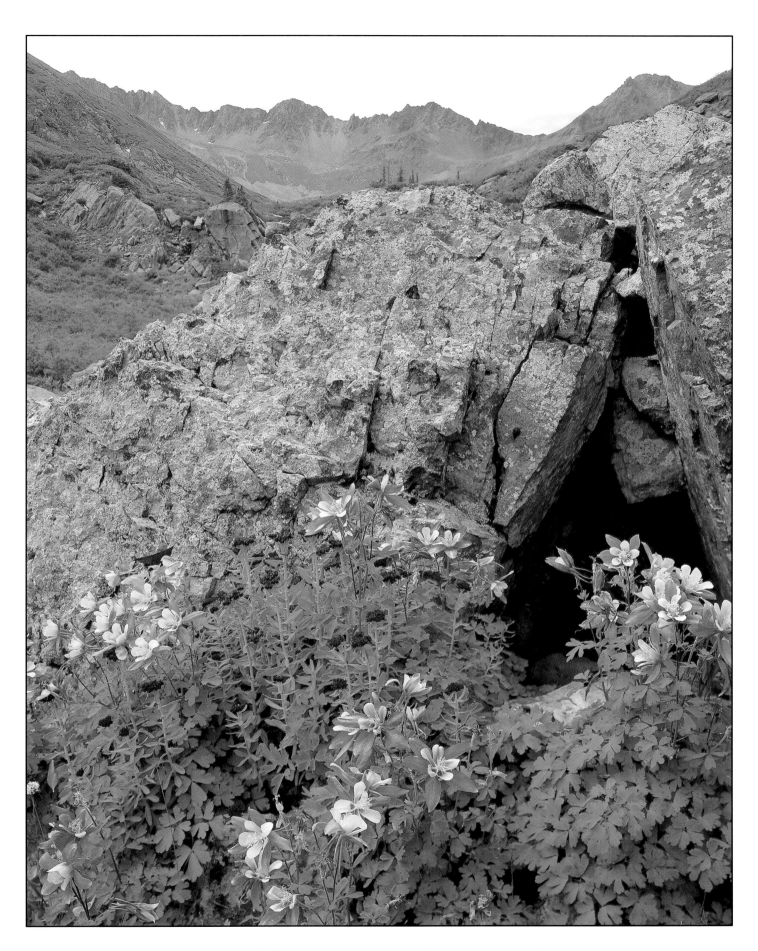

Colorado columbine wildflowers below serrated ridges of the West Silverton Group of the San Juan Mountains, San Juan National Forest

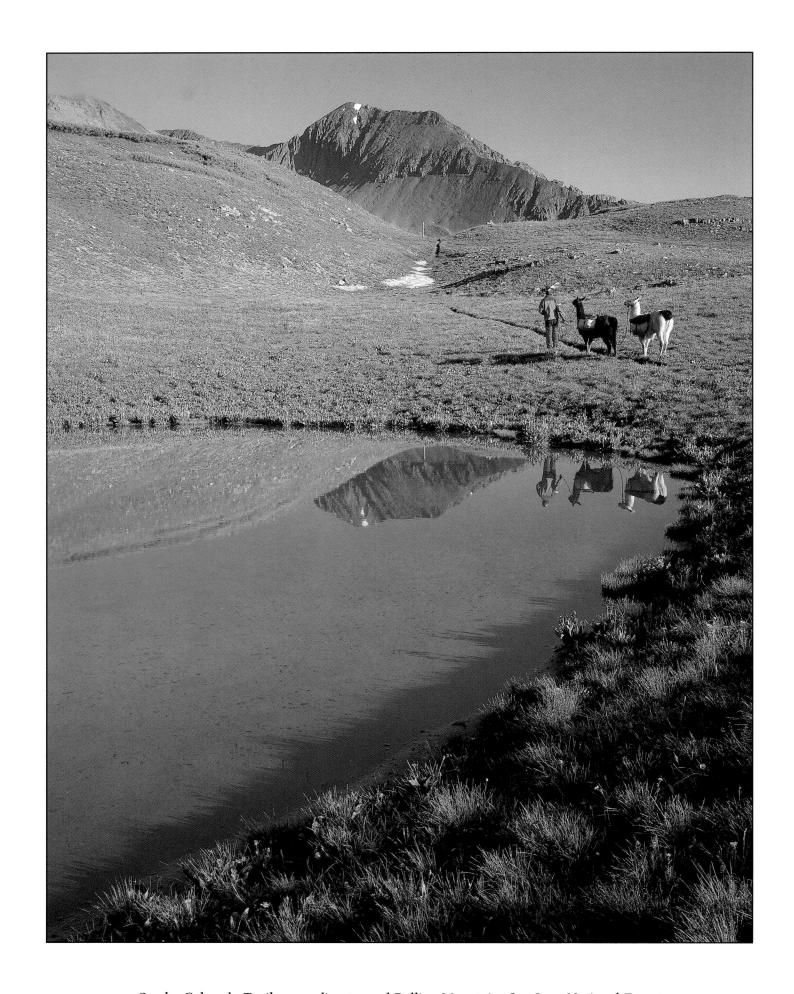

On the Colorado Trail proceeding toward Rolling Mountain, San Juan National Forest

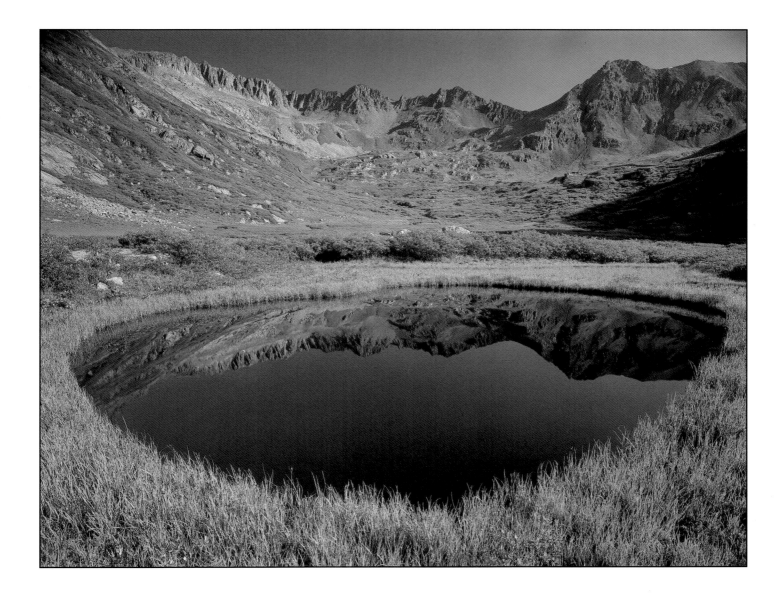

Fork of Junction Creek can be a little tough, because the canyon is so tight. But after 18 miles of hard hiking, just about anywhere — including the middle of the trail — is acceptable.

I hurry to set up my tent before a storm hits. It pours for the next three hours. And here I lie, in the heart of a perfect flash flood-type canyon. It would humiliate me beyond description to die the day before I finish this hike.

For once, I'm in a pondering mood. This is the moment, 18 or so hours before the CT becomes part of my past, when I'm supposed to be lamenting the fact that I'll soon be back treading water in Real Life. More than that, I'm supposed to be reflecting upon what this experience has meant to me as a person. Most obviously, I have lost 30 pounds. This is a lot more important to me than I pretend.

Before I started this hike, I was beginning to dislike the person I was becoming. Extra pounds were only the most outward manifestation of that person. I remember sitting in my tent at Bear Creek, a mere eight miles into this hike, feeling like a potbellied buffoon. The role was no longer funny — to me, to my wife and maybe even to my friends.

My last night on the CT seems like a perfect time to examine myself in the context of, well, myself. What, or who, do I want to be when I return home to Frisco? I'm still going to be a writer, at least partially because that's the only way I know to make a living. Understanding that, how do I carry this desire for change with me when I leave the wilderness? Metamorphoses occur naturally here, but what will happen when I return to the very civilization that played a role in making me what I was when I started this hike.

I sit scratching my head a while, searching fruitlessly for answers that, to me, are fairly significant. Then it dawns on me, several minutes after I start looking for excuses to stop entertaining all this heaviness, that finding answers is, in all likelihood, fairly unimportant at this point. What is important is that because of the CT, because of my time on the CT, because of the people I have met on the CT, because of the things I have seen in the past 43 days, I have started thinking about all this seriously for the first time in years.

The rains return, and I hustle back to my tent.

I can't stop grinning.

Grand cirque containing headwaters of Cascade Creek, San Juan National Forest

Overleaf: Cascade Creek

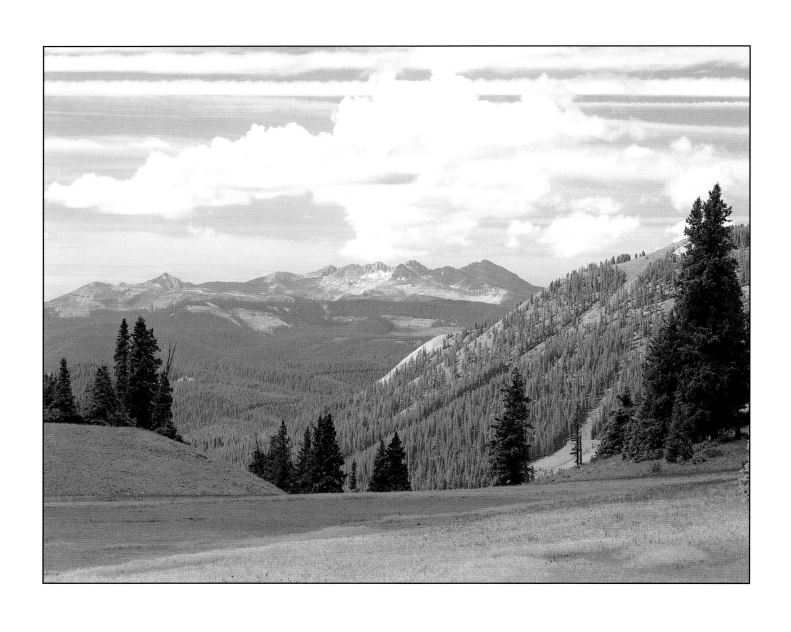

La Plata Mountains to the south, from Hermosa Peak in Rico Mountains,
San Juan National Forest

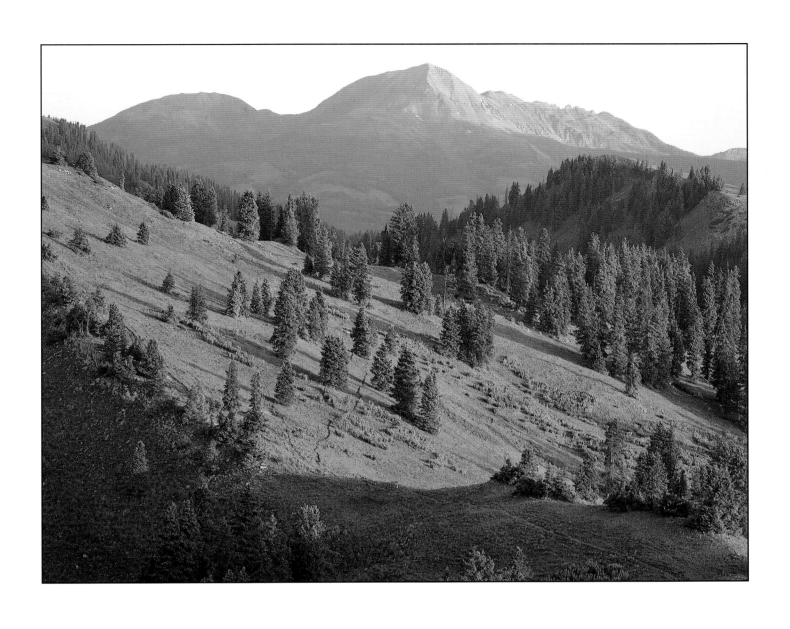

Colorado Trail winds through green grass of the Rico Mountains, San Juan National Forest
Overleaf: Sunrise, La Plata Mountains

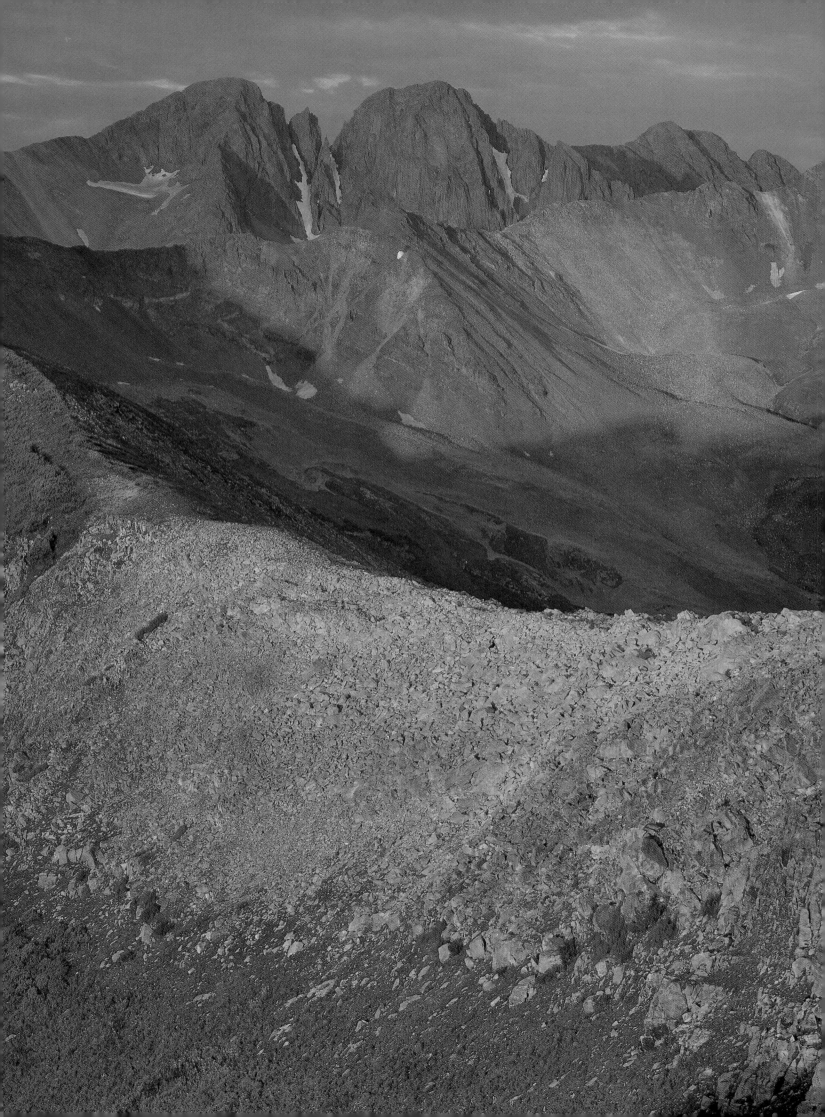

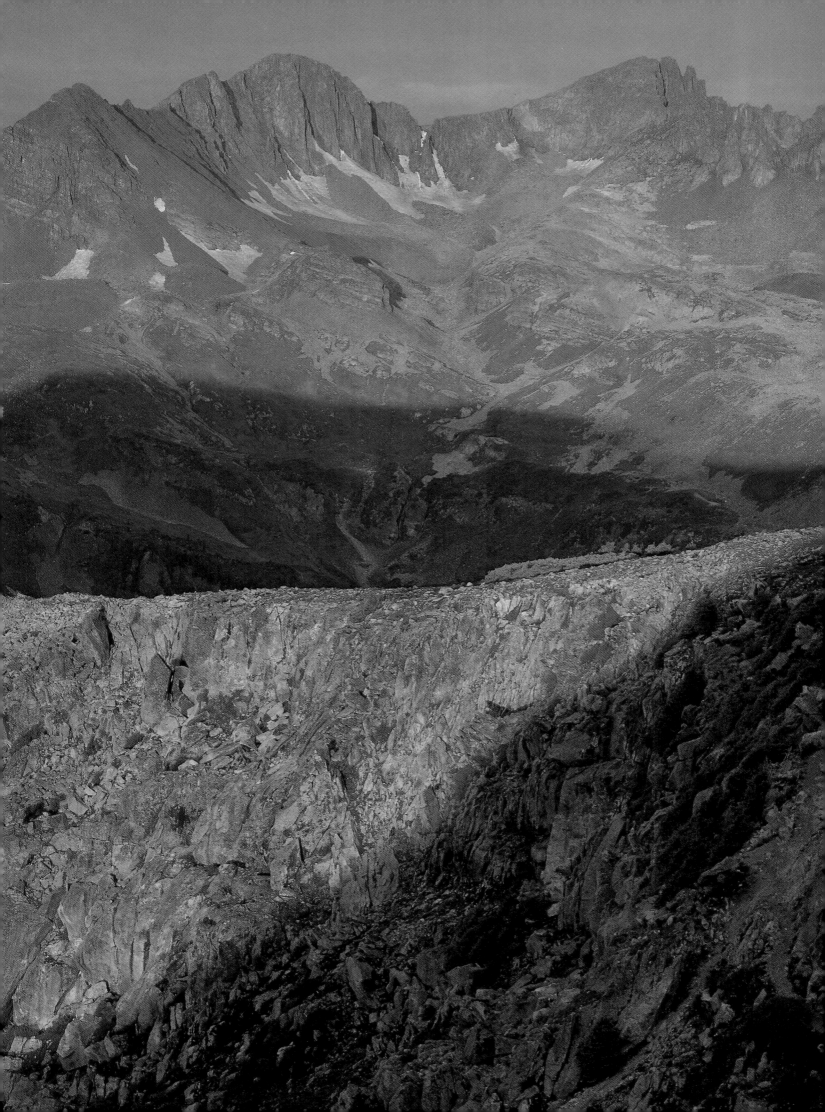

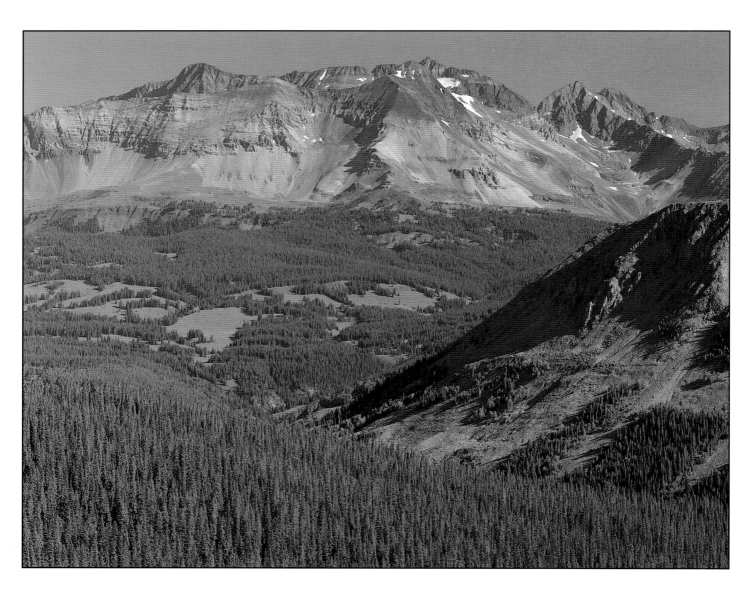

A WEEK ON A COLORADO TRAIL CREW

WE GATHER ONE Saturday afternoon, about as far in the middle of nowhere as you can be in Colorado and still be standing next to your truck. We are several miles west of the South Mineral Creek Campground, which is about 15 dirt-road miles outside of Silverton.

We are in the heart of the San Juans. This group — 1991 Colorado Trail Crew No. 19 (Rolling Mountain) — metaphorically and allegorically, is the heart of the CT.

There are 16 of us. All but three have worked on CT crews before, some as many as five times. Ours is a "backpack-in" crew, meaning that tomorrow morning we will leave behind our vehicles and hike four miles to the base camp that will serve as our home village for the next week. Backpack-in crews are fairly rare. Base camps for most CT crews are accessible by vehicle. Some, however, are more accessible than others.

Because we are unable to drive to our base camp, we were told well in advance that life for the next week will be primitive at best. Though our menu, which we received copies of several months ago, looks like the stuff of fantasy by backpackers' stan-

dards, we are told that, compared to the fare offered drive-in trail crews, we will be eating more or less like monks.

This first night we will car camp. It is time to get to know one another.

The first person to get to know is Merle McDonald, our crew leader. I met Merle last summer when he was leading a crew working on a stretch of CT that passes through Summit County, where I live. He is one of the most interesting and likable people I have ever run into. Merle laughs easily and tells a good story, two traits I admire.

When I started mentioning to people that I wanted to work on a CT crew, almost everyone recommended that I sign up for one of Merle's crews. He is the most popular CT crew leader, which is no insult to the other leaders.

Merle is a retired Army officer who flew helicopters for something like 20 years. When he retired from the military, he moved to Colorado Springs from the Washington, D.C., area, where he had cut his trail-building teeth on the Appalachian Trail. He now works almost full time, for no pay, on CT matters.

Great massif of the Lizard Head Wilderness, from the Rico Mountains

Right: Indian paintbrush wildflowers on Indian Trail Ridge

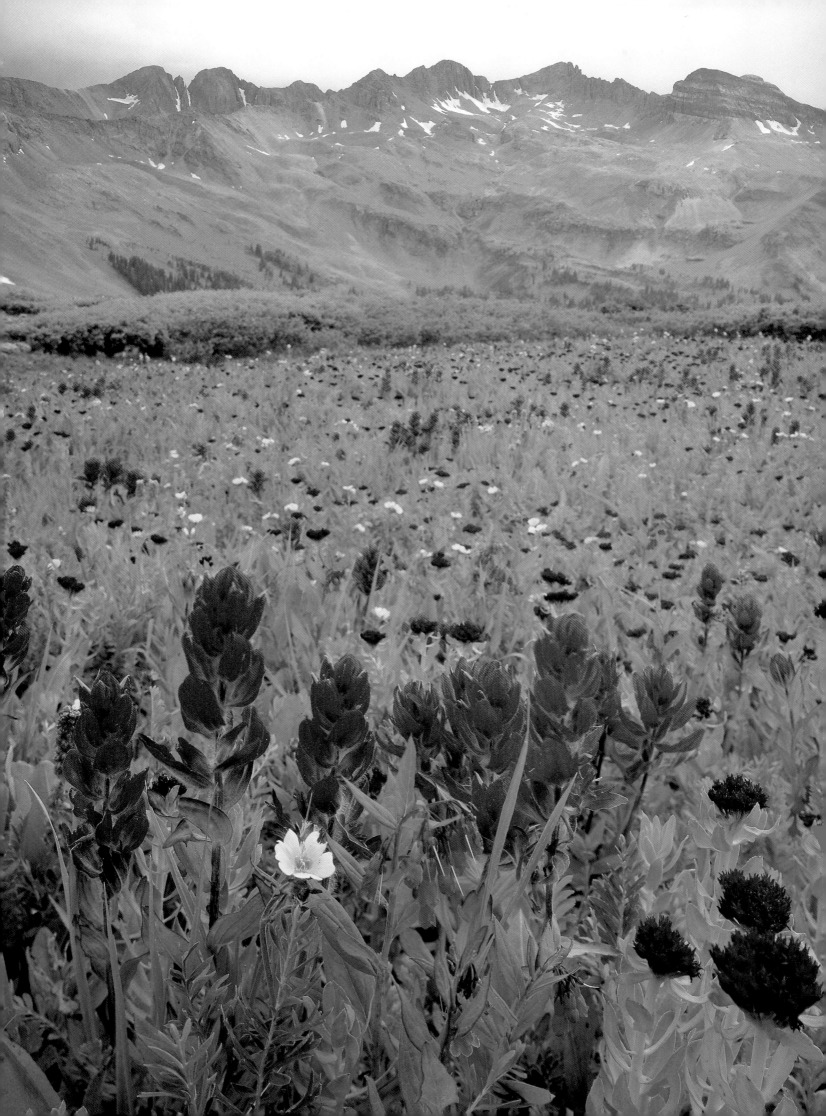

Merle not only leads several CT crews each summer, he also coordinates the CT Foundation's Adopt-a-Trail Program, wherein ordinary people agree to maintain a segment of the CT. These segments can run anywhere from a few miles in length to 19 miles. Merle has also adopted a section of trail himself. Several times in the next week I am tempted to call him "Mr. CT."

Everyone who meets Merle also meets his trusty Labrador, Max, who is as much a part of our crew as any of us. Although he is getting a little long of tooth, Max is the only dog I have ever met that likes both carrots and oatmeal.

As evening settles into dusk, Merle is in the cook tent whipping up some sort of Mexican food concoction. The rest of us drift from one vehicle to the next, shaking hands and sharing beverages. After a few hours it becomes impossible to remember any more names. There have simply been too many tossed my way this fine day.

Working on the Colorado Trail

In fact, only one name signs on for a permanent cranial stay: Larry White. It takes all of five seconds for me to realize that this is a man I like profusely and that we will be friends for many years to come.

Larry walked up to me right after I arrived and said something like, "Well, Mr. Fayhee, I've wanted to meet you for a long time." When you're a writer, you know this kind of conversation can go either way. This was a concern, because Larry is not only big, he is in tremendous shape. I shook hands tentatively and learned that Larry knew me through a book I wrote about Mexico. He wants very badly to go hiking with me down there ASAP. We become fast friends.

Merle gives us very little in the way of orientation tonight, except to point out the trail we'll be hiking to our base camp and to tell us we all need to arrive there sometime tomorrow before dark.

Just about everyone hits the sack early. With a couple of exceptions, the people who make up this trail crew do not look to be in the world's best shape. Several people have expressed trepidation about tomorrow's four-mile, 2,000-feet-up, 800-feet-down hike.

By 8 a.m., people are starting to drift toward the trail, with varying degrees of enthusiasm.

By 2 p.m., everyone has arrived safely at camp. A few people are dead tired. Those of us who arrived early have begun purifying water, chopping wood and fixing snacks. Camp, at this point, consists of two Forest Service canvas wall tents pitched just below treeline. They are next to an alpine lake in the middle

of one of the prettiest valleys in the state. One of the tents serves as kitchen and pantry; the other is the community tent. The kitchen tent has four propane burners and several dozen boxes of food. The community tent is empty, save for a small potbellied wood stove. This is where I stayed the night almost two weeks ago while hiking along the CT.

> *"There is a great deal of camaraderie and a feeling of teamwork on these crews . . ."*

We are the third crew to utilize this spot, which is good in some ways and bad in others. On the positive side, it means there's a whole lot of food left over, because the CT Foundation and the Forest Service always seem to overstock trail crews with stuff like Cheetos.

On the negative side, it means we have to dig a new latrine, because the old one is, well, old.

When night falls, Merle pulls us all into the community tent to explain how a trail crew works. Just about everyone has heard this before. Merle tells us we'll have to divide up kitchen chores. Each of us is expected to help cook at least two meals and do dishes at least twice during the week. In addition, there's wood to be chopped and water to be hauled from a nearby spring.

Merle asks each of us to introduce ourselves to the group and explain a little about why we decided to spend a week working on a trail crew instead of, say, lying on a beach somewhere.

Art Porter, a veteran of numerous trail crews and a marketing vice president from Colorado Springs, sums up the general attitude perhaps better than anyone. Trail crews, I might add, are made up almost exclusively of white-collar types, people who spend their lives, by and large, in offices. "There is a great deal of camaraderie and a feeling of teamwork on these crews," Art says. "Most of us out here really love to hike. And I wonder why the taxpayers should have to foot the bill for trail building when only about 10 percent of the people use the trails."

Resting along the Colorado Trail

Larry White adds, "These flat out are the kinds of people I like to associate with."

Ken Stegner, a trail crew veteran and a civilian employee of Lowry Air Force Base in Metro Denver, comments, "This is fun."

Fun is not a word I would have thought to associate with an act as laborious as trail building.

Reveille sounds at 6 a.m. It is cold. The breakfast cooks have

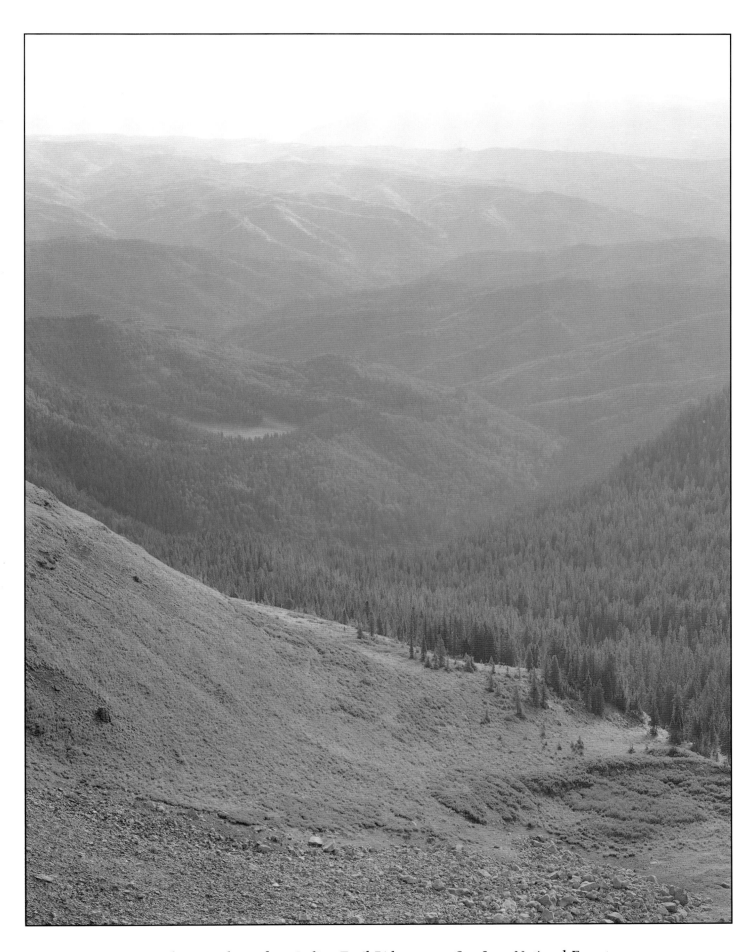

Looking northeast from Indian Trail Ridge across San Juan National Forest
Overleaf: Indian paintbrush wildflowers on Indian Trail Ridge, La Plata Mountains

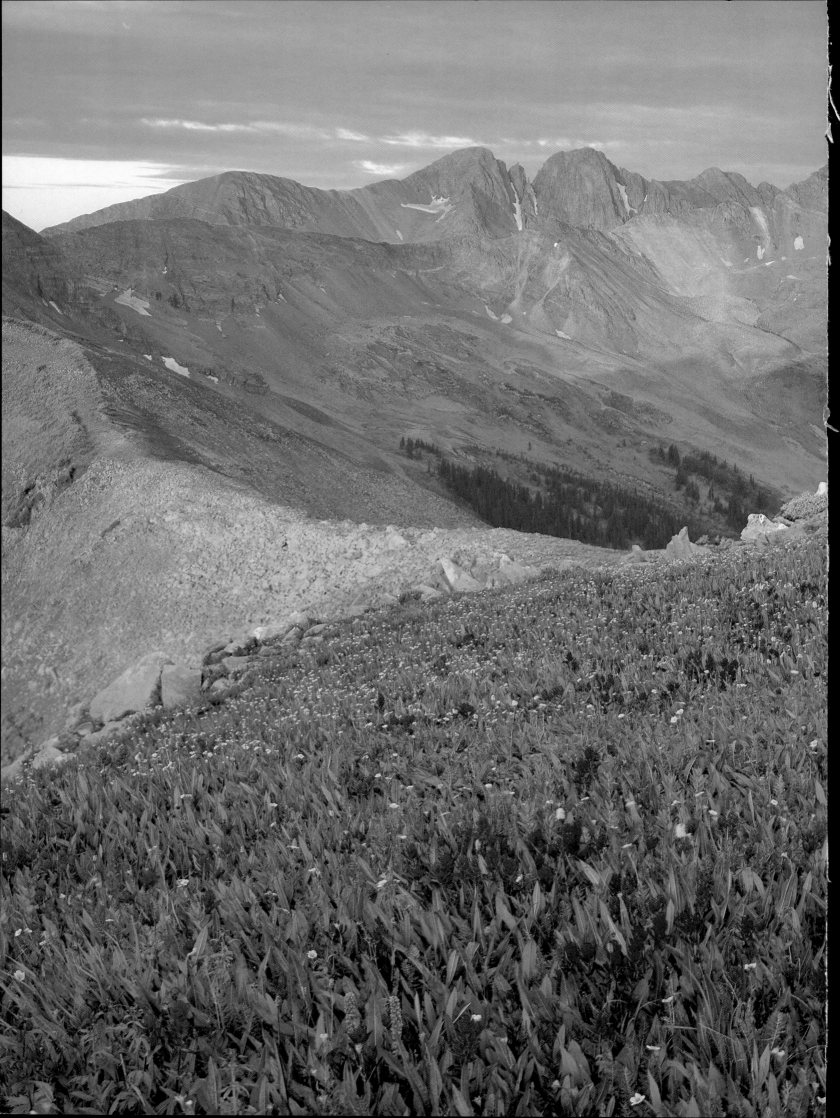

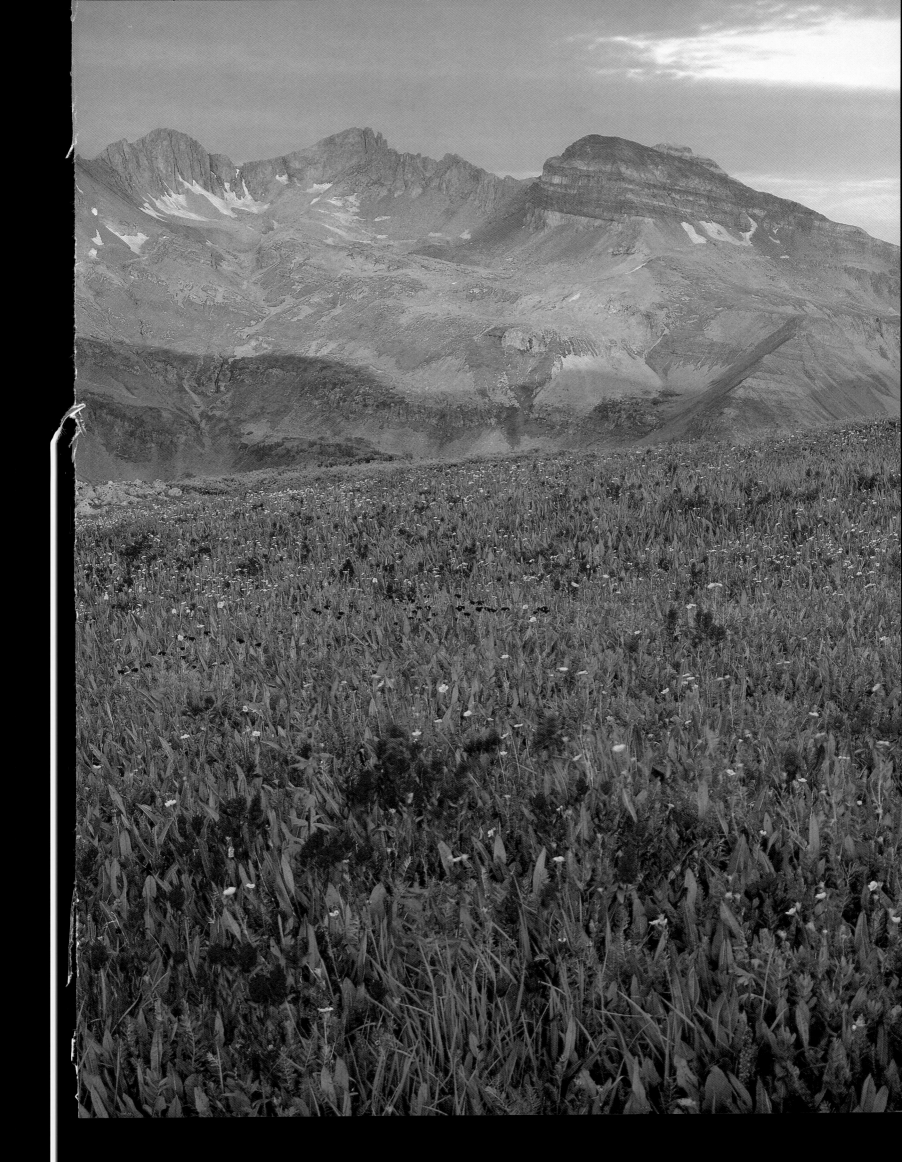

been up since 5. Breakfast is served at 6:30, and by 7, people start heading stiffly toward the trail. Merle pulls aside the three of us who have never been on a trail crew and introduces us to the tools we will be using. He also gives us a general safety lecture, which amounts to "Use common sense."

The tools belong to the Forest Service, an agency which is generally tickled pink there are so many people willing to shell out $25 each to spend a week in the woods building trail.

We work at over 11,000 feet, following a line of flagging established by the Forest Service. Though we do not delve intellectually all that much into the dynamics of trail design, it quickly becomes obvious that the people who know about these things have a keen eye for topographic features, as well as aesthetics.

The old trail — known as the Rico-Silverton Trail — has been in existence for more than a century. It's starting to suffer from erosion. And it has no switchbacks.

We spend the week building several new sets of switchbacks. The trail we build is three feet wide. It is splendid, the kind of trail anyone would be proud to walk on. The work is hard. Though I am in shape from the waist down from a summer of hiking, my arms and shoulders are weak. At the end of each day, I am exhausted. I'm beginning to have second thoughts about this trail crew stuff, at least partially because I hate manual labor so much. Which is why I decided to become a writer.

There are still all manner of chores to be done when we return to camp around 4 each afternoon. The day is not over until dark. But throughout the trail work and the camp chores, there's a feeling of community not often experienced in modern-day America. We are a group of together people working together on a common project, one that will benefit us all.

I take leave from the crew a day early, because of a social obligation back home. As I make my way alone toward Rolling Mountain Pass, I ask myself whether I have come to look upon this experience as "fun."

I cannot say that I have. But I have come to see it as rewarding. Which is probably more important anyhow.

Sunrise over peaks of the Weminuche Wilderness, from Indian Trail Ridge, San Juan National Forest

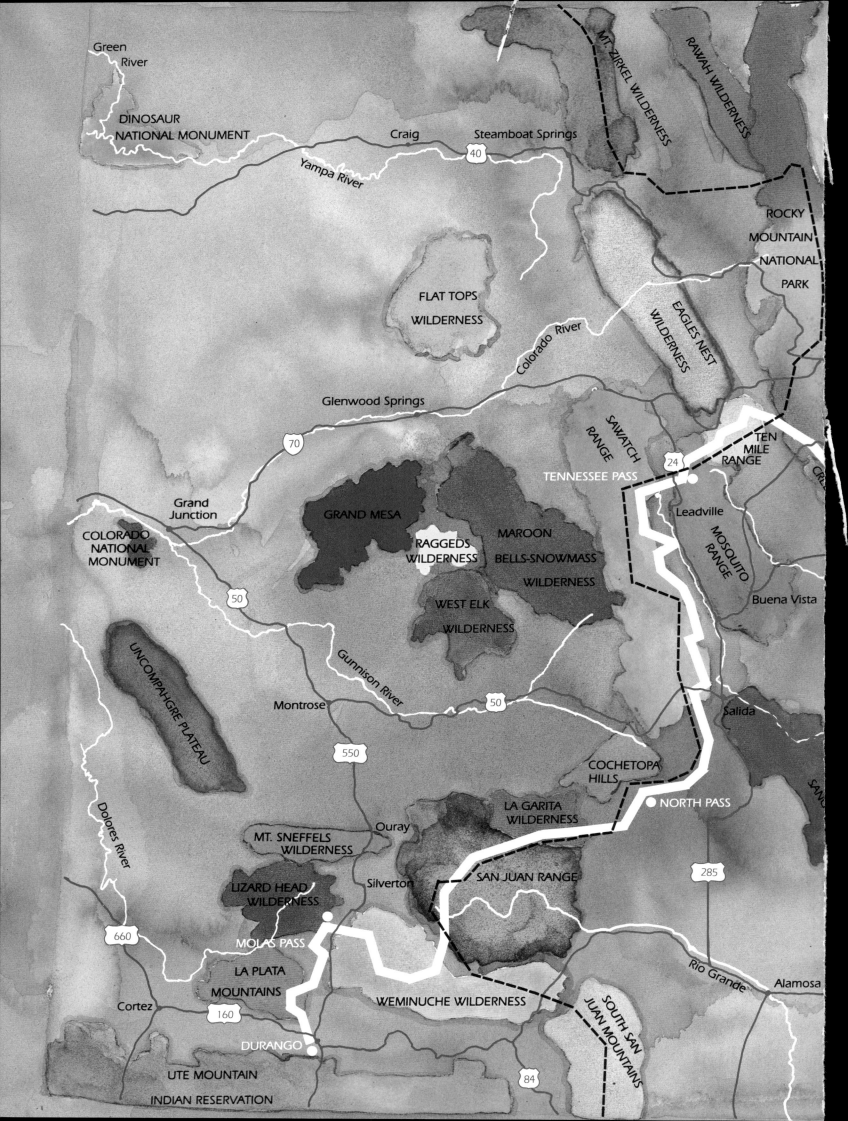